Evita

AN INTIMATE PORTRAIT
OF EVA PERÓN

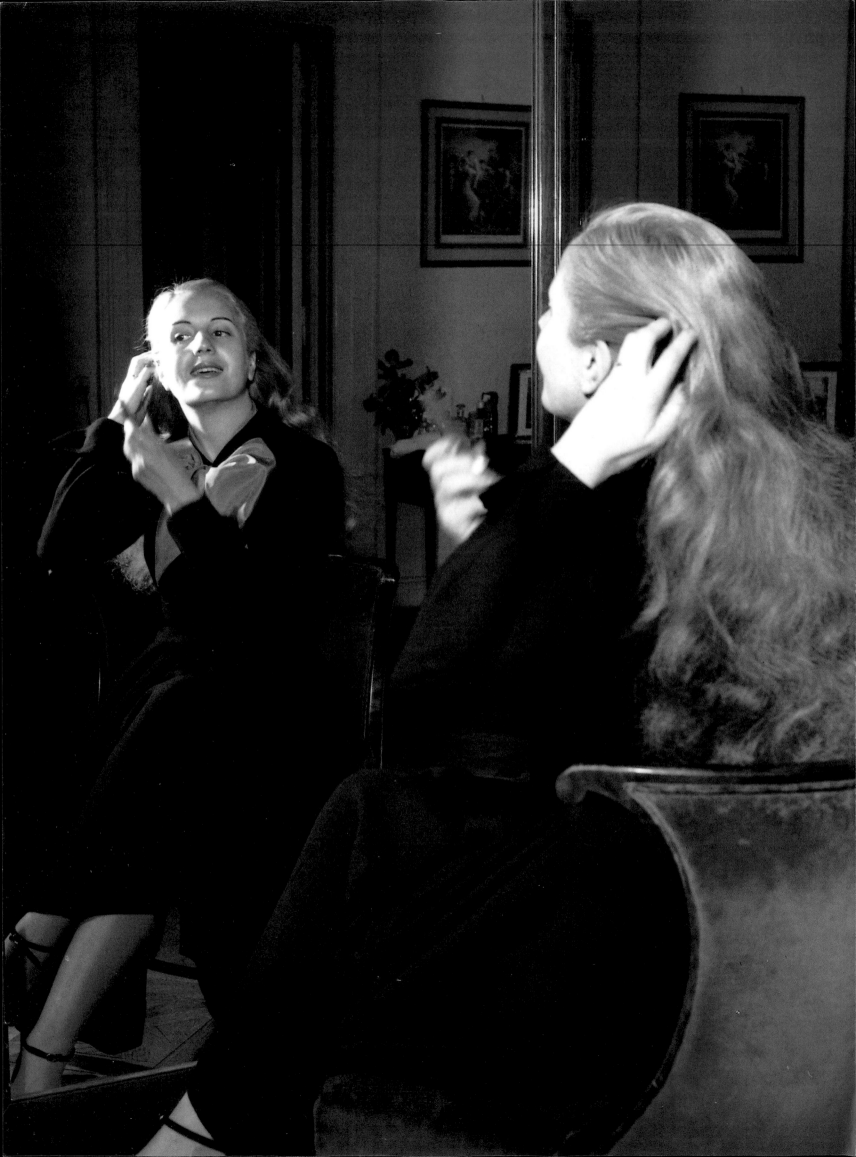

Evita

AN INTIMATE PORTRAIT
OF EVA PERÓN

Edited by

TOMÁS DE ELIA AND JUAN PABLO QUEIROZ

RIZZOLI
NEW YORK

First published in the United States of America in 1997 by
Rizzoli International Publications, Inc.
300 Park Avenue South, New York, New York 10010

Library of Congress Cataloging-in-Publication Data
Evita : an intimate portrait of Eva Perón / edited by Tomás de Elia
 and Juan Pablo Queiroz
 p. cm.
 Includes bibliographical references (p.).
 ISBN 0-8478-2028-9
 1. Perón, Eva, 1919-1952—Pictorial works. 2. Perón, Eva,
1919-1952. 3. Argentina—History—1943-1955—Pictorial works.
4. Argentina—History—1943-1955. 5. Presidents' spouses—
Argentina—Pictorial works. 6. Presidents' spouses—Argentina—
Biography. I. Elia, Tomás de. II. Queiroz, Juan Pablo.
F2849.P37E959 1997
982.06'2'092--dc21
[B] 96-40201
 CIP

Frontispiece: *Evita in her bedroom in the Presidential Residence in Buenos Aires, July 1950.*

Opposite: *Eva and Juan Perón prepare for a gala evening at Teatro Colón, July 9, 1950.*

p. 6: *A studio portrait of Eva Duarte from the early 1940s.*

p. 9: *In a Labor Day speech on May 1, 1951, Evita addresses the crowd from the balcony of the Casa Rosada.*

p. 11: *After the Liberating Revolution deposed Juan Perón in 1955, fervent sympathizers burned Peronist propoganda and images of Evita in the Plaza de Mayo in Buenos Aires.*

p. 13: *Draped in a tablecloth, 15-year-old Eva Duarte strikes a dramatic pose in her family's backyard in Junín, 1934.*

p. 189: *Evita heads home after a typical long day's work at the Ministry of Labor; the Ministry's tower clock reveals the hour—nearly 5 o'clock in the morning.*

p. 192: Santa Evita, *by Nicolás Uriburu, painted after Evita's death.*

PUBLISHER'S NOTE
The primary purpose of this book is to present a comprehensive photographic documentation of the life of Eva Perón. The publisher has honored the wishes of the heirs of Eva Perón in its representation of her in both words and images, and acknowledges the family's cooperation in providing hitherto unavailable and previously unpublished photographs from their private archive.

Design by Kevin Hanek

Printed in Italy

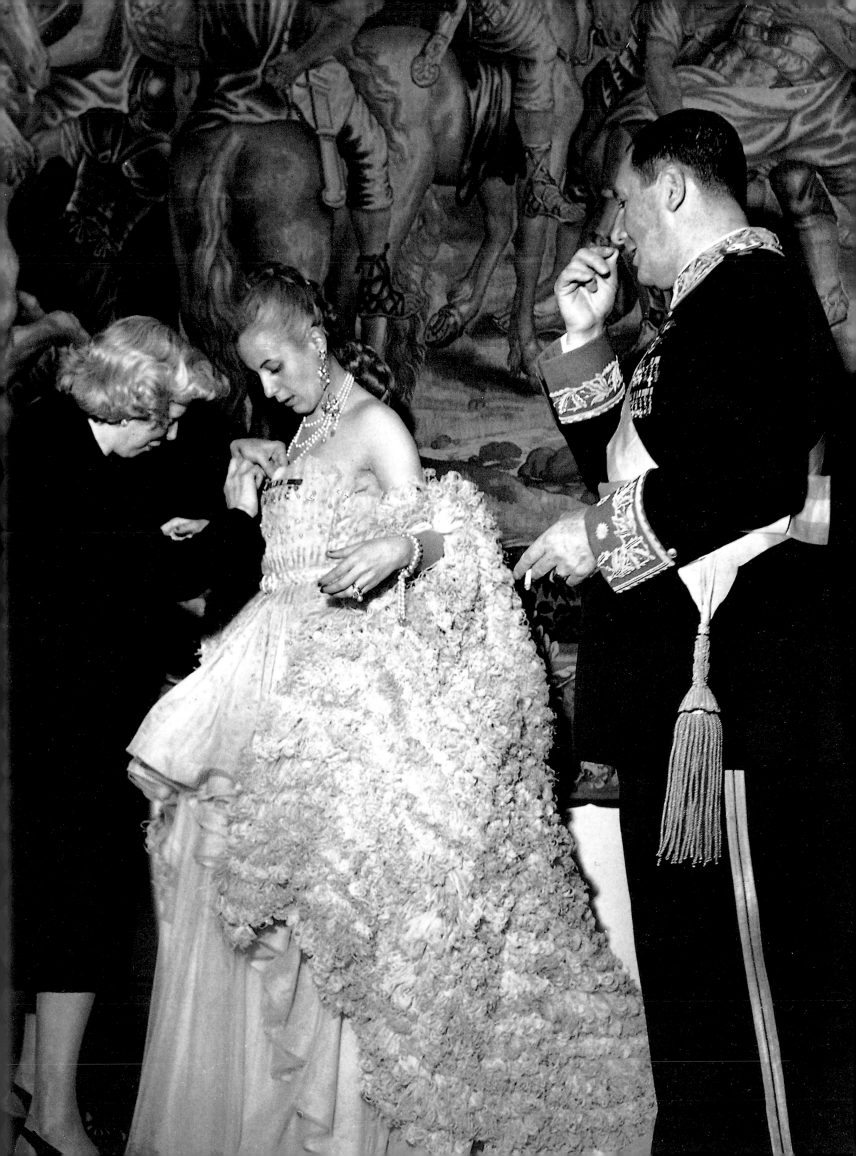

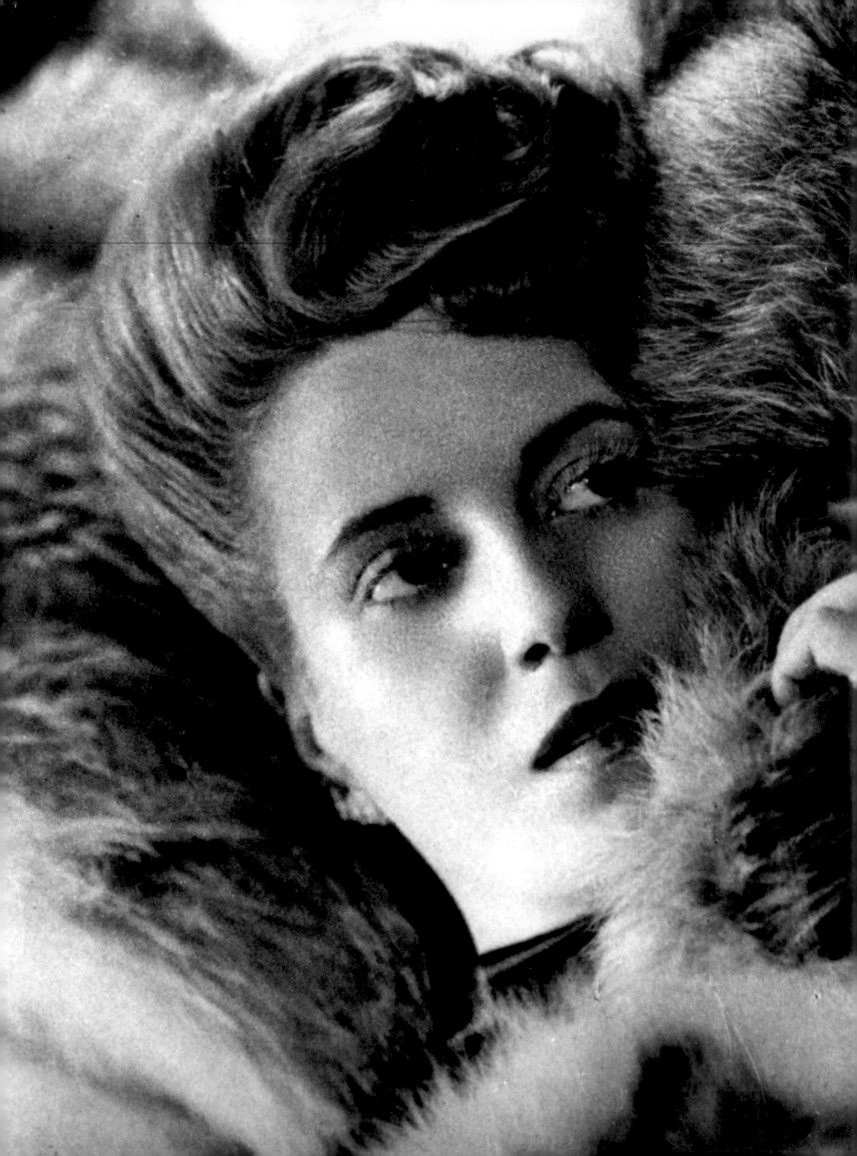

Contents

Preface

FROM THE MOMENT SHE FIRST APPEARED on the scene, Eva Perón raised passions that time and political oscillations have not diminished. Today, almost half a century after her death, the curiosity of new generations has brought forth a flood of biographies, novels, newspaper articles, plays, and films that attempt to interpret her unique personality and destiny. She remains an enigma to which many believe they possess the key, the secret for revealing the "real" Evita who exists beyond her myths. But all such attempts are condemned to failure, because even those undertaken with the greatest objectivity are soon colored by passion—the unavoidable barrier to approaching "that woman" who was herself consumed by passion's flames.

We believe that even with the increasing quantity of material now available about Eva, a book like this—primarily a visual narration of her life—will fill a void. Indeed, in many places, as we searched through thousands of photographs, including the private ones belonging to her family, we began to sense that beyond all the words, a real Eva Perón was emerging—or at least one as real as is possible for today. Photography can lie, but even in lying it tells a truth: what we see actually occurred, and along with the historical or political reflections that photographs can inspire, these images make us feel we are in the presence of concrete fragments of a past that words cannot describe. And for those who may want to press a controversial point, these photographs could provide new perspectives that would allow them to prove or disprove a claim or correct an error.

We know that the mere act of selecting photographs can involve bias. However, we believe this danger has been avoided by the nature of our project, which was to review Evita's entire life, from early childhood until death, in all its aspects, without exception. Here we see the little girl in her village, the actress, the First Lady dressed by Dior, the workers' advocate, the class-struggle activist, the gravely ill woman, and the heroine to millions. One of the surprises awaiting one here is the multitude of diverse and even contradictory personas revealed in Evita. Her brief trajectory, barely six years of which were spent in the public eye, was of such intensity that it seems to have embraced many lives. Photographs that follow one another by only a few months sometimes show a woman evolved by several years, who was already someone else and yet still the same person, flushed by the excitement of change. It was this quality of hers—her courage and determination in breaking old molds in order to bring something new into the world—that first attracted us to her and led us to undertake the book.

We believe that Evita was surely aware of the value of image and anticipated the image-conscious age we live in today. She constructed her own image with an intuitive skill that has been seldom rivaled in recent history. Although she was engulfed in controversy from her first step into the political arena, she must have known that even if arguments about her raged,

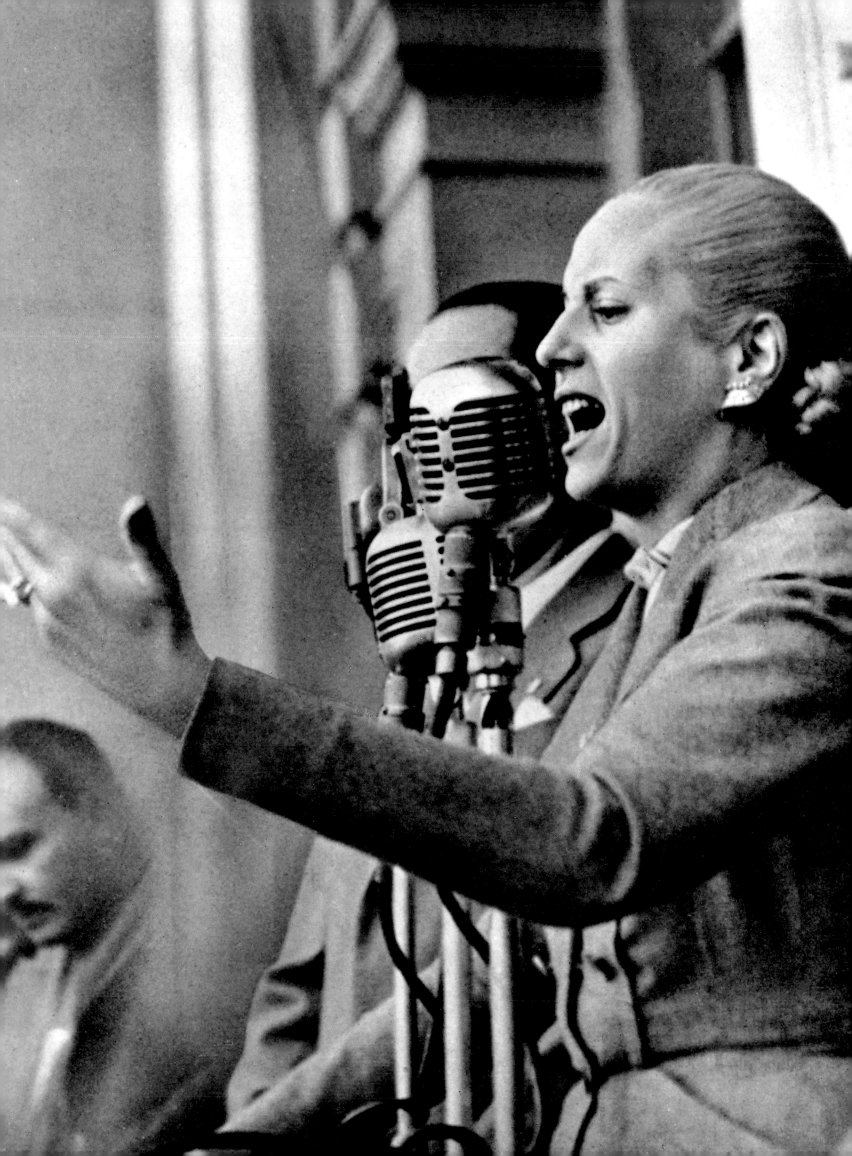

the media could be used to transmit images, like encoded messages, of her energy, her love for work, and her devotion to the people.

The leaders of the coup that overthrew the Peronist government in 1955 also must have known the power of the media when they launched their campaign to destroy all visual material related to Eva and Juan Perón, when mere possession of their photographs became grounds for imprisonment. Argentinians have a tendency to try to erase a troublesome past by destroying its monuments and documents. The razing of the Presidential Residence, where Evita lived and died, had an antecedent in the nineteenth century in the destruction of the Buenos Aires residence of Governor Juan Manuel de Rosas, a controversial, autocratic leader.

In the archives and libraries where we did our research, we frequently found nothing where there should have been material about Evita. When we looked in books, pages that contained a photograph of her according to the index, had been ripped out. In periodicals sections of libraries we would look for issues of newspapers or magazines that had published her photographs, only to find those issues missing. Collectors, generous with everything else, hid their images of Evita from view. Passions aroused so long ago have left strange and unpredictable reminders.

Even so, the patient work bore fruit. We examined, one by one, about thirty thousand photographs. With considerable difficulty we convinced three photographers who had photographed Eva extensively to let us use a sizable number of their unpublished pictures, which appear here for the first time. Their hesitation was understandable when we remember that they had been threatened and persecuted, and their homes ransacked. One of them had hidden his negatives in the basement of a farm in Patagonia. He unearthed them for us, from beneath the dust and cobwebs, in one of the more poignant encounters of our project.

In addition to our Argentine sources, we consulted archives and private collections in New York, Paris, London, Madrid, and Rome. Little by little the album filled up until not a single period of Evita's life remained unrepresented. Even her childhood, about which there has been so much conjecture, emerged through a series of photographs that had never been assembled before. The same is true about her funeral, a time when her image seemed to be disappearing but only returned, more vivid than ever, steeped in pain. From all of these images a convincing sense of reality emerged, a life portrayed with a freshness and newness that transcends time.

— TOMÁS DE ELIA AND JUAN PABLO QUEIROZ

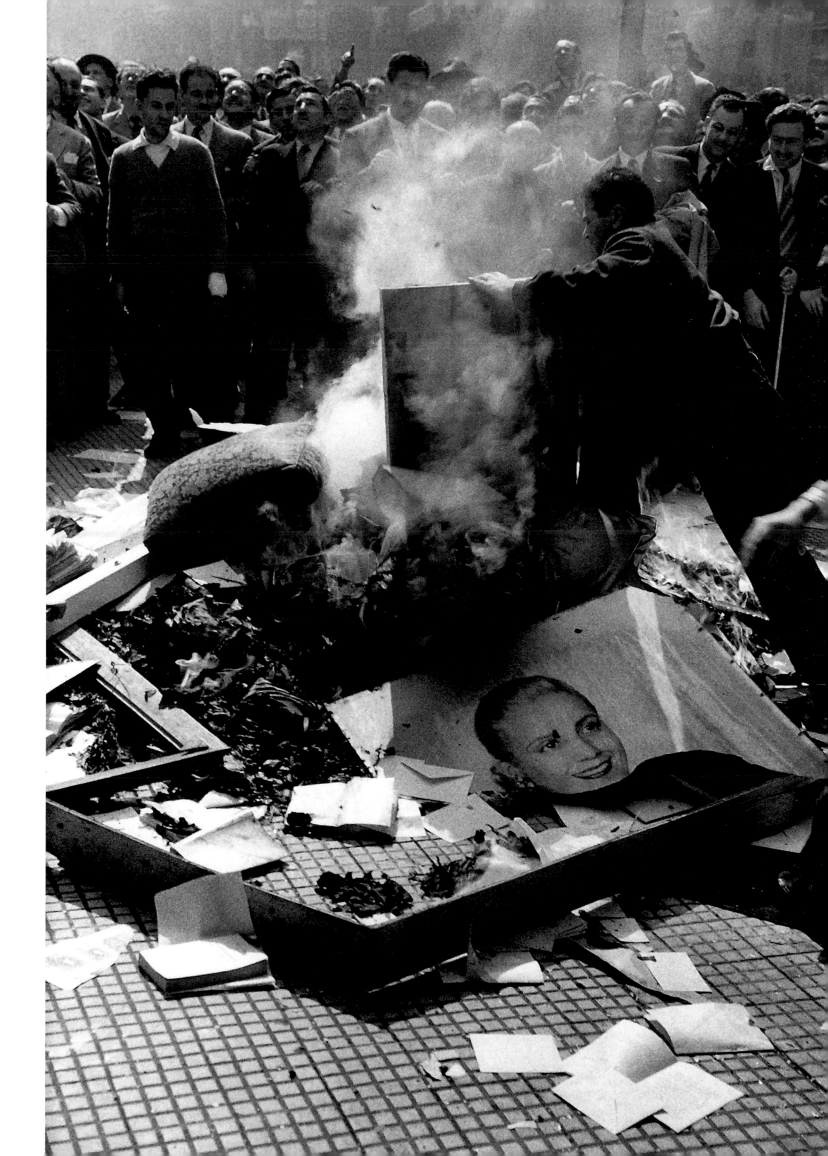

Introduction

Valiant, alluring, and powerful, intimidating yet simultaneously vulnerable and unknown: this is the paradox of Eva Perón. Her reputation has an aura of myth and ambiguity about it, partly because of the elusiveness of her private life, but mostly because of the singularity of her role in Argentine politics. After working as an actress for radio and for stage, Eva came to prominence in 1945 when she married Juan Perón, who was elected President of Argentina the following year. During the first six years of his presidency, she virtually became his partner in governing the country and ran the ministries of health and labor, and controversy surrounding her role has still not been fully resolved.

When Eva Perón died in 1952, the official bulletin from Buenos Aires announced the death of "the spiritual leader of the nation." Though the news had been expected for months, it sent shock waves through Argentina, and the country went into deep mourning. She was only thirty-three years old at the time of her death, but she had dominated the public scene in Argentina like no one before her. This exposure had a high cost, however. While she was a passionate orator and a militant champion of the poor and oppressed, the response to Evita, as she was known, was extreme. The working class, identifying with her humble background, felt an almost religious veneration for her; the middle and upper classes rejected her as an ambitious opportunist at war with established values.

Again and again in her brief life, Evita triumphed over circumstances to become a champion of the people; her public persona endured and flourished despite dramatic shifts and turns that seem to confound generalization. Evita's career has been a historical enigma obscured by the very myth she engendered. Over the more than four decades since her death, many books have been published about her, and she has been repeatedly "discovered" by Broadway and Hollywood. But who was Evita? How did she come to such power and fame? Was she of her time or ahead of it? What is important about her story is the inherent fascination it holds even for those who are not interested in politics. It is a very human story that tells of a dramatic life, the life of someone who was passionate, tender, intelligent, and indomitable.

Eva María Duarte was born on May 7, 1919 in Los Toldos, a tiny village in the countryside surrounding Buenos Aires. She was the youngest of five children born to Juana Ibarguren and Juan Duarte, a conservative rancher from the nearby town of Chivilcoy. In Los Toldos, which means "the tents," siestas were long, streets were unpaved, and the passing of a train was the major event in a day. Juana and her children lived in a modest house, but there were large open spaces where they could play.

When Eva María was only eight years old, her father was killed in a car accident and Juana and her children were left to fend for themselves. Eva's modest

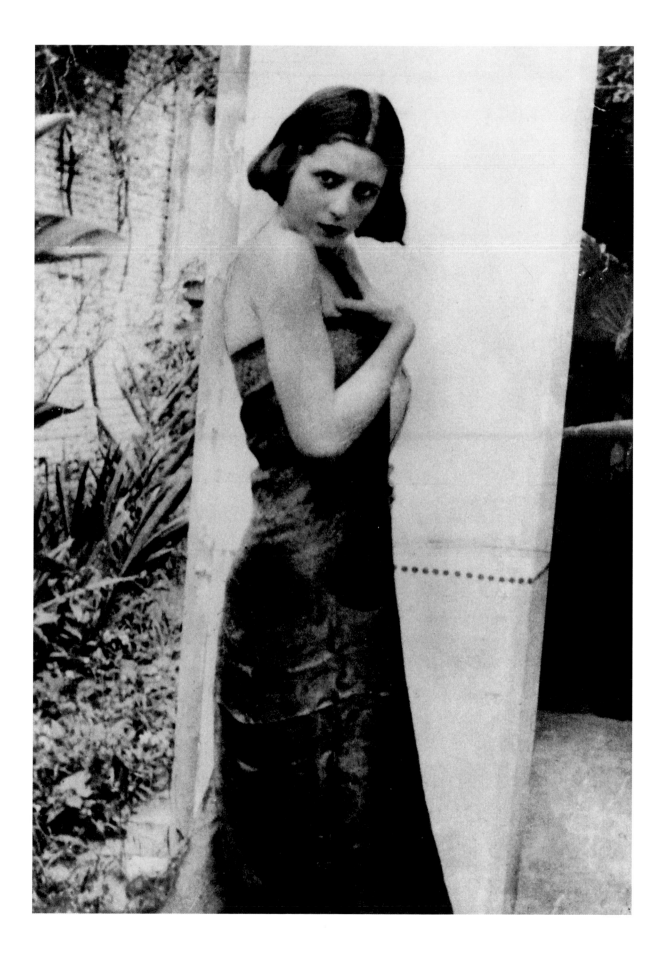

roots in Los Toldos were vital to her later role as a champion of the poor and working classes. In a memoir entitled *My Sister Evita*, Erminda Duarte recounts that ". . . Mama couldn't buy us toys. She and a sewing machine, working from morning until after midnight, provided us with the bare necessities." The memoir goes on to tell about the beautiful doll that young Eva wanted desperately and asked the Three Kings to bring her. Her wish was granted but the doll had a broken leg. Her mother explained that it had fallen off one of the camels ridden by the Wise Men. "What our mother didn't tell you was that the doll had cost almost nothing . . . precisely because it was damaged. What she said instead was that the Kings had brought the doll for you to take care of. [It was] a mission."

In 1930 the family moved to Junín, a neighboring city, where Juana worked as a seamstress. Eva continued to attend school in Junín, and it was there that her acting ambitions began to take shape. Through her sister Erminda, who belonged to the Cultural Council at the Colegio Nacional (the National Secondary School), Eva joined the student theater group and her recitations were heard over loudspeakers set up by a music store for the use of local amateurs.

As for any true dramatic instruction or development, though, Junín was barren. The alternatives for a young girl in Eva's position were few and unappealing: a low-level job or, in Eva's words, the "inevitable domestic slavery" of marriage. She described her desire to leave for Buenos Aires in terms of her own personal freedom. "At a very early age I left home, left my town, and I have been free ever since." Indeed it was a tender age. At only fifteen years old, having struggled through primary school, Eva had made her decision, and she delayed acting on it only for as long as it took to obtain her mother's permission. This could not have been easy, and there are several accounts of her departure from home. The most persistent legend involves the tango singer Agustín Magaldi, who would have accepted responsibility for the aspiring young artist, but the more plausible story is the one told by her family: Doña Juana took her daughter to Buenos Aires to audition at a radio station, and Eva arranged to stay on at the home of family friends, the Bustamantes.

BUENOS AIRES IN THE 1930S was the continent's most cosmopolitan and elegant metropolis and soon became known as the "Paris of South America." As in any great European capital, the center of the city was filled with cafés, restaurants, theaters, movie houses, shops, and bustling crowds. Eva was one of many people from the provinces, attracted by the process of industrialization, who came to the capital during the 1930s. When she arrived in 1935 with little more than a cardboard suitcase containing her few possessions, the bold teenager must have felt a wrenching sense of vulnerability and solitude. In direct contrast to the glamour of the city, the 1930s were also years of great unemployment, poverty, and hunger in the capital, and many immigrants from the interior were forced to live in tenements, squalid boardinghouses, and in outlying shantytowns that became known as *villas miseria.*

One must assume that young Eva Duarte was possessed of uncommon strength of character, enormous pride, or driving ambition; perhaps it was a combination of the three. Despite the early hardships she endured, she did not return home to her family; she did not give in to the temptation of finding work in an office or shop, nor did she choose the simplest and most acceptable way out, marriage. Instead, she embarked on the first tentative steps of her acting career, which would last ten years. Shortly before her sixteenth birthday, she was cast in a small role in a light stage comedy, *La Señora de los Pérez* (The Pérez Woman), performed at the Comedia Theater by the troupe of Eva Franco, a leading actress. The following year, in 1936, she toured the interior with the Pepita Muñoz company, and that summer, in Buenos Aires and Montevideo, she appeared in an adaptation of a play by Lillian Hellman.

After two years, Eva was still trying her luck on the stage, but never played anything but very minor roles. What she learned from her acting jobs, though, became only a small aspect of her rapidly accelerating education. While not an exceptionally talented actress or particularly successful, she acted in theater of all kinds, appeared briefly in a few films, modeled for commercial photographers, and endured long periods of unemployment. These experiences, while sharpening

her determination and forging a foundation for her later endeavors, provided only a precarious living in rented rooms or modest apartments shared with coworkers. Friends who knew her at this time recalled her as withdrawn, serious, exceedingly thin, and not very pretty, although they all mentioned something remarked on by everyone who knew Evita: her perfect skin. One of her greatest opportunities, however, also came at this time in the form of another medium, radio.

Radio was a popular passion in the 1930s and had a huge audience. It was also the medium that allowed Eva to shine. Through her voice, she came into contact with millions of listeners. Both the pathos of the dramas she acted in, as well as an emotional intensity that would be amply demonstrated in the future, explain her swift success. In 1939, she headed her own acting company in a historical drama, *Los jazmines del '80* (The Jasmines of '80), written especially for radio by Hector Pedro Blomberg. Between May and July of that year, Radio Prieto broadcast the show every afternoon. Eva performed on other radio stations as well (Radio El Mundo, Radio Argentina), but there continued to be periods when she had no work.

As Eva was making her way as an actress in *radionovelas*, the revolution of June 4, 1943, in which the conservative president and the civilian government were overthrown by a group of Army colonels, brought significant changes to Argentina and to radio. In line with the campaign for public morality launched by the new military government, broadcasting was regulated, pessimistic plots in radio dramas were discouraged—as was the tango—and it became necessary to obtain a permit from the Postal and Telecommunications Bureau for each program. Lieutenant Colonel Aníbal Imbert was in charge of that bureau for the new regime and Eva wisely befriended him, his secretary, Oscar Nicolini, and Nicolini's wife. Through these contacts, Eva signed a contract with Radio Belgrano, where she acted in romance and mystery serials. Prophetically, Imbert even procured for her the starring role in a new series based on the lives of famous women in history—Mme. Chiang Kai-shek, Queen Elizabeth I, Isadora Duncan, Sarah Bernhardt, Catherine the Great—in which she would perform until she ended her artistic career in favor of a political one.

Despite conflicting versions of the role initially played by Colonel Juan Perón in the June 4 coup, it was he who emerged as the real authority in the new regime. He was named Minister of War and was in charge of labor relations through his position as director of the National Department of Labor, which he transformed into the Secretariat of Labor and Social Welfare. With the approval of the General Staff, he used the Secretariat to gain union support by implementing a bold policy of concessions to labor. Like millions of other Argentines, Eva Duarte responded immediately and powerfully to Perón's appeal.

BY MOST ACCOUNTS, Eva Duarte and Juan Perón first met on January 22, 1944, at a benefit to aid victims of a recent earthquake, although they may have been introduced at a party a few days earlier. The benefit was organized by Perón through the Secretariat of Labor, and popular figures from the world of entertainment played a dominant role in the relief effort. Eva was there to help solicit donations and as spokesperson for the Argentine Radio Association, a trade union she had helped to found. Juan Perón was 49 and had been a widower for five years; Eva was 24. From that moment of initial contact until her death eight years later, she fervently devoted herself to him and *la fe peronista*—the Peronist faith—that he embodied.

Over the next few decisive months, Perón gradually—though increasingly—occupied the seat of political power, and he shocked his comrades by allowing his new companion to take part, timidly at first, in his political meetings. President Ramirez resigned in March 1944 and was replaced by Farrell, who made Perón his vice-president. On June 1, Eva made her political debut by beginning a series of morning talks on Radio Belgrano promoting the principles of the June 4 revolution. Her texts, which were prepared by Francisco Muñoz Aspiri, the scriptwriter for her radio plays, already had the exalted tone and the demand for justice that would characterize all of Evita's public performances.

Her schedule was hectic during this time. At Radio Belgrano, in addition to her morning talks, she performed in an afternoon radio play, and continued the biographies of famous women series at night. In May she was elected president of the Argentine Radio Association. And with the prestige she enjoyed as the established paramour of the most powerful man in the country, she was offered a movie contract for a major film, *La Cabalgata del Circo* (Circus Calvacade). This was immediately followed by the leading role in *La Prodiga* (The Prodigal Woman). Almost simultaneously, her transformation into a political figure had begun. Perón seems to have realized the full extent of her political cachet, and she appeared at his side everywhere, accompanying him to demonstrations and even campaigning for him. By the time the second film was finished, Perón was president and it was never released. It is believed that Eva ordered the film withheld because she felt her former public persona as an actress was incompatible with her new role as First Lady. This was only one of many instances of the Peróns' pressure on the media during their years in power.

By this time, Perón had become more and more of an irritant not only to the opposition, but to the other colonels with whom he had overthrown the civilian government. They were annoyed by his increasing prominence among them, and further provoked by the continual presence of his very vocal, very visible companion, who stood not behind him, which would have been socially acceptable, but beside him, sharing both his interests and his struggles in a confluence of two uncommon personalities who realized that they complemented one another.

The brewing conflict came to a head on October 13, 1945, when a faction of officers arrested Perón and forced him to resign from all posts. While there was significant support for this action from the middle and upper classes, these events deeply stirred the workers, who realized that the fall of Perón would wipe out his pro-labor policies and all the victories they had achieved. On October 17, the working class descended upon Buenos Aires from all quarters of Argentina in larger numbers than anyone could have imagined.

They converged at the Plaza de Mayo and demanded the presence of Perón.

Whether Evita had a hand in mobilizing the workers, the first direct intervention by the masses in Argentina's politics, is unclear and remains the subject of debate. Eva never explicitly confirmed or denied that she had helped orchestrate the mass movement to the Plaza de Mayo. Her position at the time makes it seem unlikely that she was the driving force behind Peronism; she was, after all, not yet Perón's wife. At the same time, given her character and all that was at stake at this critical juncture, it is difficult to imagine her completely passive. In a letter Perón wrote to Eva during his brief imprisonment, he spoke of requesting a discharge, marrying her, and going off "someplace to lead a quiet life." His captors, in the face of the riotous crowds, quickly released him. By the time Perón appeared that night on the balcony of the Casa Rosada, the governmental palace facing the Plaza de Mayo, and announced to the cheering throng that elections would be held, a leader had been born, and the setting for Perón's contact with the people—the balcony on the Plaza de Mayo—had been established. He won the elections in February 1946 with the steadfast help of his new wife, Eva Duarte de Perón, whom he had married in October, days after being released, but there would be no quiet life for either of them.

ONCE PERÓN WAS PRESIDENT, Eva adopted an unprecedented way of fulfilling her duties as First Lady. From that moment on, her redefinition of herself was made in relation to Perón, who, as the helmsman, could turn the demands of the working class into reality. Eva would be the emotional link between the masses and their leader, the human face of politics, the guarantee that they would stay on course. Highly charismatic and trained as an actress to mesmerize the public through her dramatic voice and gestures, Evita certainly seemed conscious of the influence she held over the masses. Ultimately she came to be known as the "Bridge of Love," who devoted her life to the task of conveying the people's hopes to the President; yet at the same time she conveyed to the

people the President's demand of unconditional loyalty to the Peronist cause. In the exigencies of this role, assumed with an energy that could be termed fanatical, the persona of Evita was clearly drawn.

The transformations she underwent at this time also manifested themselves in her physical appearance. Her hair was dyed blonde and pulled back tightly from her face. She was obsessed with self-presentation and daily went to work dressed in smart designer suits and elegant jewelry. Critics and the oligarchy, however, continually questioned Evita's motives for lavish expenditures on her formal wardrobe. "The poor like to see me beautiful," she reportedly argued. "They don't want to be protected by a badly dressed old hag." The aspiring *radionovela* actress had been left behind forever. For his part, Perón placed no obstacles in her way.

Her first center of operations was the fourth floor of the post office building, turned over to her by her friend Nicolini, then General Director of Radio Broadcasting. Here she began to receive delegations of workers requesting her intervention to obtain better conditions, or her assistance in organizing unions. This relationship with the labor movement would constitute her firmest power base. She also began to make frequent visits to factories and poor neighborhoods, and to meet with the needy, who were naturally drawn to her. On July 25, in a message to the women of the country, she announced new government measures to combat usury and speculation.

For five years, until she was too ill to do so, Evita came to the Secretariat of Labor and Social Welfare (it was by then the Ministry of Labor, but she called it by the old name) every day, working longer and longer hours. It was a symbolic place since this was where Perón had created his power base. In her autobiography, *La razón de mi vida* (My Mission in Life), she wrote: "I went to the Secretariat of Labor and Social Welfare because there I could encounter the people and their problems more easily; because the Minister of Labor and Social Welfare is a worker, and with him Evita can speak frankly, without bureaucratic evasions; and because there I was given what I needed to begin my work." Evita set a grueling pace for herself and demanded the same of her colleagues.

She began early in the morning, when she attended to the most urgent cases at the Presidential Residence; then she would go to the Secretariat, where she received petitioners and trade unionists, and did not leave until she had spoken to every person waiting to see her.

She met with delegations of workers and countless humble people from all over the country. All accounts agree concerning her fierce dedication and genuine interest in the problems they brought to her, the generous amount of time she spent with each person, and her unpatronizing courtesy and cordiality. Her informality was not affected, for she too was a woman of the people, and she treated everyone—unionists, legislators, and ministers—the same, though she was more impatient with ministers than with her petitioners. In 1947, she would leave the Secretariat at ten at night; in subsequent years, she would work there until the small hours of the morning. When she fell ill, and was advised to slow down, her answer was a definitive no: "I can't, I have too much to do." Her physical presence was necessary, for she met with the poor face to face and resolved emergencies—great or small—on the spot: money for clothing, for example, a job, medicine, a place to live.

IN 1947, EVA PERÓN MADE an extended and highly publicized tour of Europe that was a highlight of her career. The idea for the trip originated with an invitation from the Spanish government to Perón. Spain was suffering an economic crisis at the time and was politically isolated from the rest of Europe. By contrast, Argentina was one of the most prosperous nations in the world and General Francisco Franco was eager to form closer relations.

Evita traveled with an entourage of ten people, including her friend Lillian Lagomarsino de Guardo, the wife of the President of the Chamber of Deputies; her brother, Juan, who served as Perón's private secretary; two military aides; her speechwriter, Muñoz Aspiri; a photographer; her hairdresser; and the head seamstresses from Henriette and Naletoff, the couture houses that designed her wardrobe. Her close friend, shipping magnate Alberto Dodero, who financed her entire tour of Europe, acted as her guide.

On June 8 she arrived in Madrid, where she received a magnificent welcome, as she did throughout Spain. She attended gala evenings, official ceremonies, bullfights, and the opera. Franco even decorated her with the Grand Cross of Isabella the Catholic, Spain's highest honor. Everywhere she went in Spain, the streets overflowed with cheering crowds.

This kind of enthusiasm was not repeated in the other countries she visited, but Evita was clearly becoming an internationally prominent figure. *Time* magazine, for example, which was known to be unsympathetic to Peronism, assigned a reporter to cover the tour, and featured Evita's picture on the cover. She appeared intensely concerned about her public image on this trip; throughout her entire two-month tour, she spoke with Juan Perón by telephone daily to assess the public impact of her trip at home, and to keep abreast of Argentine politics.

From Spain, Evita traveled to Italy, where Pope Pius XII granted her a private audience. In Paris, after fulfilling her official duties, Evita, extremely fatigued, left her hotel only to visit Versailles (closed since World War II, it was opened especially for her) and Nôtre Dame Cathedral, where Cardinal Roncalli, the future Pope John XXIII, was her guide. She spent a few days on the Côte d'Azure, visiting Monaco and cruising the Mediterranean on one of Dodero's yachts. Her trip to England was cancelled, and she went to Switzerland instead. Her final destination was Portugal. The entire tour was punctuated by visits to working-class neighborhoods and institutions engaged in social action. These were stops made on Evita's initiative, as they were not part of the official program, and she made contributions at various places, including a large gift to the victims of an explosion in the port of Brest that occurred while she was in France.

She traveled home by ship, which gave her a few needed days of rest after more than two months of incessant activity. As she passed through Brazil and Uruguay on her way to Argentina, her schedule was once again filled with official ceremonies. In Rio de Janeiro she attended the Inter-American Conference on Peace and Security. When she finally arrived home in Buenos Aires, she received a hero's welcome.

UNDER THE PERONIST GOVERNMENT, Evita was the natural spokesperson and defender of women's rights, which were now intimately tied to changes in the labor sector. A month after her European tour, the law was passed that gave Argentine women the right to vote. Even though they had fought for suffrage for more than fifty years, it was a cause that Evita had made her own ever since Perón had assumed office and the legislation was linked to her name. In 1949 the Peronist Women's Party was created in support of Perón and his policies; Eva was elected president of the party, with full organizational authority. Moreover, the Peronist Party was the only political party in Argentina at that time that included women on its membership rolls; in 1952, twenty-three women deputies and six women senators were among the Party's representatives in the parliament.

By the middle of 1947, it was obvious that the many social programs undertaken by Evita with characteristic speed required an organizational structure. The Eva Perón Foundation was created, in her words, "to fill in gaps in the national organization." The largest of these gaps were in aid to women, children, and the elderly. In these three areas, the Foundation sponsored an uninterrupted series of projects, from homes for the aged and shelters for abandoned women and single mothers to childcare centers, specialized hospitals, athletic leagues for youths, a nursing school, and housing for workers. Financial support for the Foundation was granted through laws passed by the parliament, as well as through contributions from the labor unions, with whom Evita maintained a close relationship until the end of her life. While contributions were not mandatory, the implications of refusing a Foundation appeal were clear: it was not in one's interest to decline. Her personal executive style maintained the pace of work at the Foundation. She supervised each project—during construction and in its operation—and she visited all of them frequently, often accompanied by foreigners who were traveling through the country. Evita insisted that everything be done on a grand scale, even (and especially) projects intended for the poorest recipients.

By contrast, her own life was exceptionally austere. She did not smoke or drink alcohol, ate sparingly, and

attended few private parties. At major official events, she was always at the side of Perón on the balcony of the Casa Rosada. Although her illness, uterine cancer, was first diagnosed in 1950, she chose not to have an operation at that time because she had too much to do. One senses that Evita was acutely aware that she had little time left to complete what she saw as her mission, and it drove her to work herself even harder.

While it is unlikely that her illness influenced her refusal of the candidacy for vice-president, this episode still needs to be studied and clarified. Her candidacy had been proposed for some time, backed by the labor unions, and she had made no objection to it. In a memorable dialogue with an exceptionally large crowd in August 1951, she tried to proclaim her withdrawal from "the honor, but not the fight." It was rejected by acclamation. The crowd in the square below was electrified at the sound of her voice over the loudspeakers and, as was often the case, her speech turned into a dialogue, with a shouted chorus of responses from the multitude. She asked for time to decide. Four days ("No!"), one day ("No!"), two hours ("No! Now!"). Her communication with the people reached an unprecedented intensity; even Perón must have been astounded that night. A few days later, she announced her official withdrawal on the radio.

Confined by illness to the Presidential Residence, which she left less and less often, on May 1, 1952, she spoke for the last time from the balcony of the Casa Rosada. In sharp contrast to her wasted body, her speech on this occasion was the most combative she had ever given. The end was near and it had only made her more impassioned. "I will go with the working people, I will go with the women of this country, I will go with the *descamisados* [the 'shirtless' poor] of our nation, dead or alive, to make sure that the only bricks left standing are Peronist!"

In a miraculous exertion of will, she joined Perón in the inaugural ceremony in early June for his second presidential term. She died the following month. The overwhelming display of mourning took the world by surprise. For two weeks, hundreds of thousands of people filed past her coffin. Death, however, did not bring her the rest or peace that she denied herself in life. A respected Spanish specialist worked for an entire year embalming her body, and plans were made to erect a monument to house it. Construction was delayed, and Perón was overthrown three years later in the Liberating Revolution. By this time publicly despised and lacking the popular support that Evita had always garnered, Perón was forced to flee in exile to Spain; Eva's body remained in the custody of the CGT, a national labor federation. It was stolen from CGT headquarters and for sixteen years its location was unknown. In a covert operation, it had been taken to a military installation in the center of Buenos Aires, and from there to Italy in the late 1950s. With the cooperation of the Vatican, Eva's body was buried in a Milan cemetery under an assumed name. In 1971, her mutilated body was returned to Juan Perón at his residence in Madrid, where it remained until 1974 when, following his death, it was brought back to Argentina. Since 1976 it has lain in the Duarte family crypt in the Recoleta Cemetery, under security.

OVER THE YEARS the popular cult to Evita has persisted, reached immense proportions, and remained intact despite attacks and efforts to demythologize her. In the wake of the Liberating Revolution of 1955, the leaders systematically destroyed documents and photographs of Eva and Juan Péron, and those who secretly retained them risked arrest. But no myth is more resistant than the one that is also a fact. Her achievements remained in the memories of her people and in the streets of her nation, even though her name was officially erased for two decades. More than the romantic legend of a beautiful young woman adored by the people, more than a heroine whose tragic death came too soon, Evita was a political and historical reality that forever changed Argentina.

— FRANCISCO M. ROCHA

Childhood on the Pampas

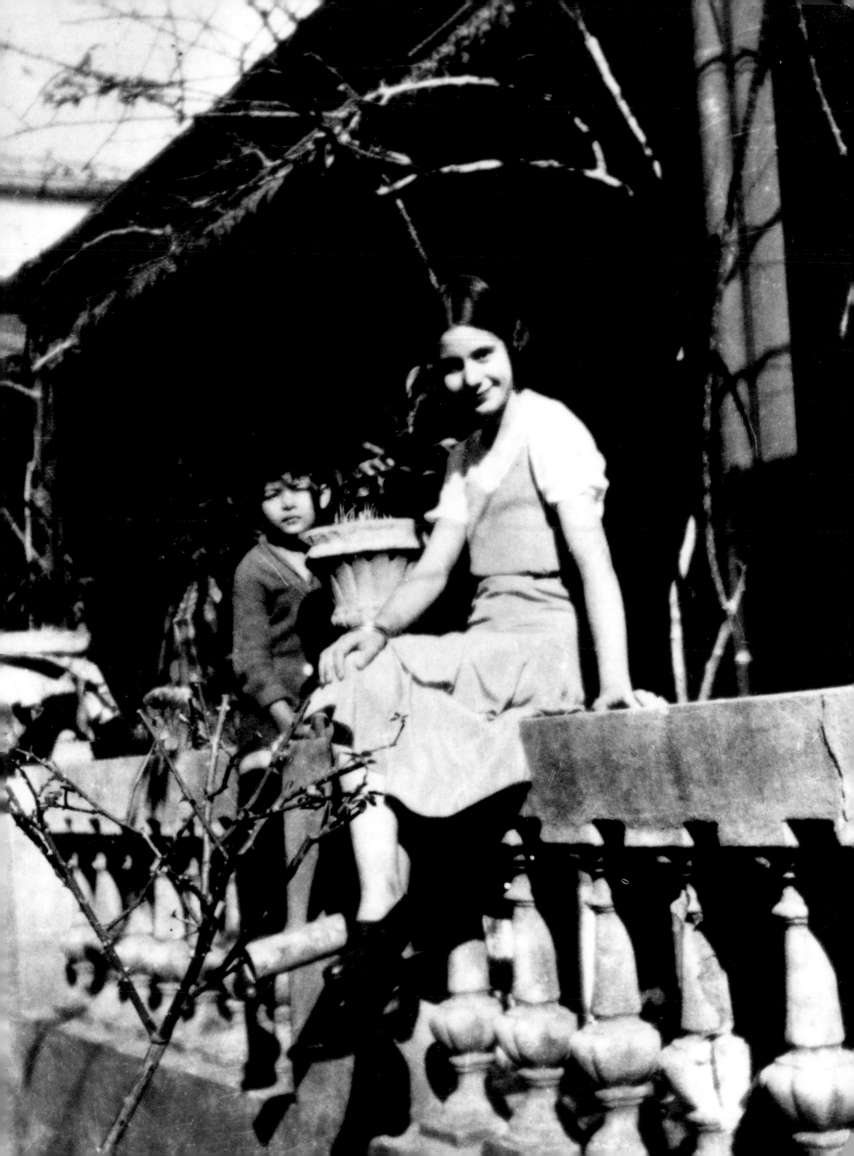

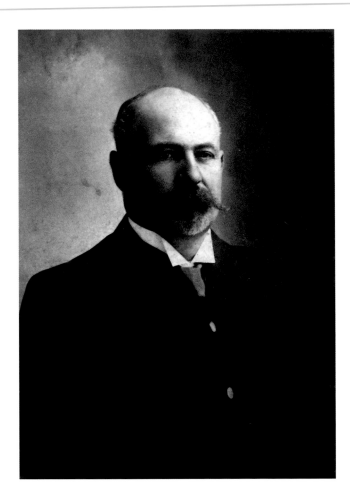
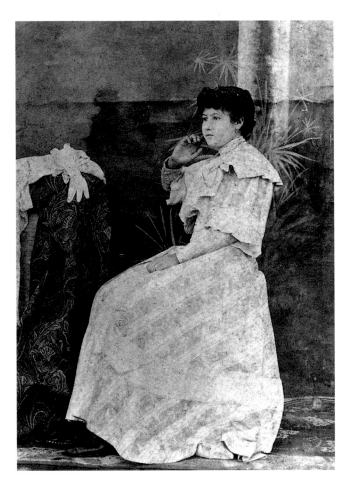

ABOVE

*Evita's parents, Juan Duarte and Juana Ibarguren, in studio portraits taken
around the turn of the century. After Duarte was killed in an automobile accident in 1926,
Juana Ibarguren worked as a seamstress to support their five children.*

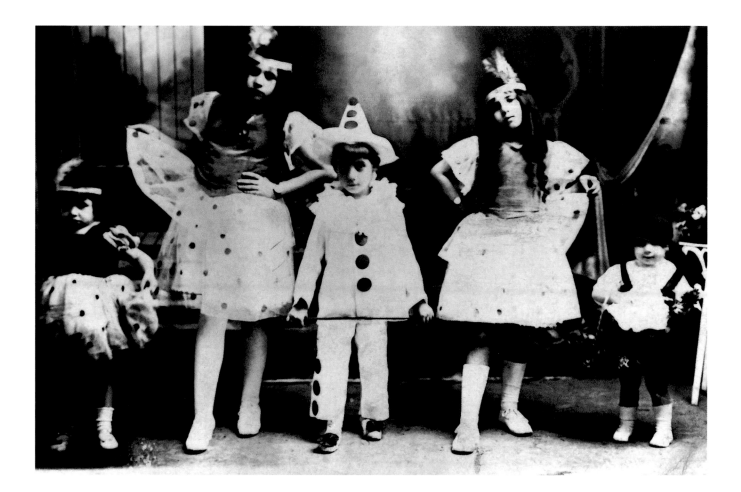

*Evita, age 2, and her brothers and sisters in their costumes for carnival celebrations
in Los Toldos, the remote pueblo where they were born. From the left are Erminda, Elisa,
Juan, Blanca, and Evita. Since the village offered few diversions, the Duarte children
entertained themselves by dressing up and inventing stories and plays.*

TOP
A luncheon honoring Evita's mother, Doña Juana, and other students who had received a diploma in dressmaking from the technical school in Los Toldos. Although she had enrolled in the school to learn to make clothes for her own children, she ultimately used her skills to support the family.

ABOVE
Los Toldos was not much more than a few houses clustered around unpaved streets, as seen in this view from the 1920s. Located in the midst of the vast pampas 150 miles west of Buenos Aires, the pueblo was named after the tolderías, *or Indian settlements, that dotted the landscape in the nineteenth century.*

FACING PAGE
Evita (right), age 5, and her sister Erminda, age 6, in the backyard of their house in Los Toldos. Inseparable, the two spent entire days inventing games, climbing trees, and playing with León, the family dog.

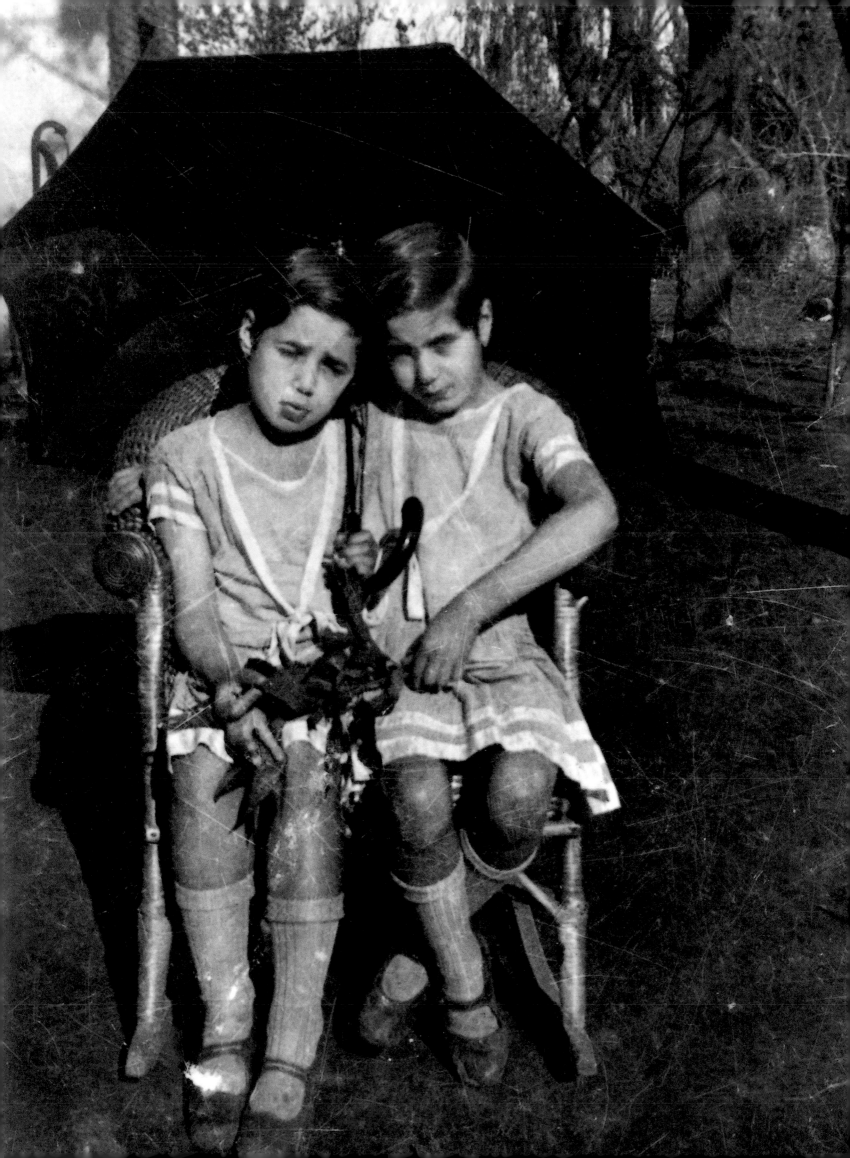

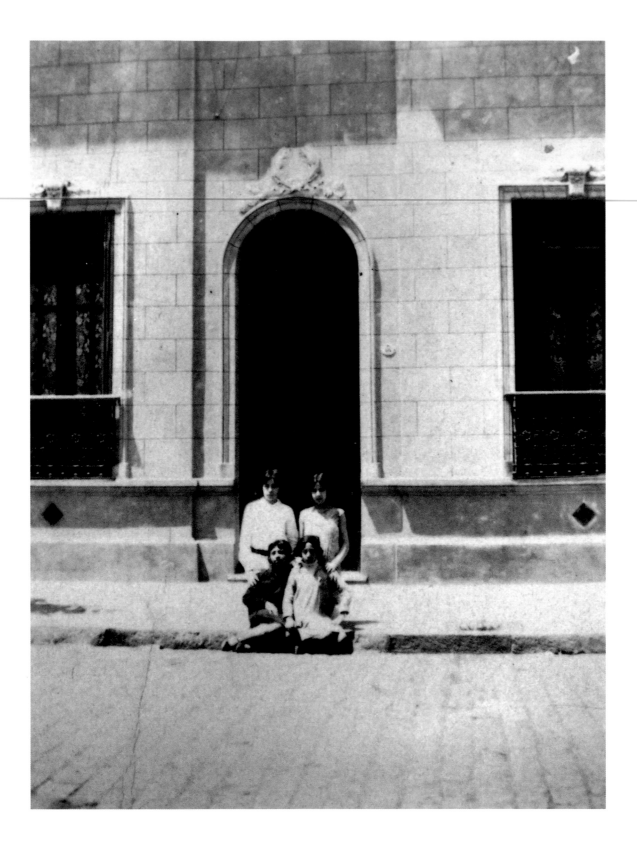

ABOVE
Evita, age 11, (right rear) with Erminda and two friends on Roque Vazquez Street, in front of the family's first home in Junín. The Duartes moved to the larger town so that Elisa, the eldest daughter, could take a job in the post office. Blanca and Juan also found work there.

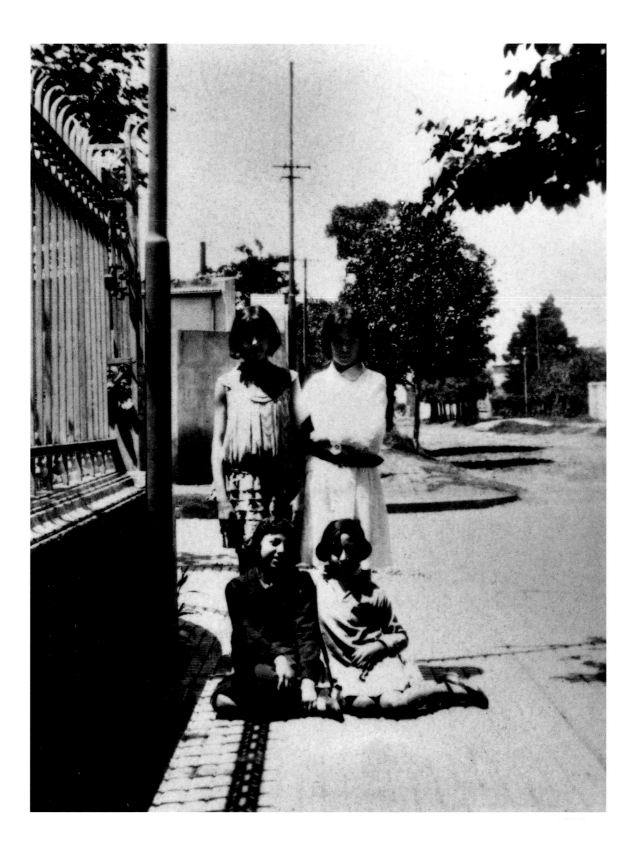

Evita (left rear), Erminda, and their friends in Junín. At home Evita begged to take
Erminda's place drying dishes to earn money to buy movie magazines for her collection.

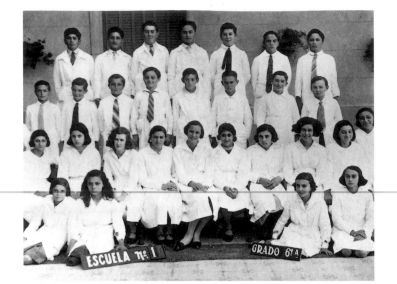

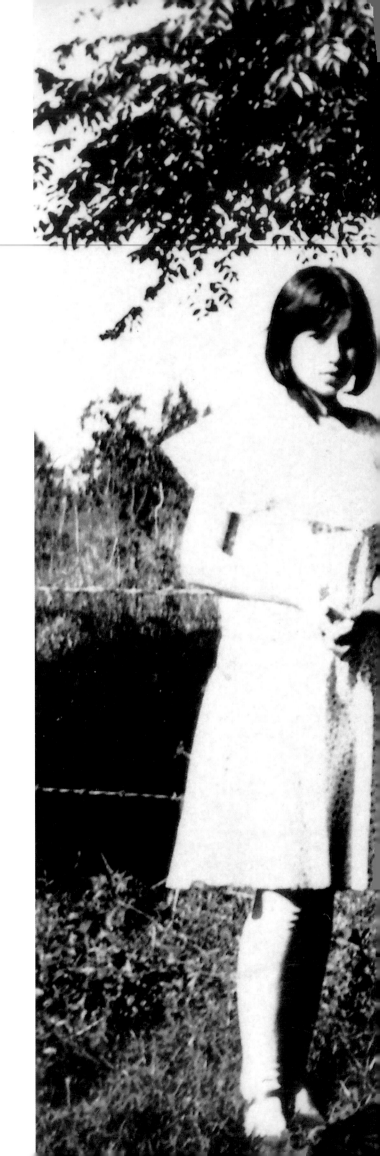

ABOVE *Graduation at Public School No. 1 in Junín marked the end of Evita's formal education. During her school days her walk home took her past a music store that encouraged patrons to use its sound system. Evita sometimes stopped there to recite poetry she had memorized.*

FACING PAGE *Eva (far right), Erminda (far left), and family friends in the countryside of Junín. Evita was a solitary girl, a dreamer, and a rebel. "Like the birds, I always loved the fresh air of the woods," she recalled in her autobiography. "Very early in my life I left my home and my pueblo, and since then I have always felt free."*

OVERLEAF *Juan Duarte took this photograph of his sisters and two family friends during a picnic on the banks of the Gómez lagoon near Junín. From left: Blanca, Erminda, Elisa, and Evita.*

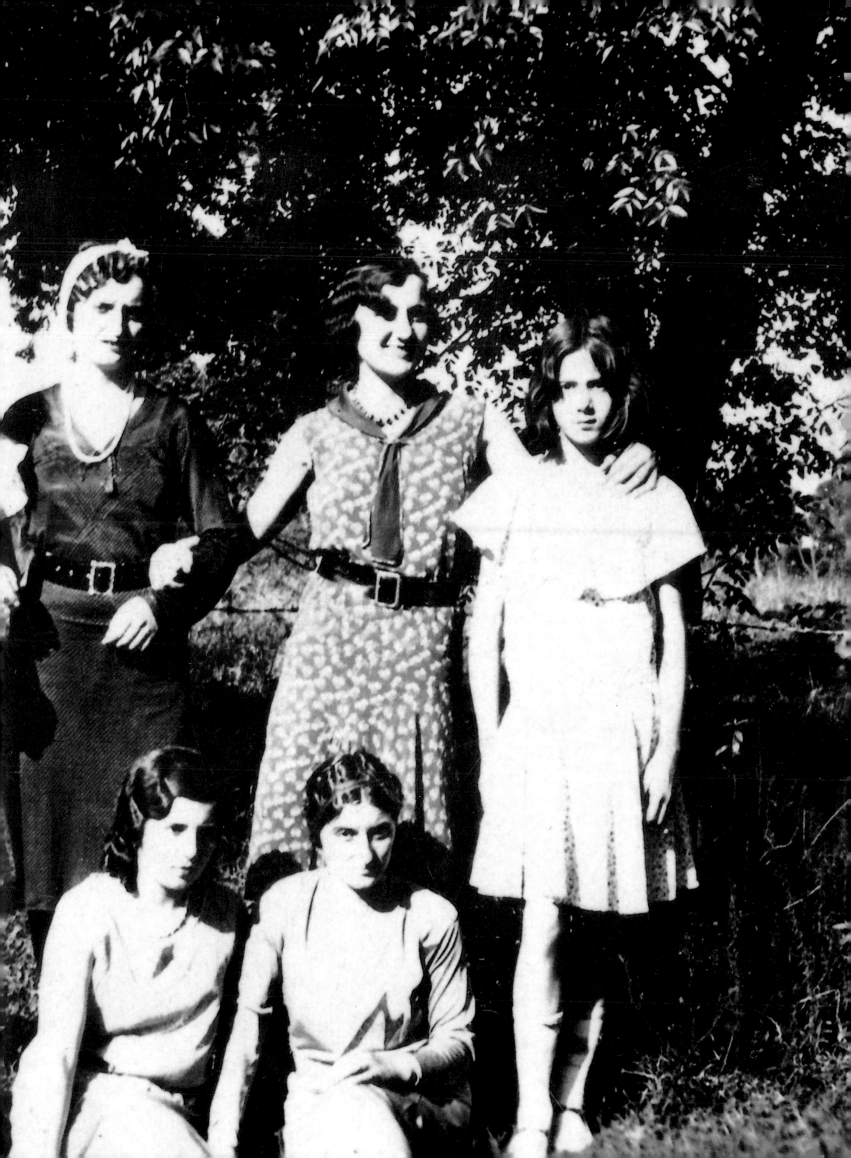

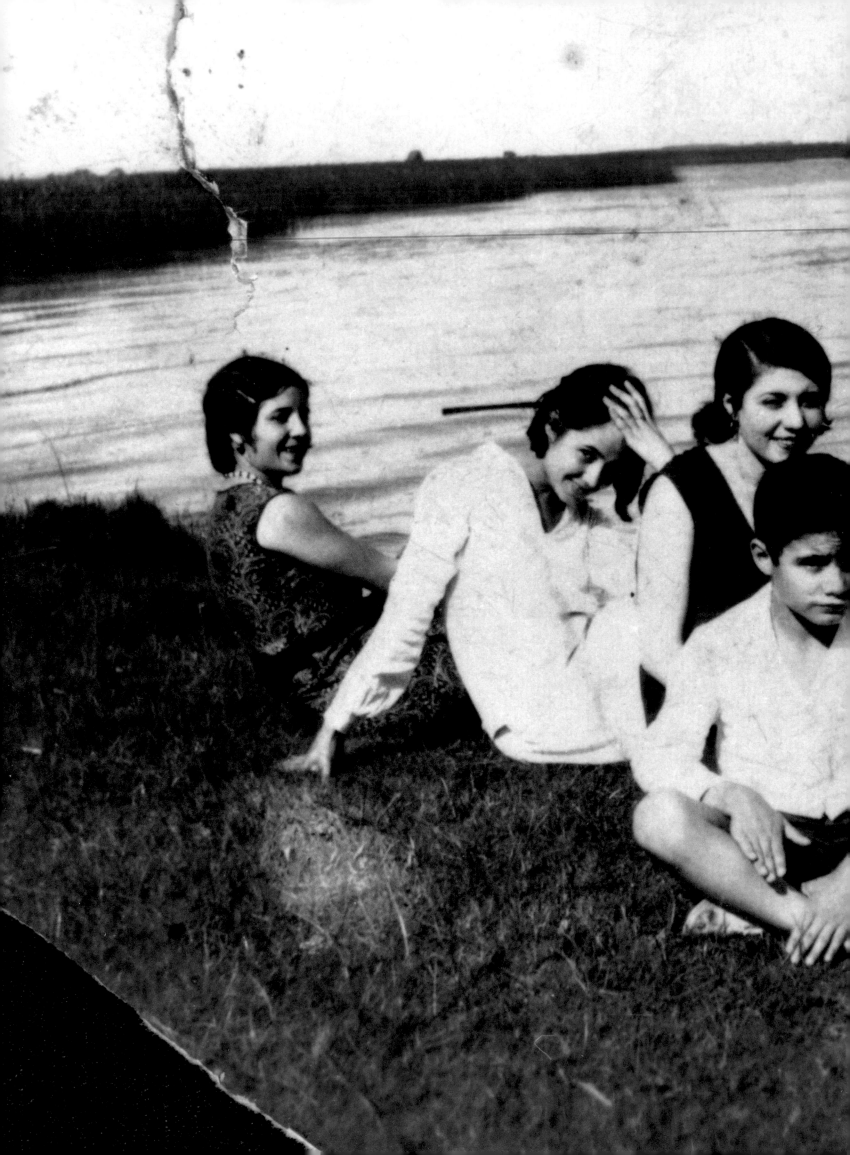

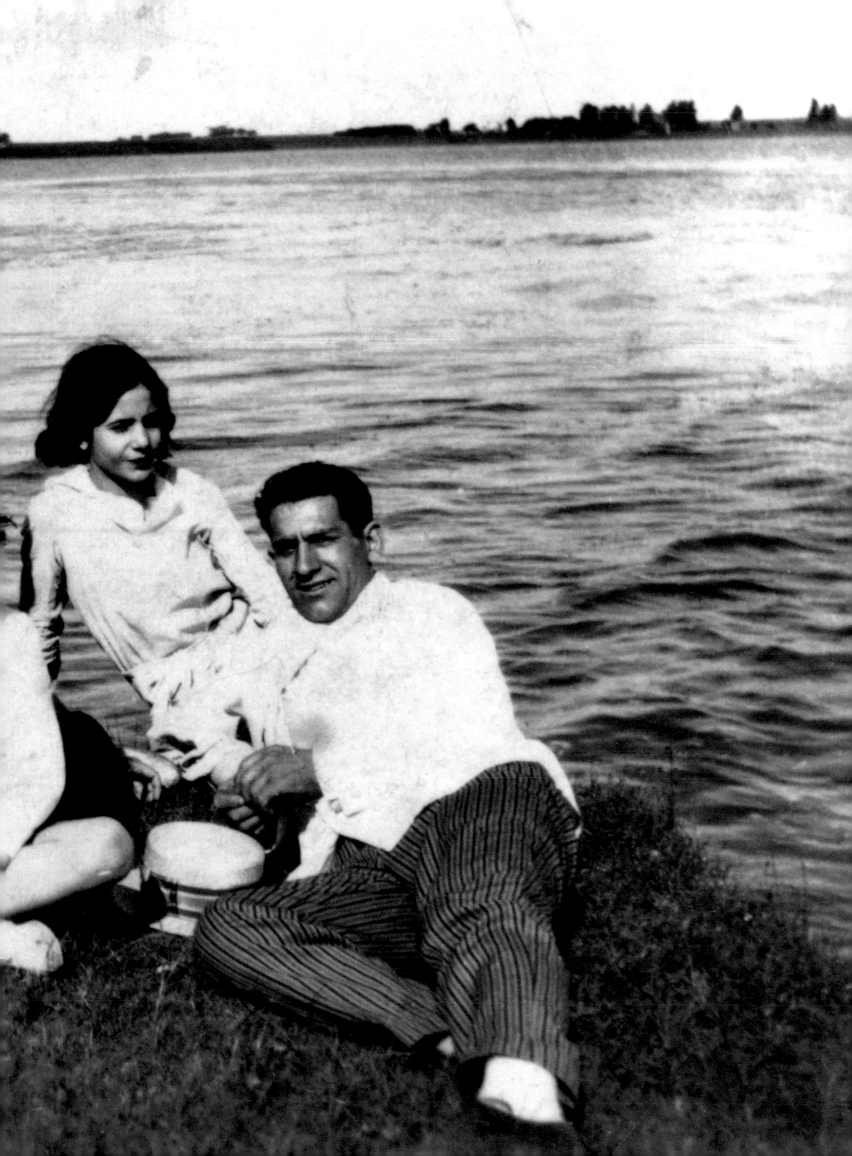

Eva's Debut in the Capital

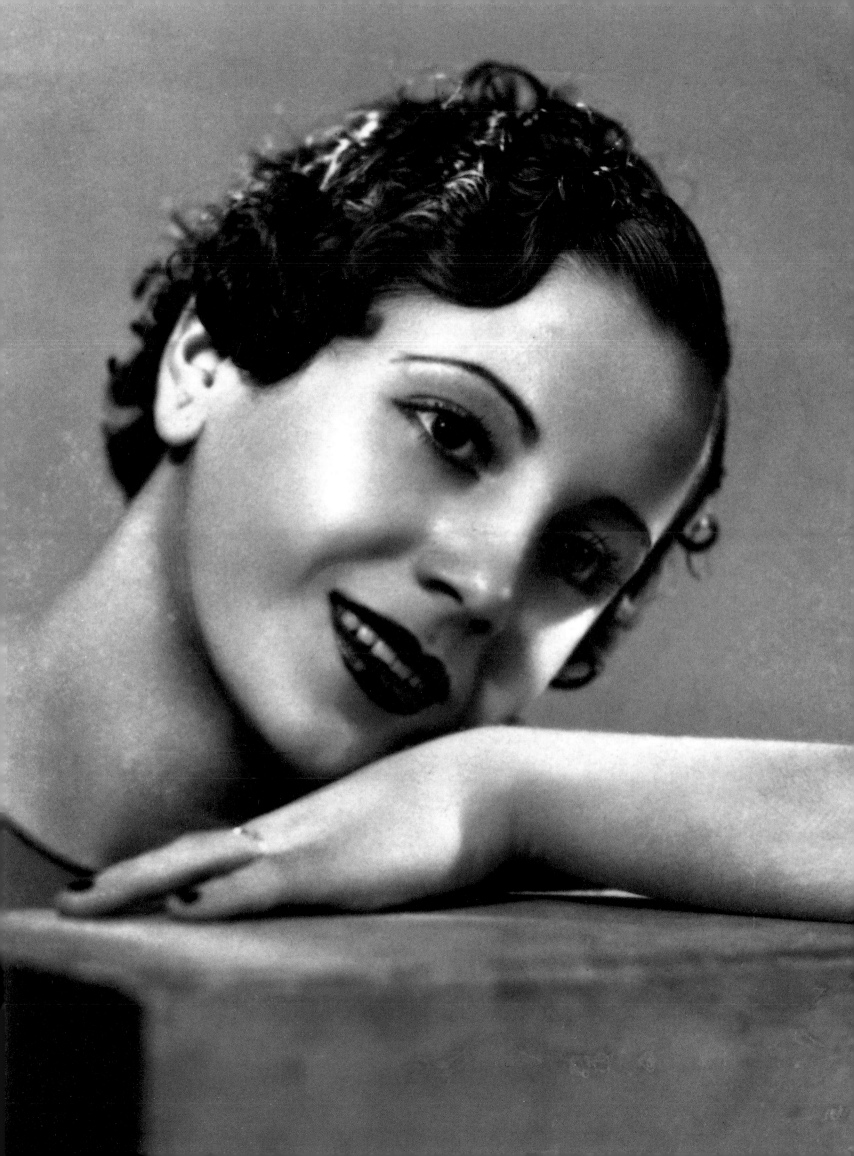

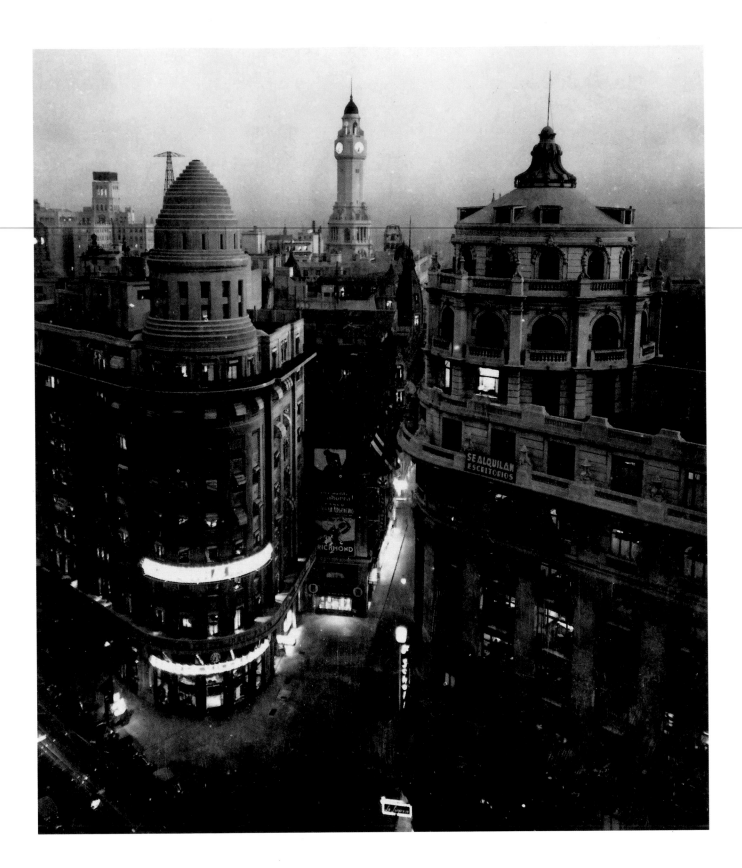

ABOVE

Known as the "Paris of South America," Buenos Aires had an international reputation as an elegant, cosmopolitan city. In the 1930s it was also a city of harsh contrasts. Millions of immigrants had arrived from the country and from Europe in the early decades of the century, creating extreme class divisions and labor conflicts.

FACING PAGE

The tango originated in the working-class neighborhoods of Buenos Aires. Unemployed but stylish couples danced in the streets to bittersweet lyrics and pulsating rhythms that expressed the pain of their poverty, their passion, and their machismo.

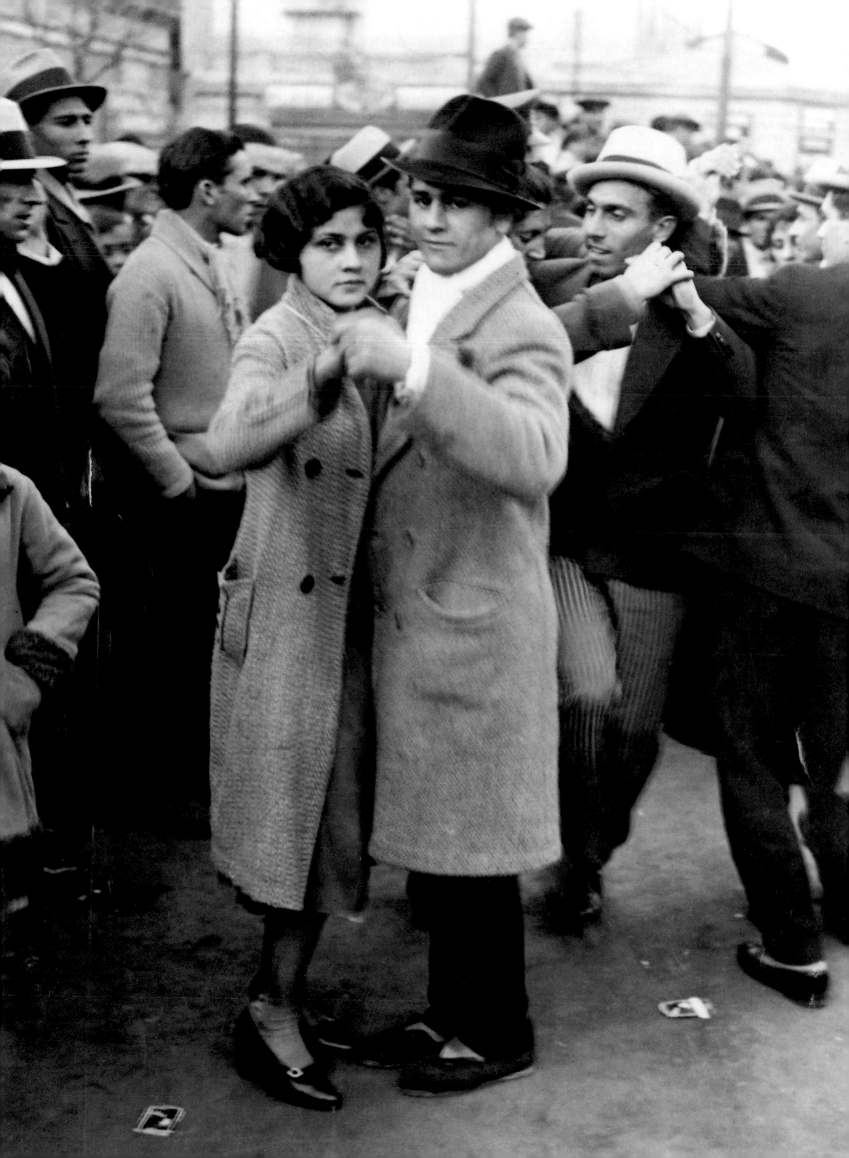

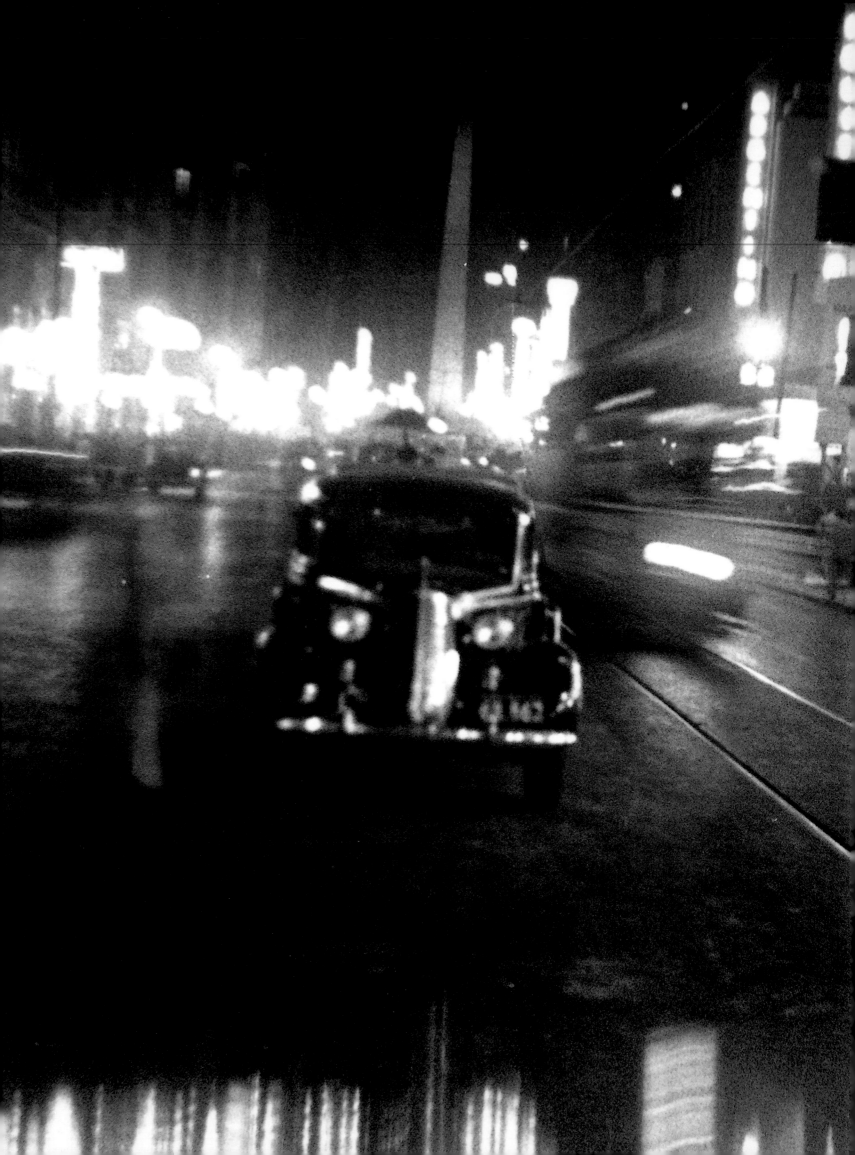

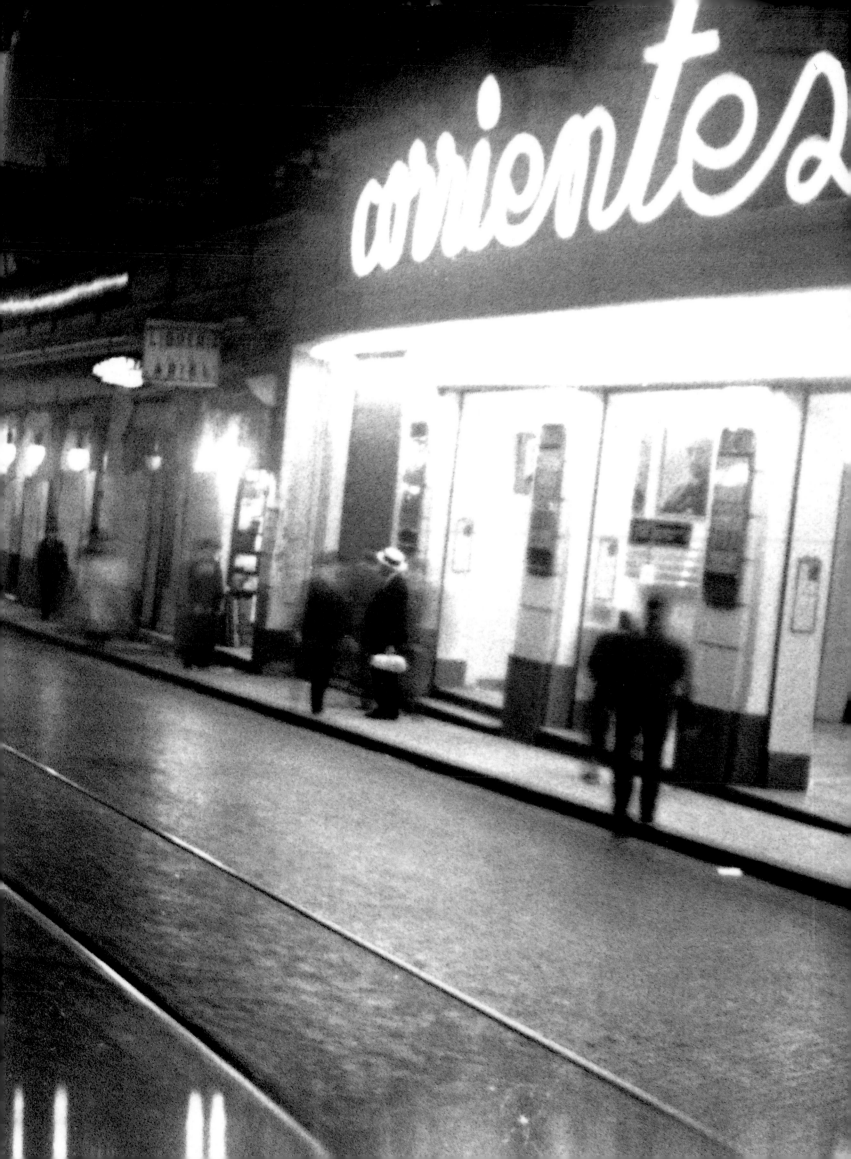

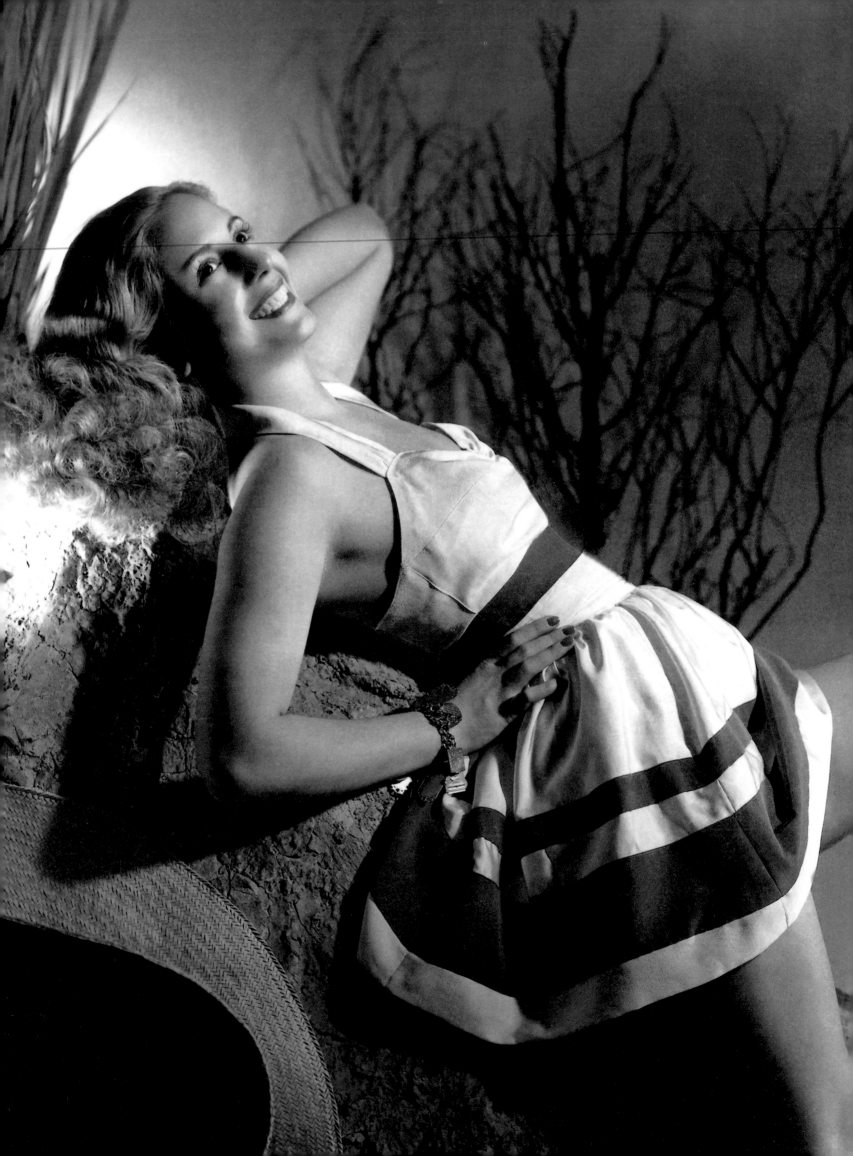

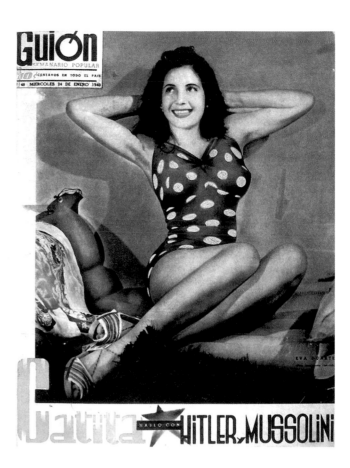

PRECEDING PAGES (36–37) *Actress Eva Duarte in 1937 when she worked in the theater company of the celebrated Argentine director Armando Discépolo. To her mother's pleas that she return to Junín, Eva replied, "First I'll conquer Buenos Aires. Then I can leave."*

PRECEDING PAGES (38–39) *The Broadway of Buenos Aires, Avenida Corrientes was the heart of a lively theater district with cafés and cinemas open until the early hours of the morning. Here, Evita would meet friends after performances and stop by theaters to look for work. In 1936 she had a small role in* LAS INOCENTES, *produced at the Teatro Corrientes.*

FACING PAGE *Evita's big break finally came in 1939; she became the star of a radio drama group and won a part in the successful stage play* MERCADO DE AMOR EN ARGELIA, *in which she played an odalisque.*

RIGHT *As Evita became better known, she began to be featured in Argentina's most widely read movie and arts magazines. She appeared on the cover of* GUIÓN *(January 1, 1940, above) and* CINE ARGENTINO *(March 27, 1941, below) with the actor Bernardo Gandulla. Both of them wore uniforms modeled on those of the enormously popular soccer team, Boca Juniors.*

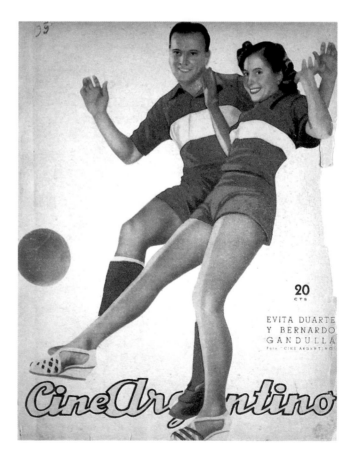

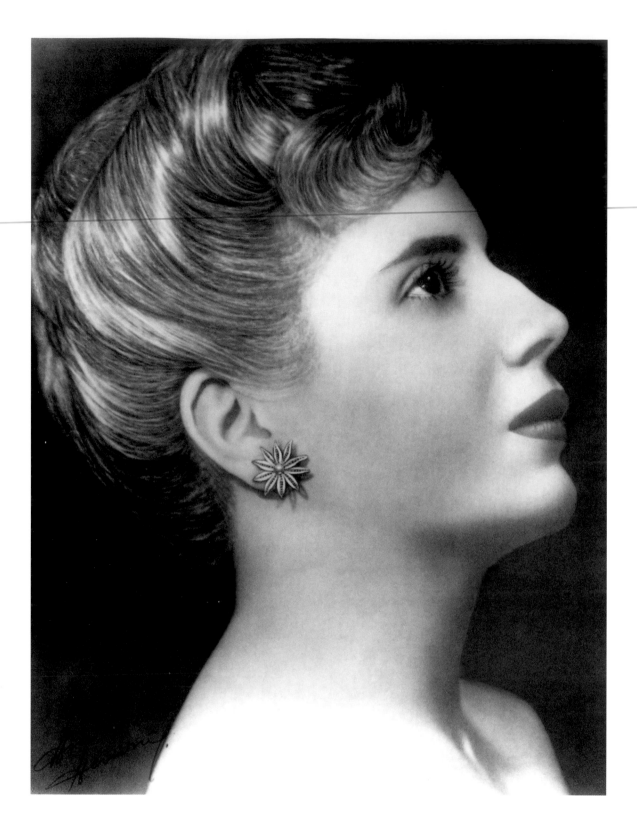

ABOVE AND FACING PAGE
By 1940, Evita, now 21, was becoming widely recognized. Studio portraits such as these convey her great beauty, but her talent as an actress was reportedly unremarkable. Her friends remembered her as serious, withdrawn, and very thin—but all noted her flawless skin.

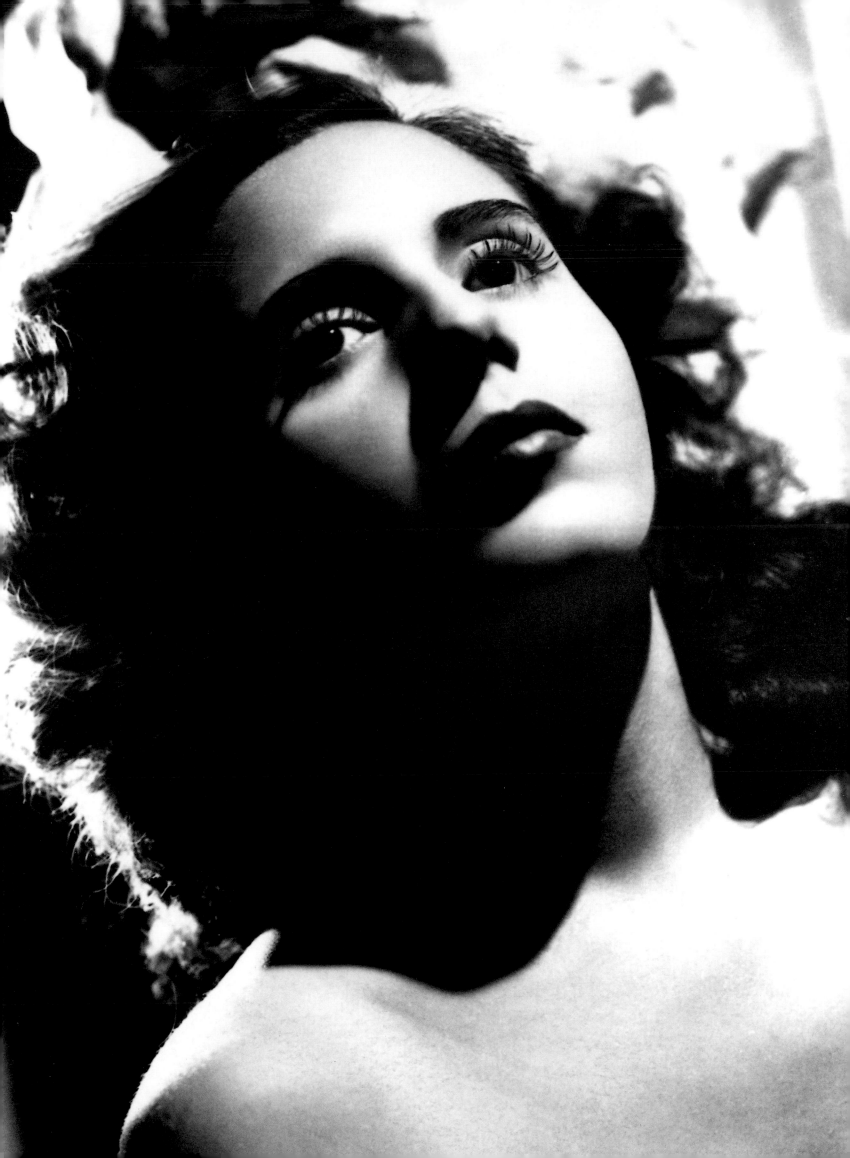

ABOVE
Images from Evita's acting career include promotional stills and posters from her various radio dramas and movies; the cover of the October 1939 issue of SINTONÍA, *a movie magazine that Evita had collected as a child; and (center) Evita on a yacht in a publicity shot for* SINTONÍA.

FACING PAGE
In LA PRÓDIGA, *Evita portrayed "the mother of the poor," a generous peasant woman who protects the people of her village—a role she was later to fill in real life. After she became First Lady of Argentina in 1946, she prevented the release of the movie because she considered her past career beneath her new position.*

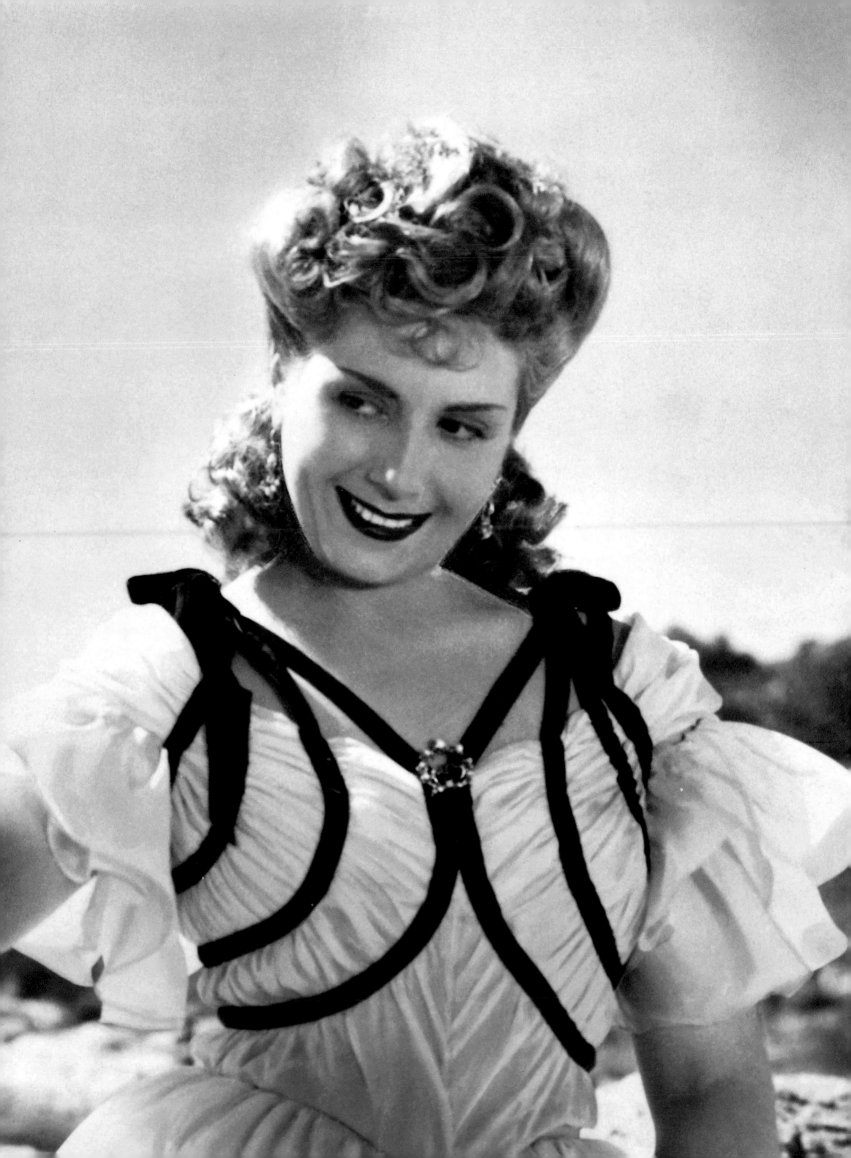

The Actress Meets Juan Perón

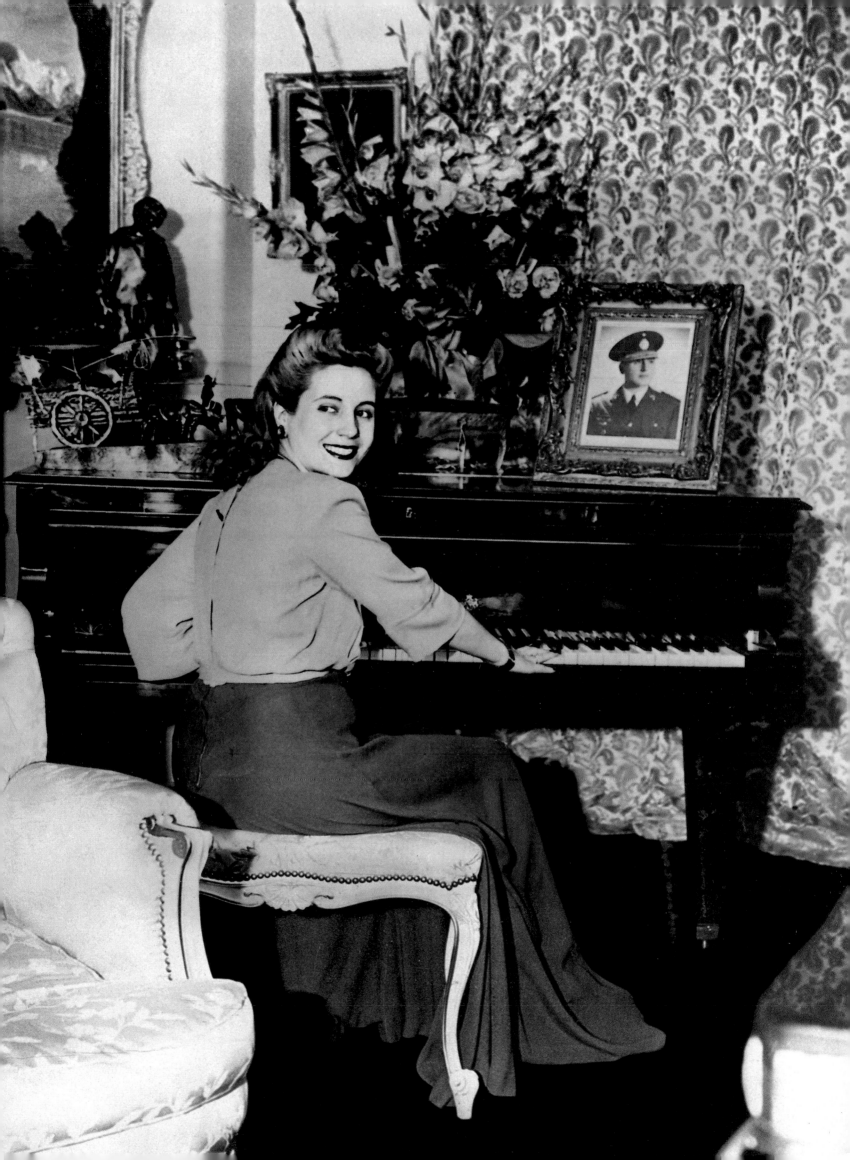

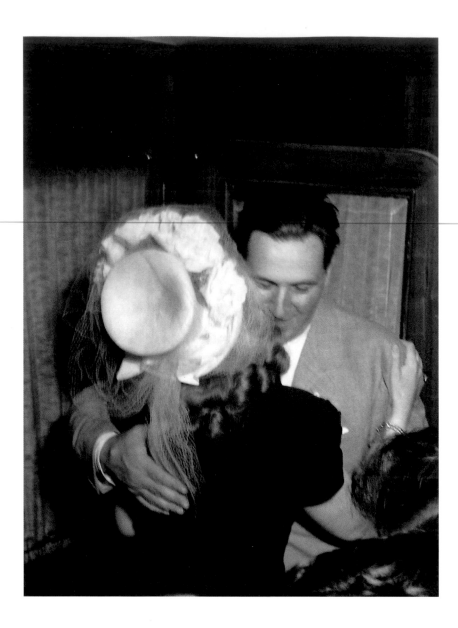

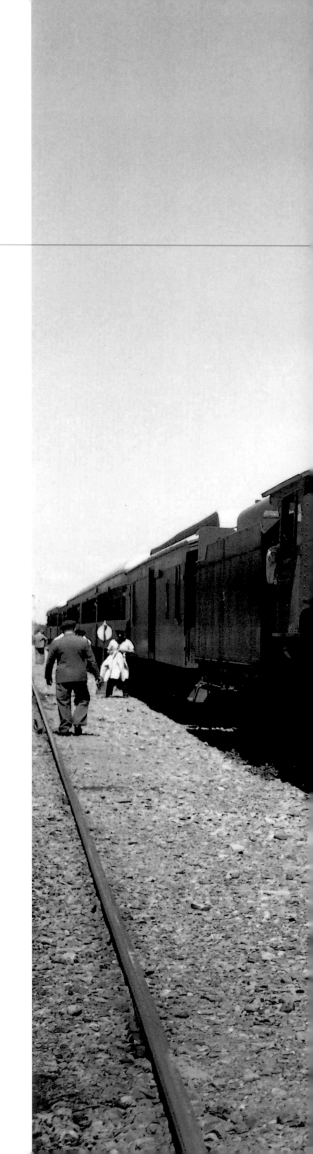

ABOVE *After he and Evita were married in October 1945, Juan Perón embarked on his first nationwide presidential campaign tour. Here Evita embraces her husband in the Retiro train station upon his return to Buenos Aires in December.*

FACING PAGE *On a whistle-stop tour of the country, Perón's campaign train, dubbed "El Descamisado" (The Shirtless), the sobriquet of the Argentine laborer, stops in the northern province of Jujuy, where his partisans have decorated it with palm fronds and a poster of their charismatic candidate. The campaign pitted Perón's Labor Party against the Democratic Union, a powerful coalition of parties ranging from conservatives to Communists, in a contest characterized by heated debate and violence from both sides.*

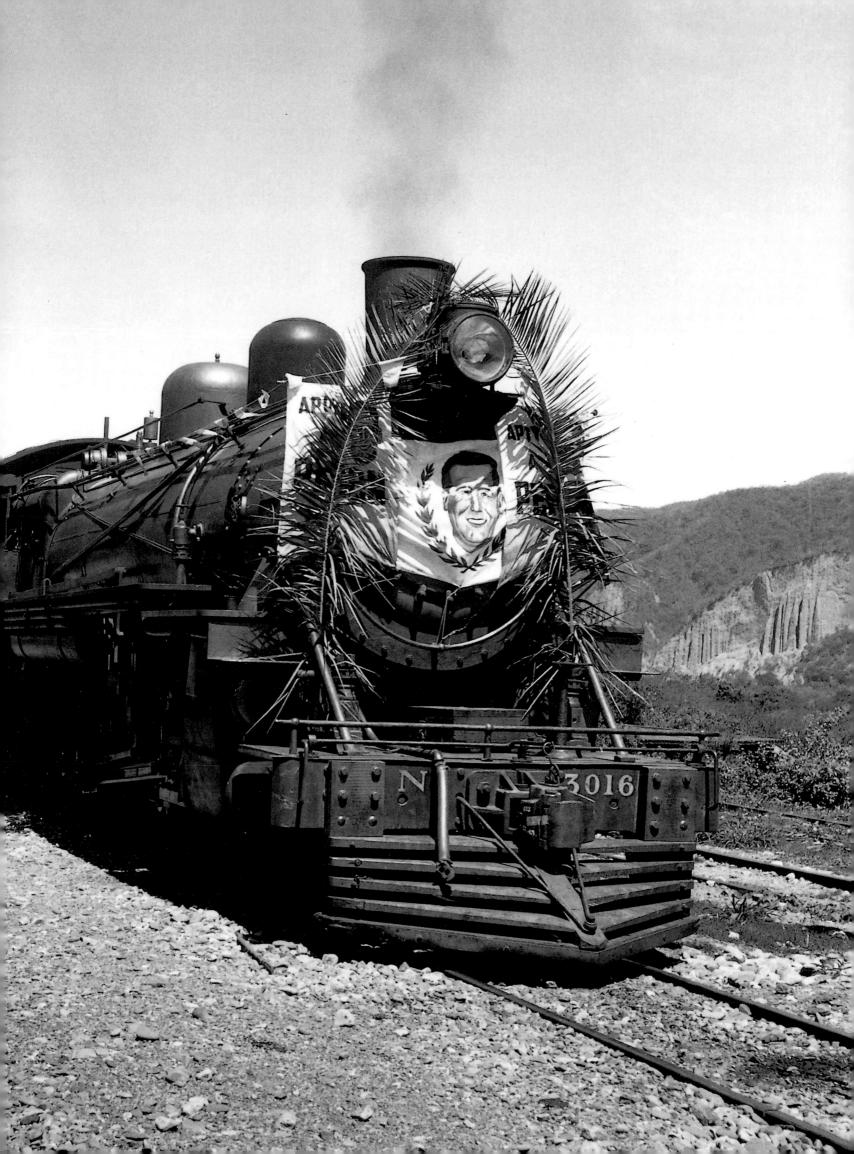

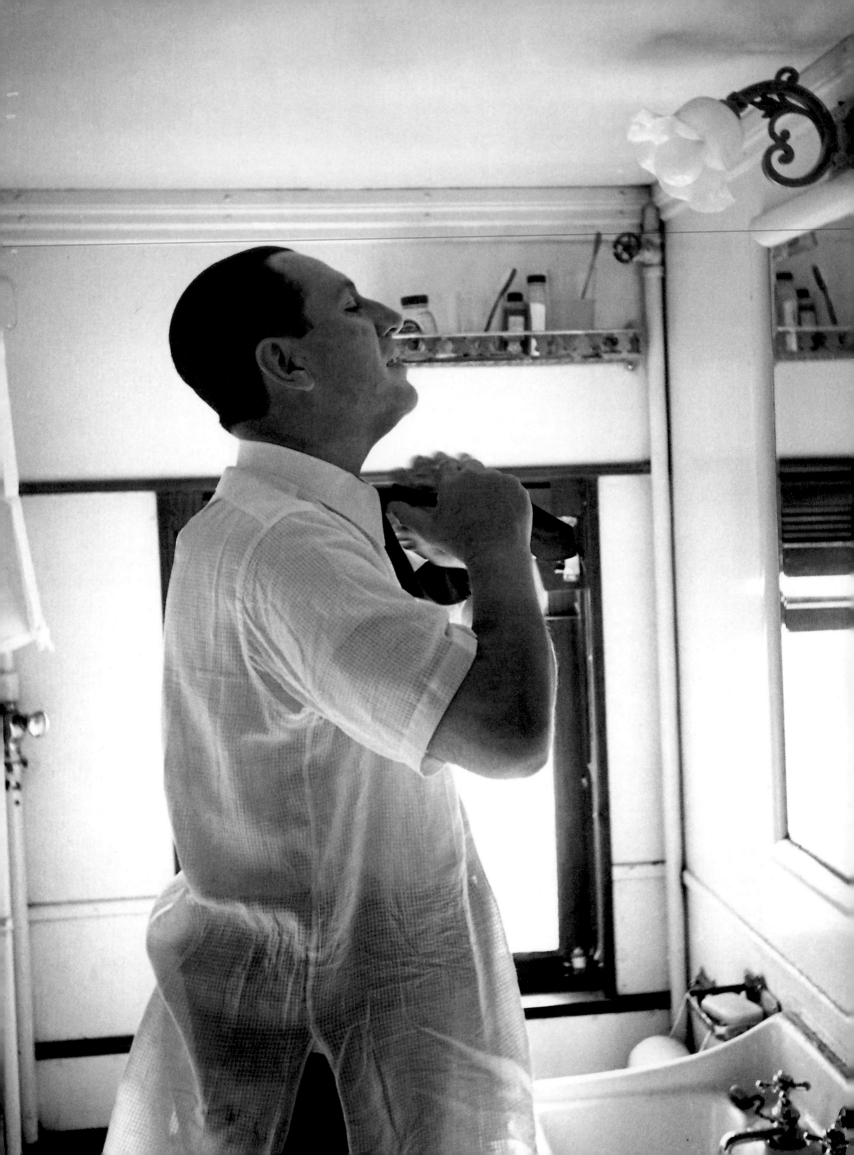

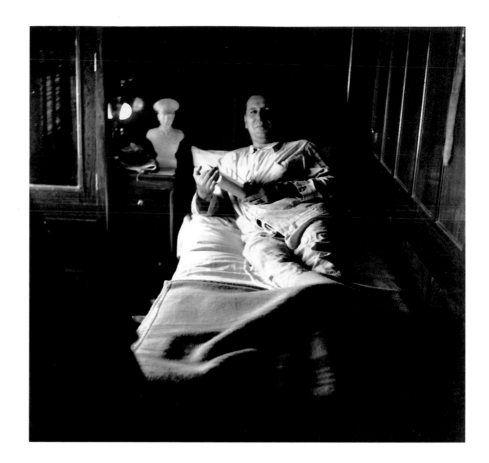

FACING PAGE *Perón adjusts his tie in his cabin on the campaign train, preparing to address a throng of sympathetic sugar-industry workers in the province of Tucumán. In his speech, Perón promised labor reform and improved working conditions— changes that were vehemently opposed by the powerful landowners and sugar magnates of the province.*

RIGHT *Ready for a restorative nap amid the daily rigors of the campaign, Perón reclines in his cabin with a copy of Salgado's* LIFE OF JESUS *and a bust of himself on the bedside table.*

RIGHT AND OVERLEAF *Although she did not take an active role in the election process, Evita frequently accompanied Perón on the campaign trail. At stops in remote villages around the country she distributed leaflets and buttons to the crowds. This was her first encounter with the people of Argentina, and it was an emotional initiation into political life.*

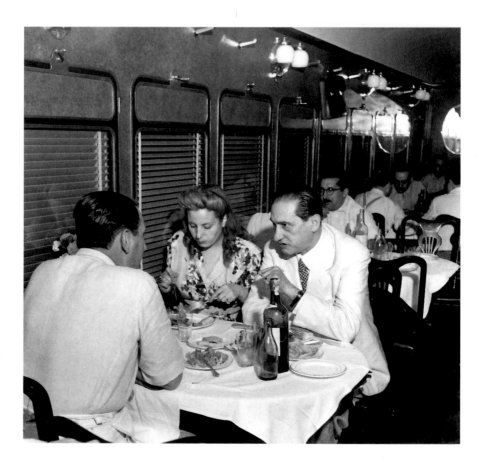

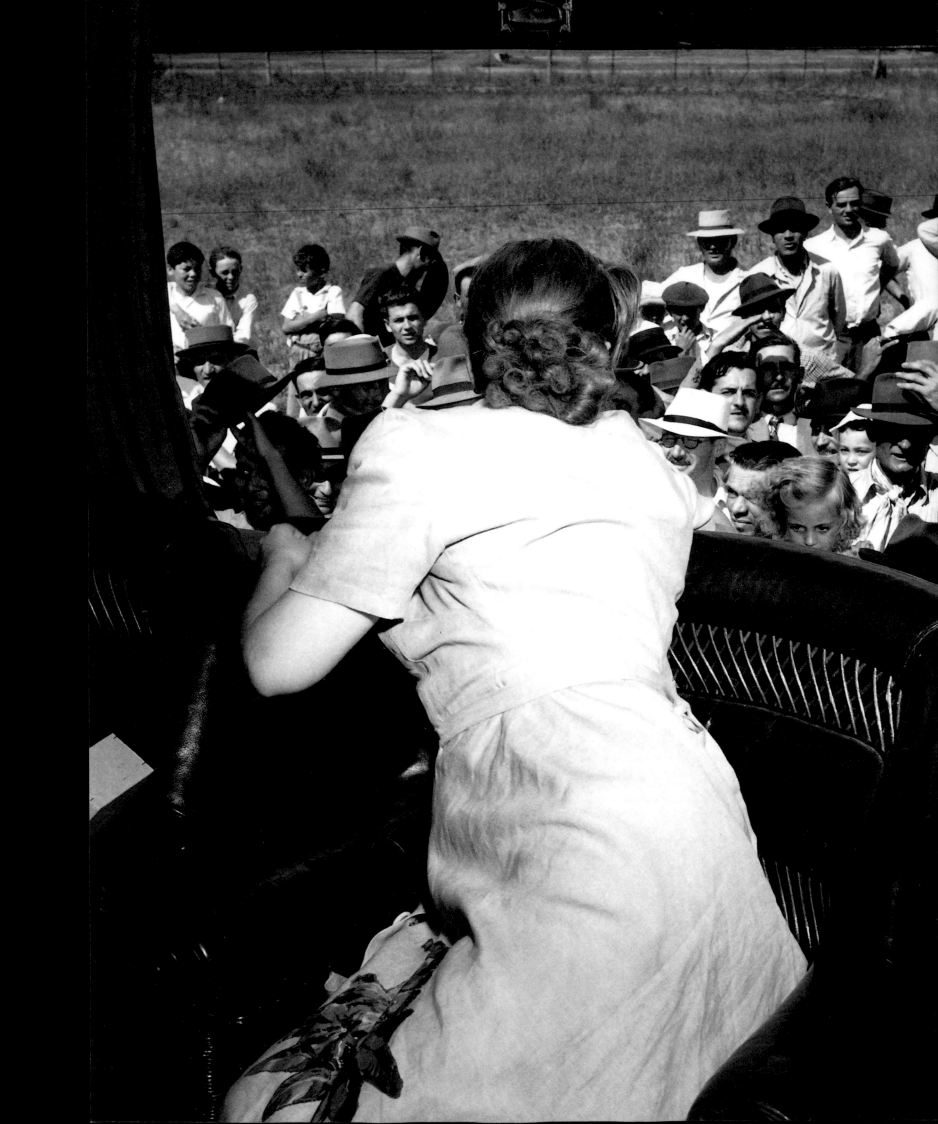

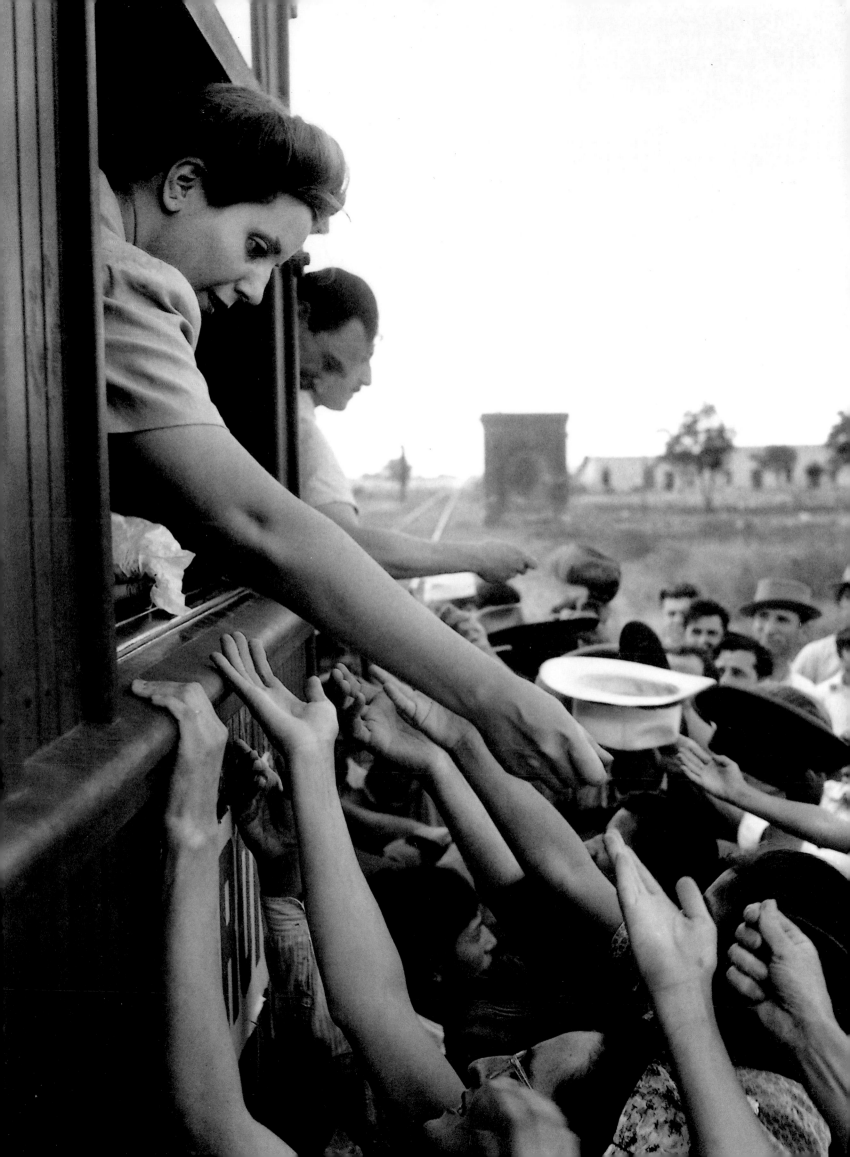

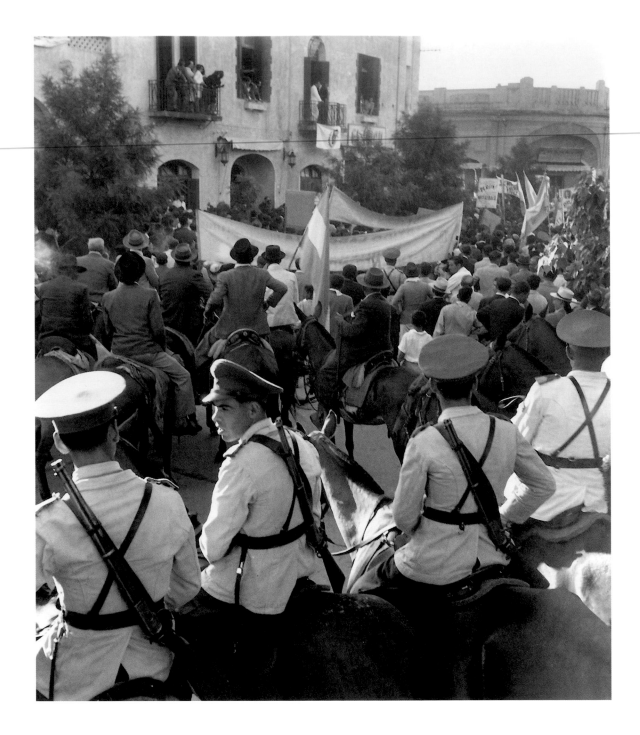

ABOVE
*Crowds fill the square to welcome Perón and Evita (on the balcony at right) in the province
of Santiago del Estero. The volatile political situation required heavy security.*

FACING PAGE
*New Year's Eve, 1945: Evita and Juan celebrate at a party given by Dr. Jorge Alvarez,
a supporter in Santiago del Estero.*

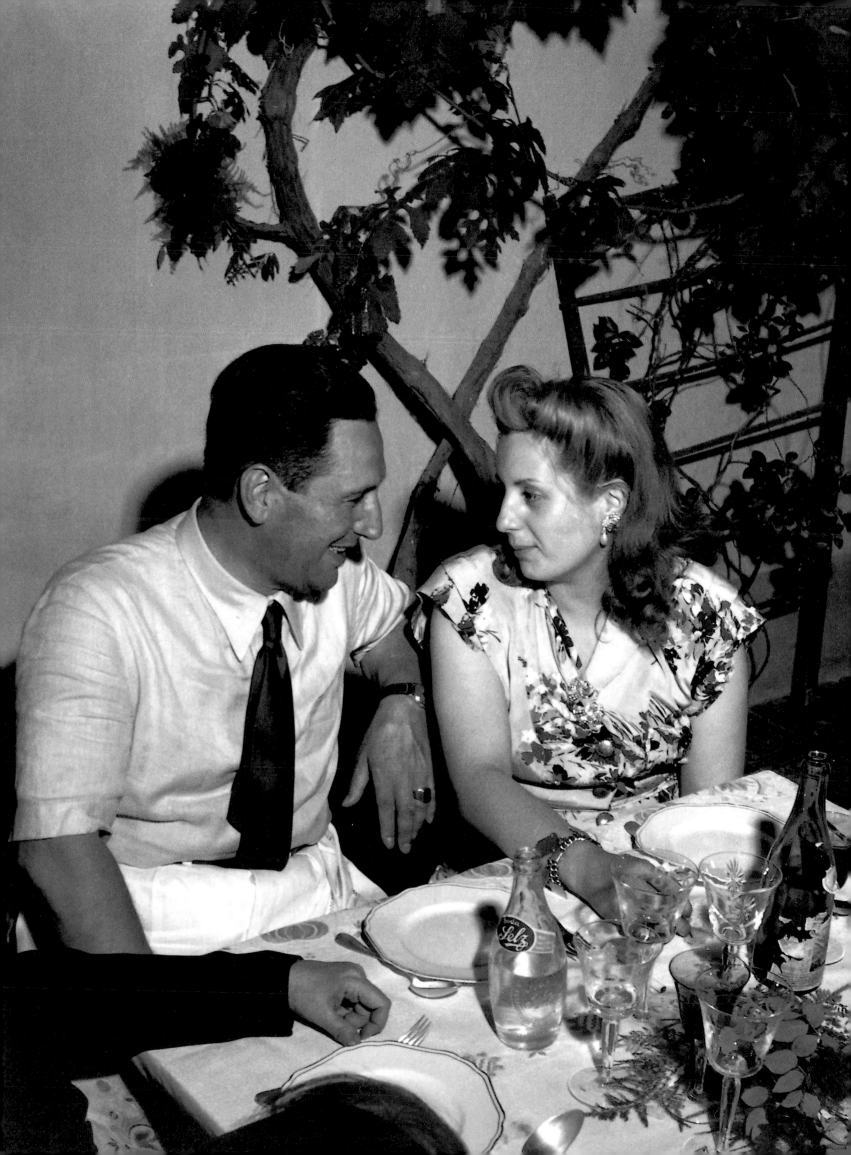

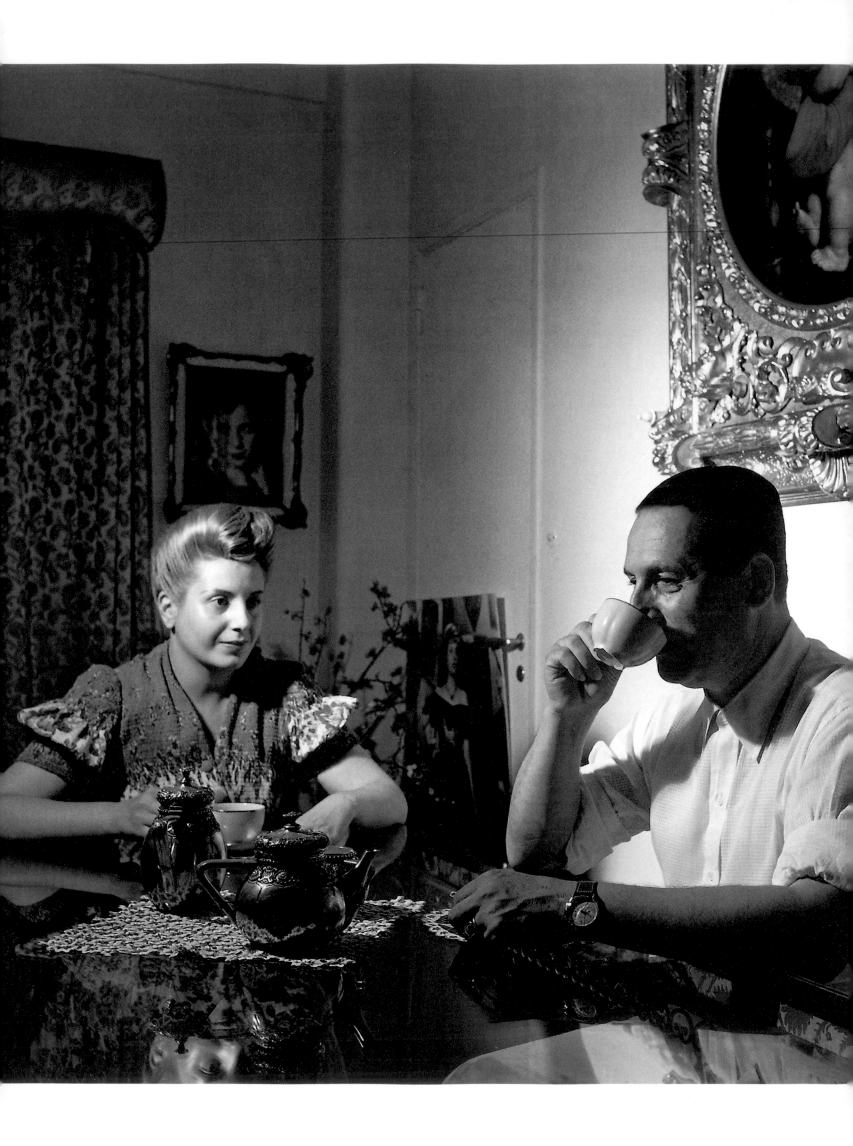

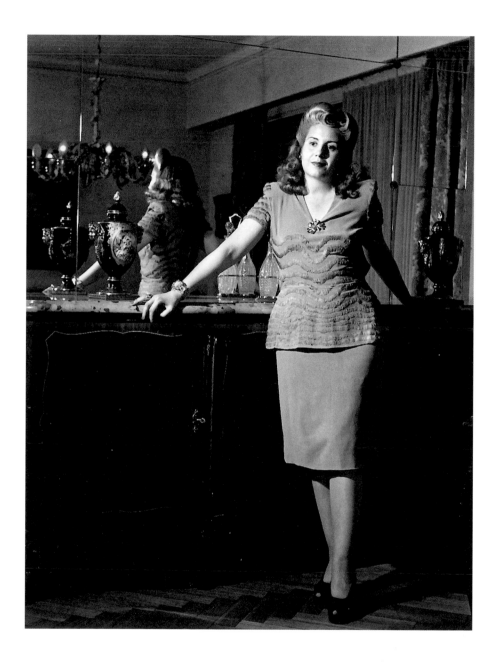

Eva and Juan Perón in their apartment on Calle Posadas in December 1945.
In the early days of their marriage Evita dressed casually and had little use for
social formalities—she used the familiar form of address, the Argentine vos,
with most people regardless of their position or background. After Perón was
elected President in 1946, the couple moved to the Unzué Palace,
the official Presidential Residence.

RIGHT *A radiant Evita in her living room two months after her marriage. Perón frequently held strategy sessions in the apartment, and his advisers were startled and offended to find Evita listening attentively to the lengthy political discussions. The fact that she stood beside rather than behind him at political events was a source of irritation to military and social leaders.*

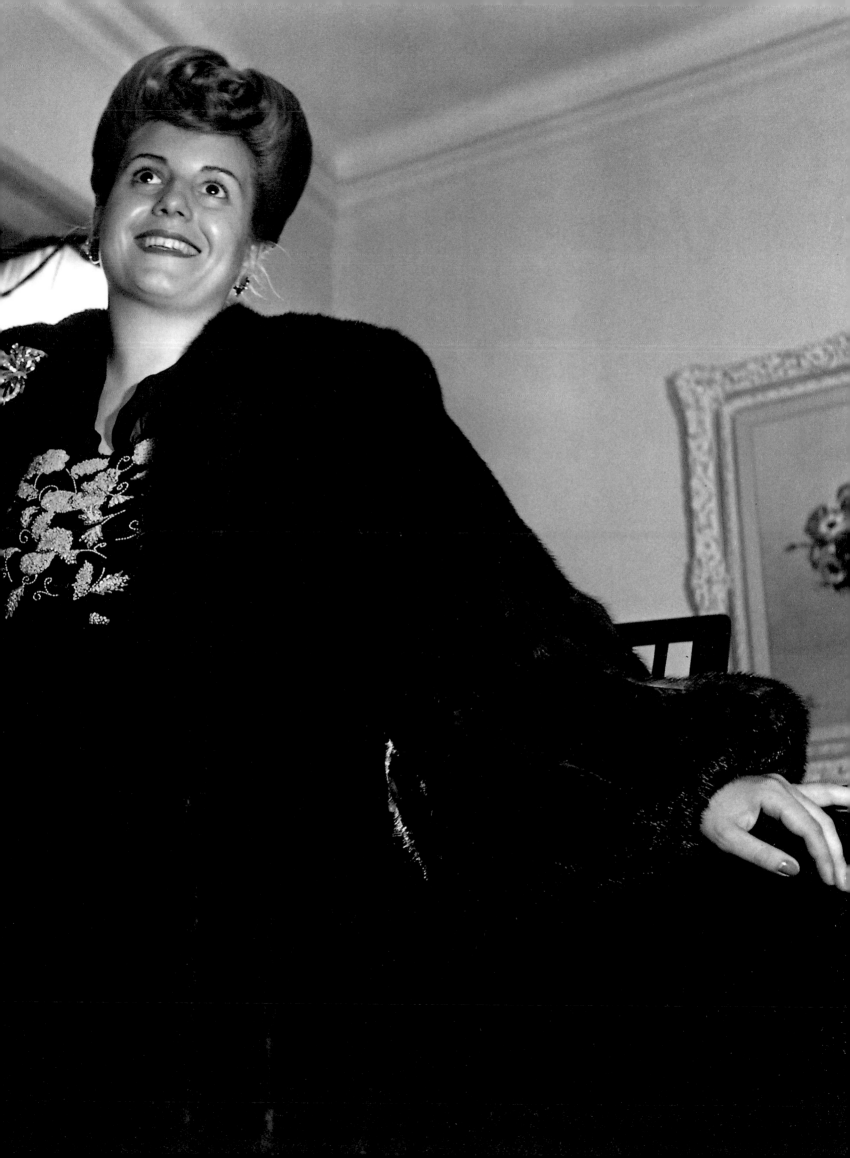

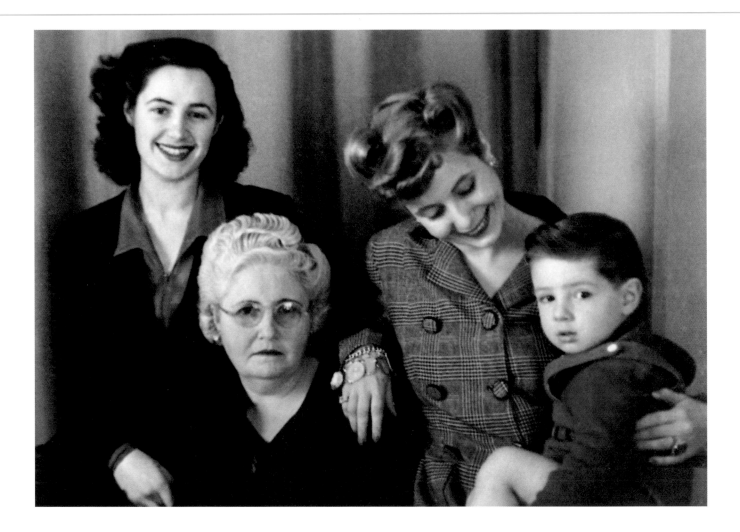

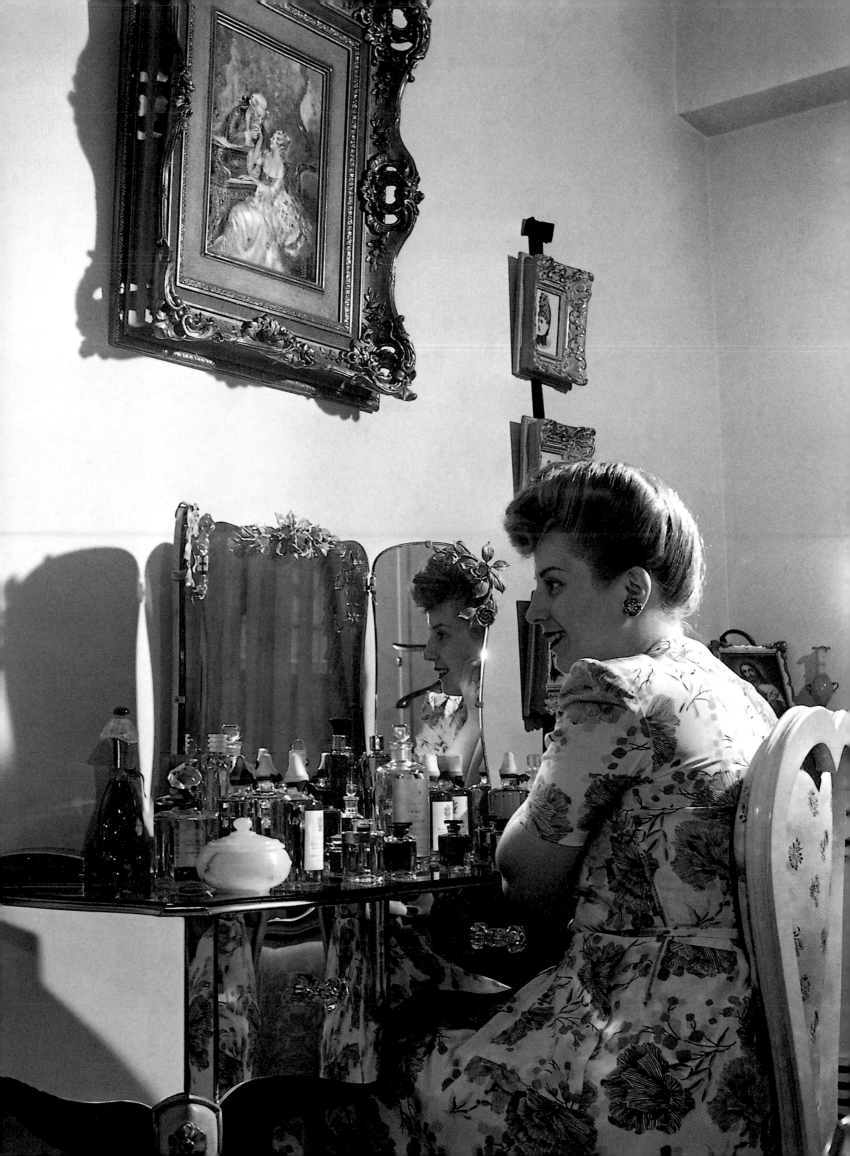

Eva Duarte de Perón, First Lady

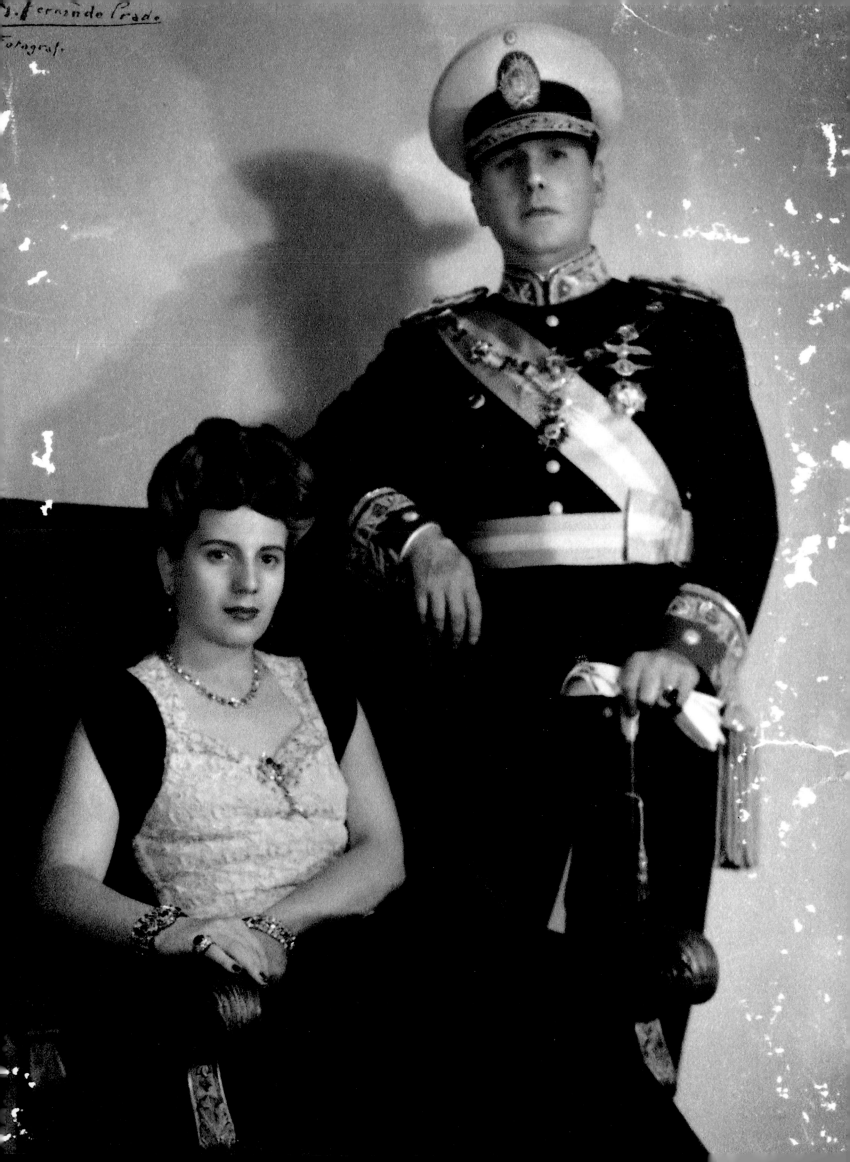

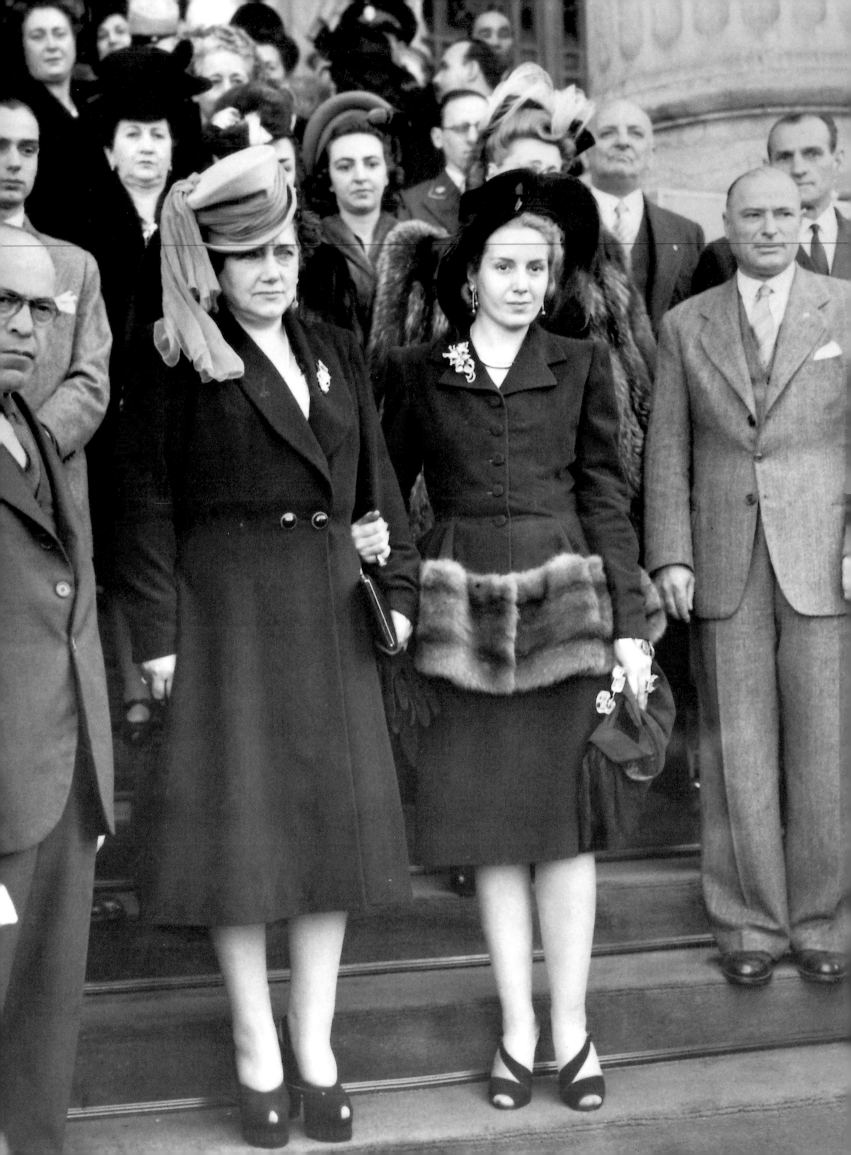

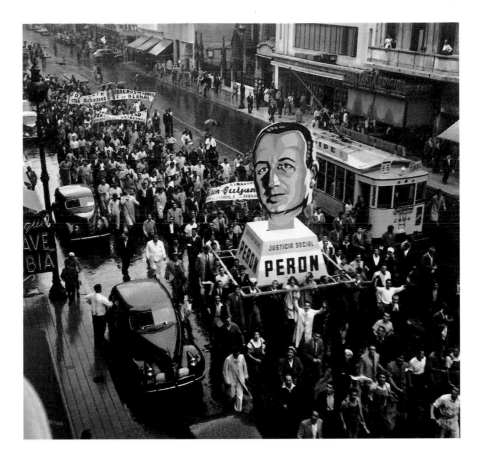

FACING PAGE *General Juan Domingo Perón was inaugurated as President of Argentina on June 4, 1946, having garnered slightly more than 50 percent of the vote. At the inaugural ceremony Evita (right) stands with Maria Teresa de Quijano, wife of the Vice-President. Behind them is Lillian Lagomarsino de Guardo, wife of the President of the Chamber of Deputies.*

RIGHT *The streets of Buenos Aires erupted in a frenzy of working class citizens waving flags, chanting, and celebrating Perón's victory— a spectacle derided by the upper classes as "a flood of animals let loose from the zoo."*

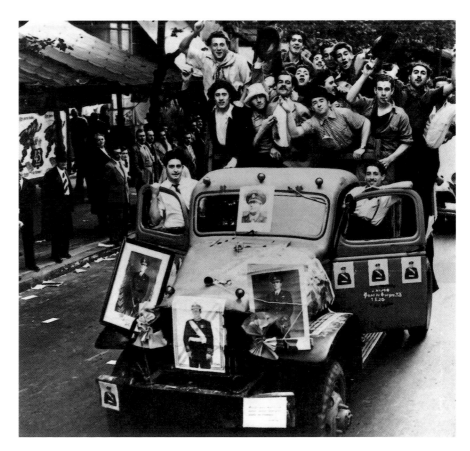

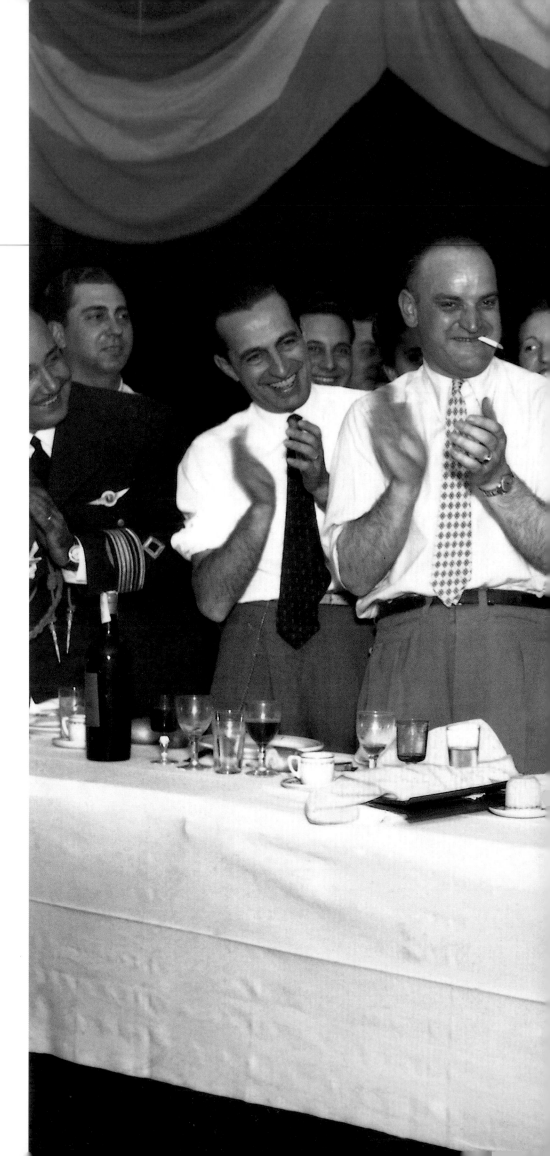

RIGHT *Evita enjoyed informal gatherings, such as this Peronist party at a Buenos Aires restaurant, where she could talk freely with union members and workers. Once Perón was in office, Evita embarked on her mission to improve the lot of the poor, receiving daily delegations of workers in her office at the Ministry of Labor and visiting factories and poor neighborhoods in Buenos Aires.*

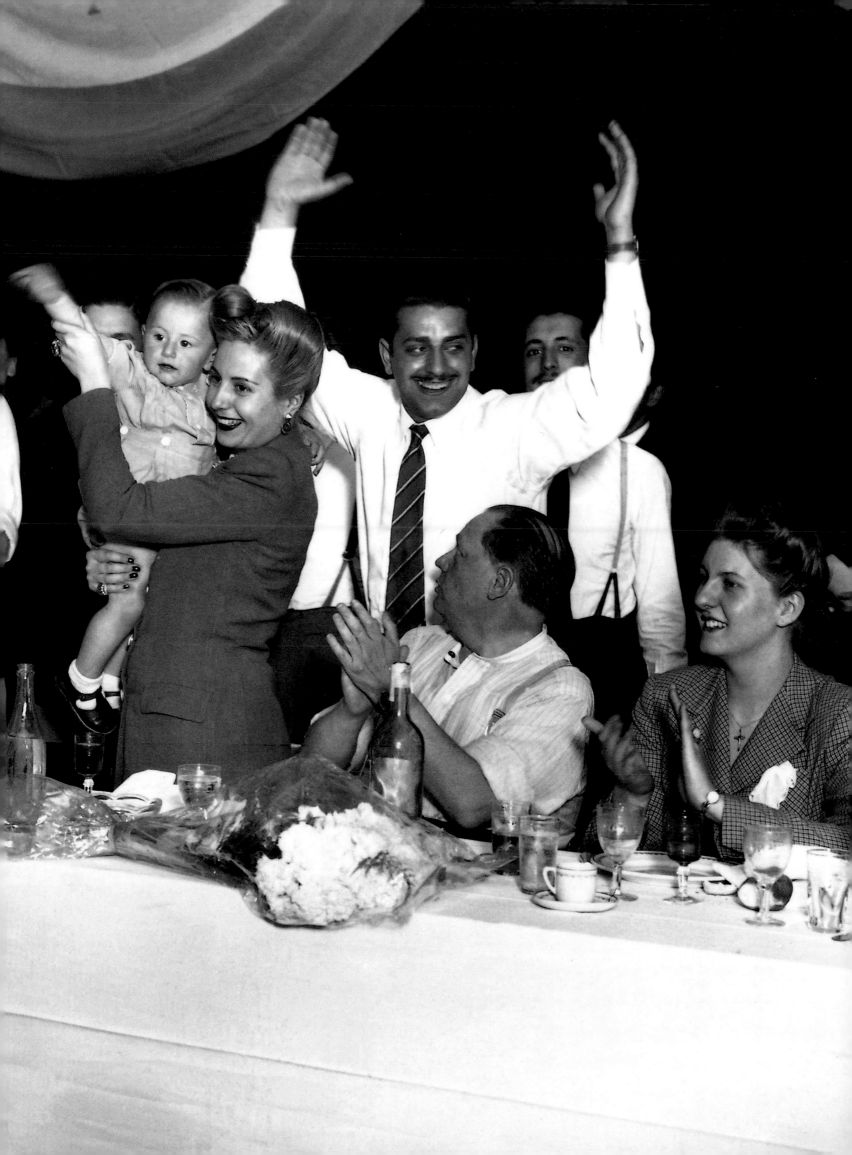

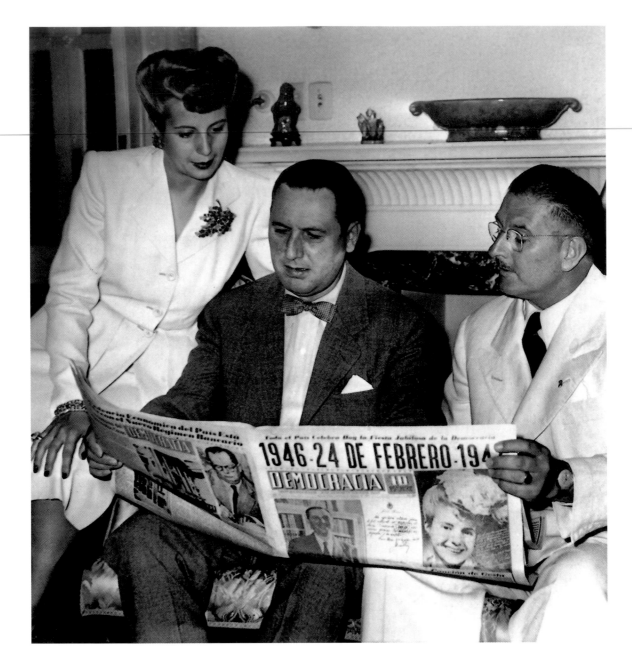

ABOVE

On the first anniversary of Perón's election, he and Evita and their close friend Lieutenant Colonel
Domingo A. Mercante, governor of the province of Buenos Aires, review the coverage in DEMOCRACIA,
the official newspaper of the Peronist party, at the Presidential Residence.

FACING PAGE

A private moment during the preparations for Evita's trip to Europe in 1947. She was invited to Spain by
General Francisco Franco, who was anxious to establish close ties with Argentina, at that
time a prosperous country and a potential source of aid. Evita's name and word of her ambitious
social programs were beginning to spread throughout Europe.

OVERLEAF

Evita's energy and infectious enthusiasm far outweighed her husband's: she spontaneously approached
poor and sick people on the street, listening to their problems and showering young and old alike
with hugs and affectionate kisses. Attempts to thwart the people infuriated her, and her wrath is evident
in this incident where a policeman stopped a young boy trying to speak to her.

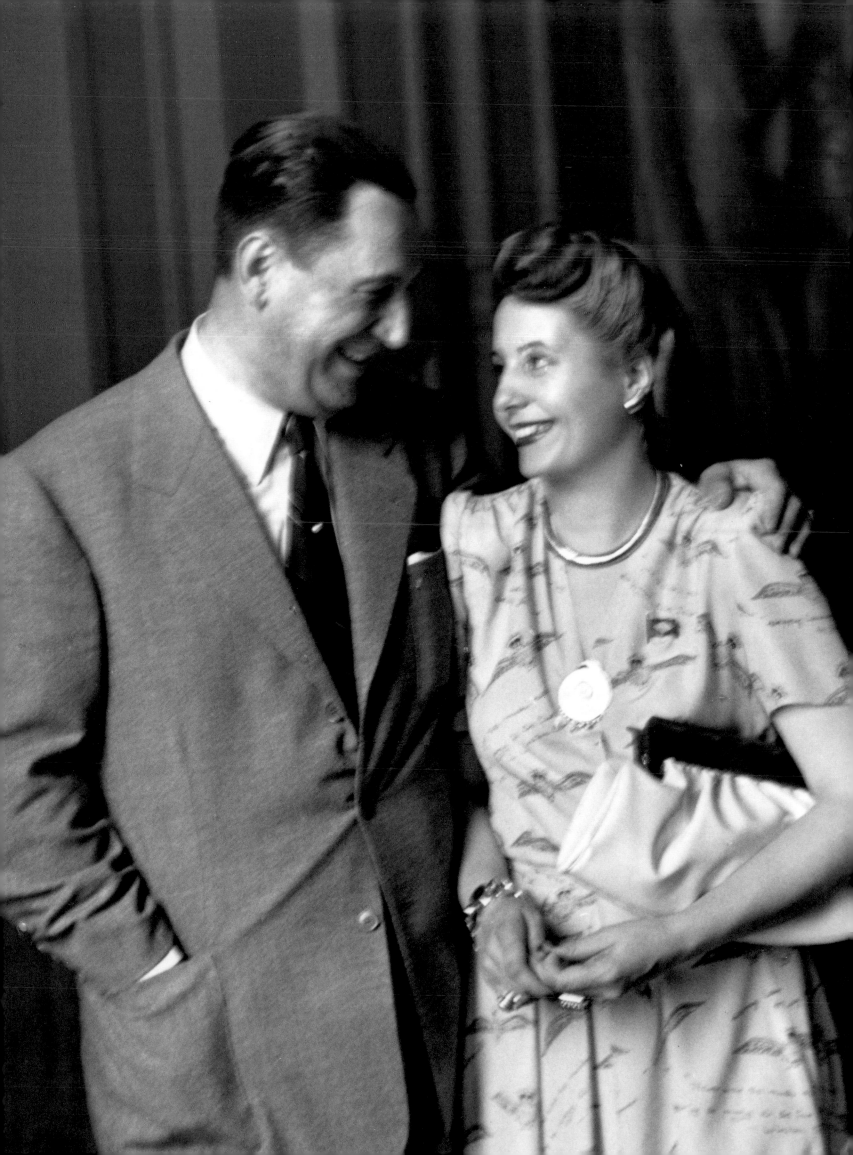

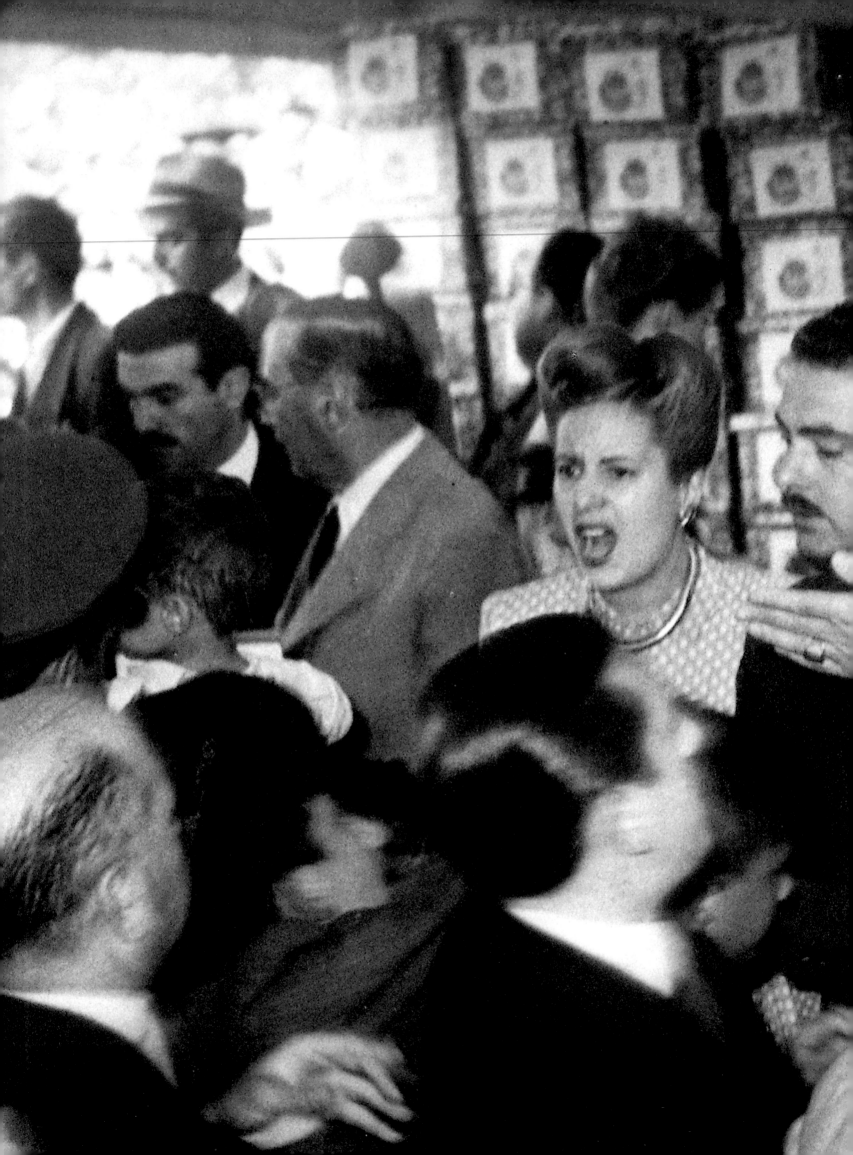

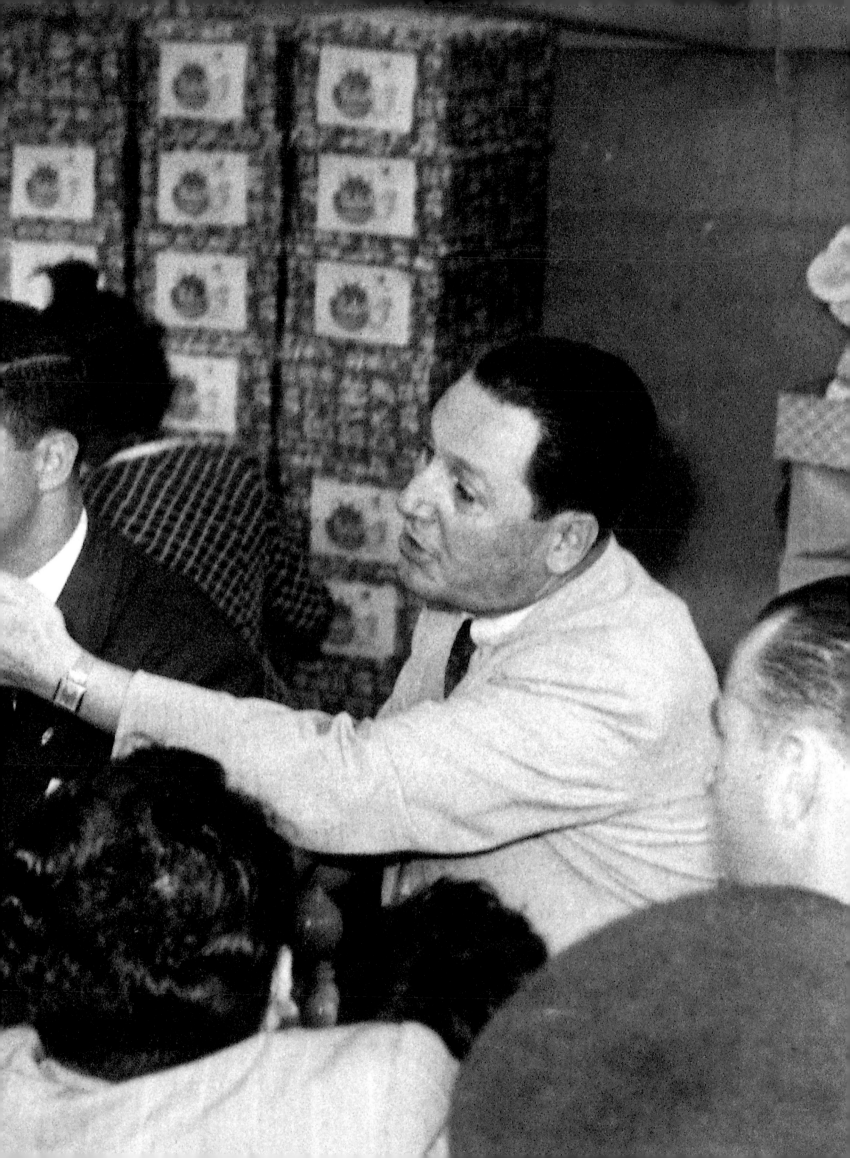

Evita Conquers Europe

In one of the defining episodes of her career, Evita traveled to Europe in 1947 at the invitation of the Spanish government. In Rome, her third stop, she was granted an audience with Pope Pius XII at the Vatican. Here, Evita stops for a portrait on leaving St. Peter's.

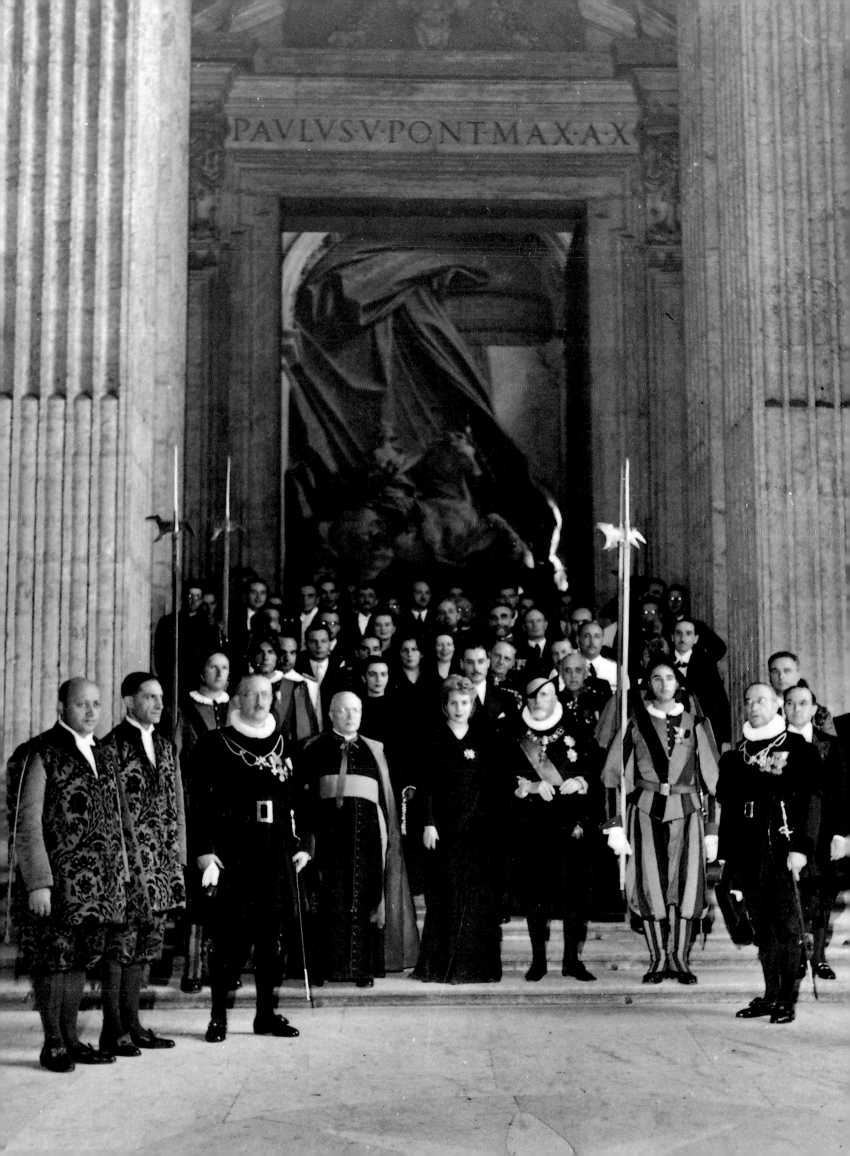

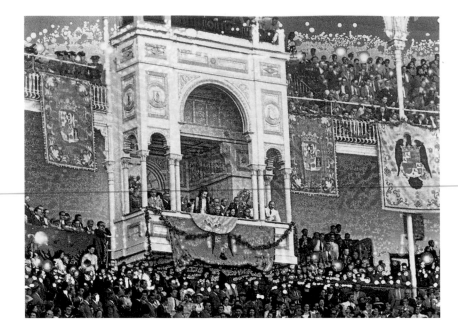

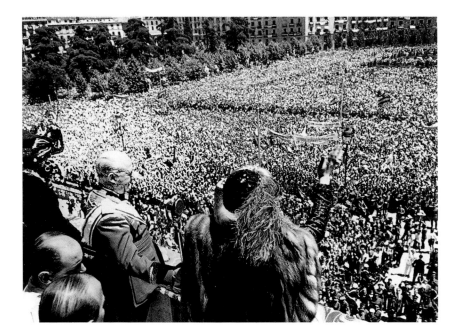

TOP *As a guest of the mayor, Evita attended a bullfight in Madrid's Plaza de Toros. She arrived a half-hour late, delaying the start of the event, but fans were mesmerized by the arresting figure of the Argentine First Lady wearing a black lace mantilla.*

ABOVE *From the balcony of the Royal Palace in Madrid, Evita salutes the crowd on a sweltering day in the Plaza de Oriente. General Francisco Franco, standing to Evita's left, had just decorated her with Spain's most distinguished honor, the Grand Cross of Isabella the Catholic.*

FACING PAGE *Evita smiles triumphantly upon her arrival at Barajas airport in Madrid. Her DC-4 plane, lent by the Spanish government, was escorted by a squadron of forty planes from the Spanish air force.*

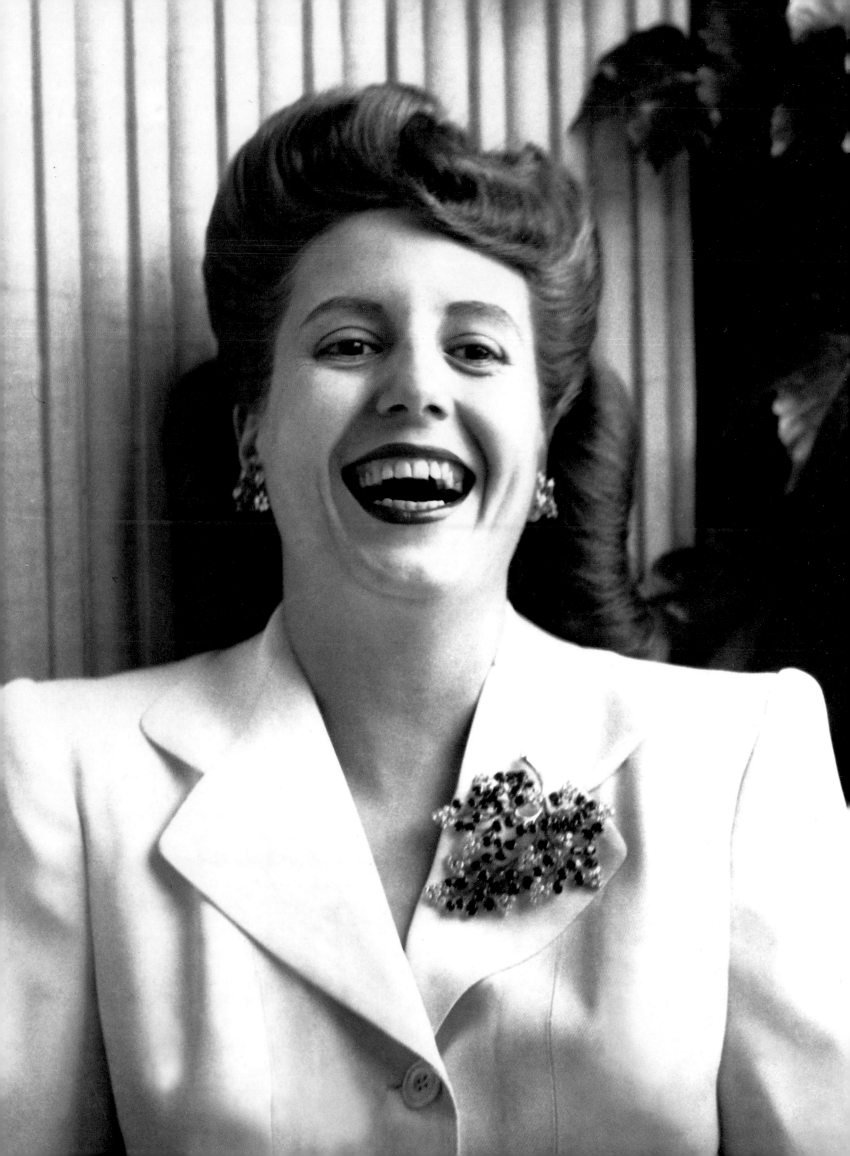

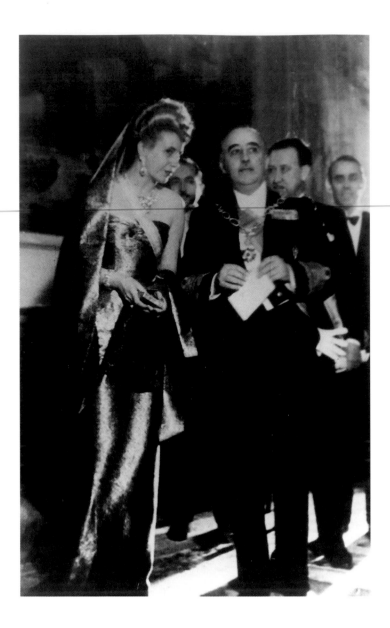

ABOVE *With Franco, Evita arrives at a ball held in her honor at the Presidential Palace outside Madrid wearing the medallion of the Grand Cross of Isabella the Catholic.*

FACING PAGE *Evita's eighteen-day tour of Spain ended in Barcelona, where she attended an elegant ball at the Palace of Montjuich. On the right is the Spanish First Lady, Carmen Polo de Franco.*

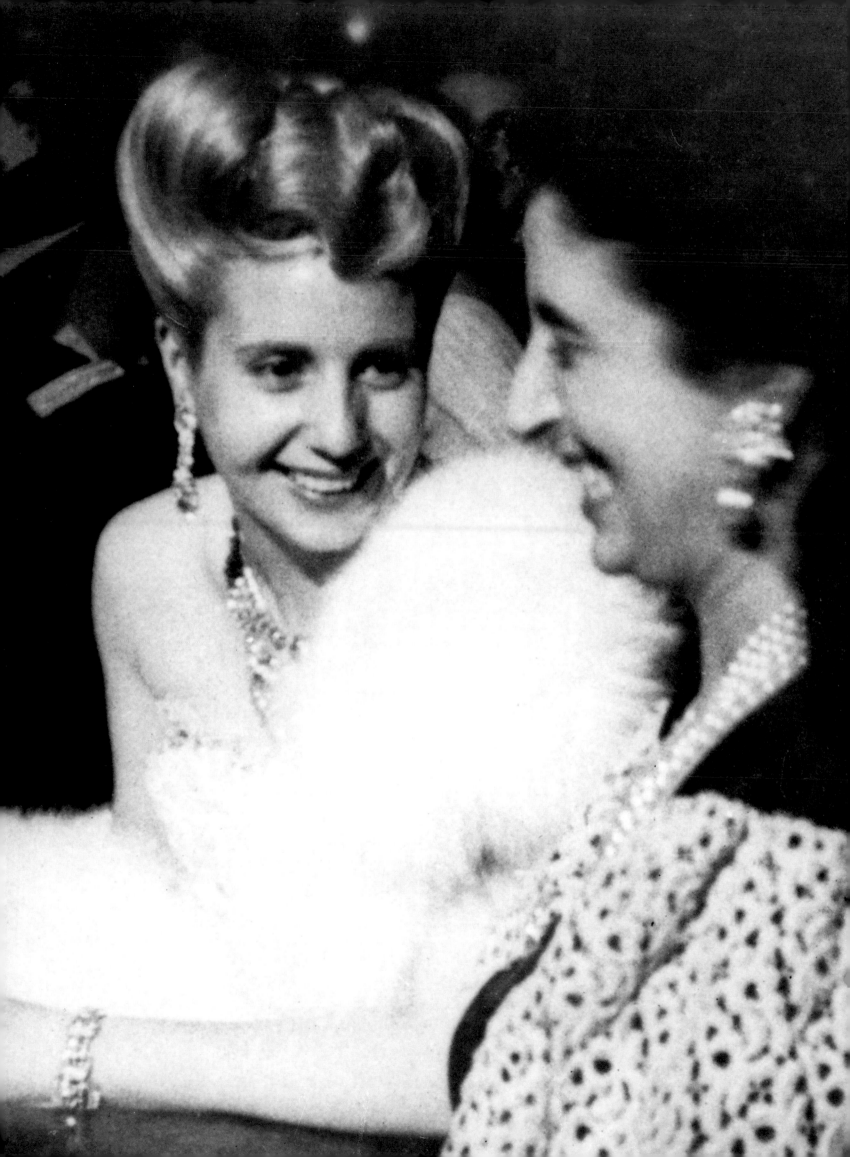

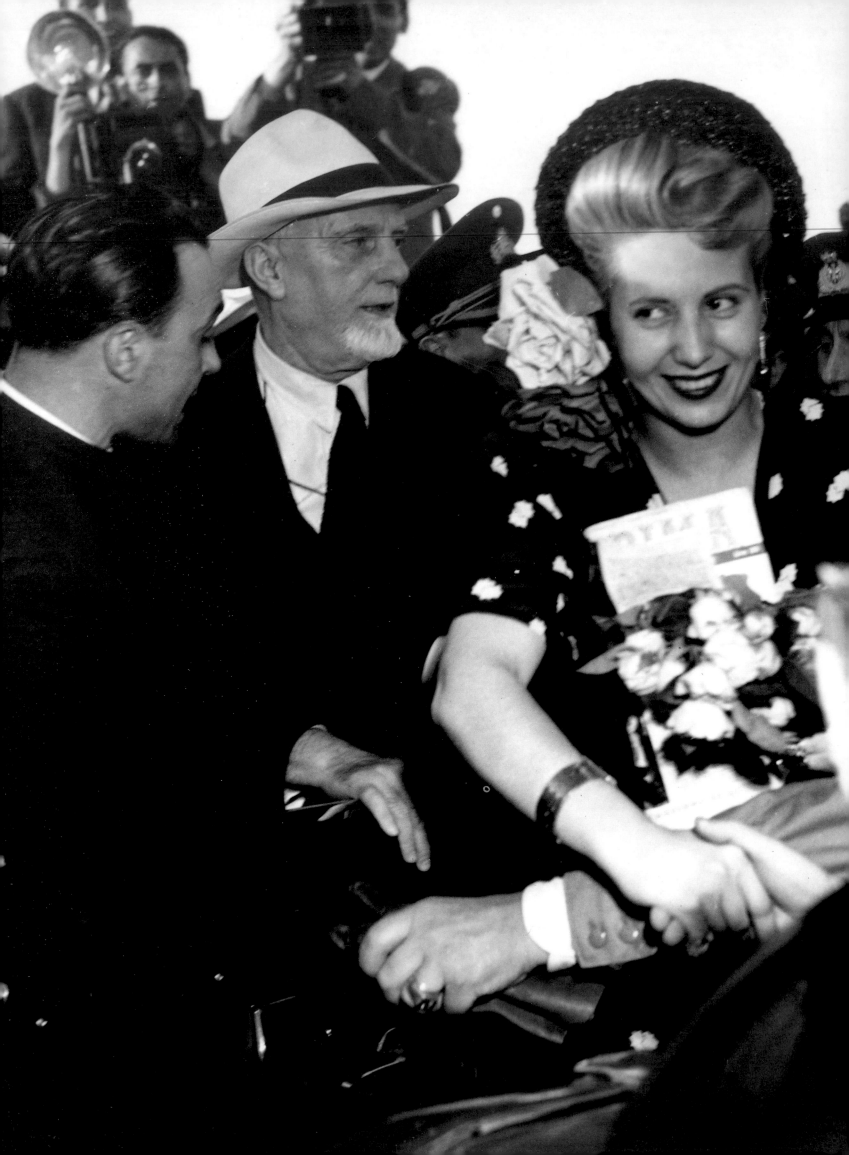

LEFT *From Barcelona, Evita traveled to Rome, where she was greeted by an enthusiastic crowd. She was officially received by the wife of Prime Minister Alcides de Gasperi, and by Count Carlo Sforza, the Italian foreign minister.*

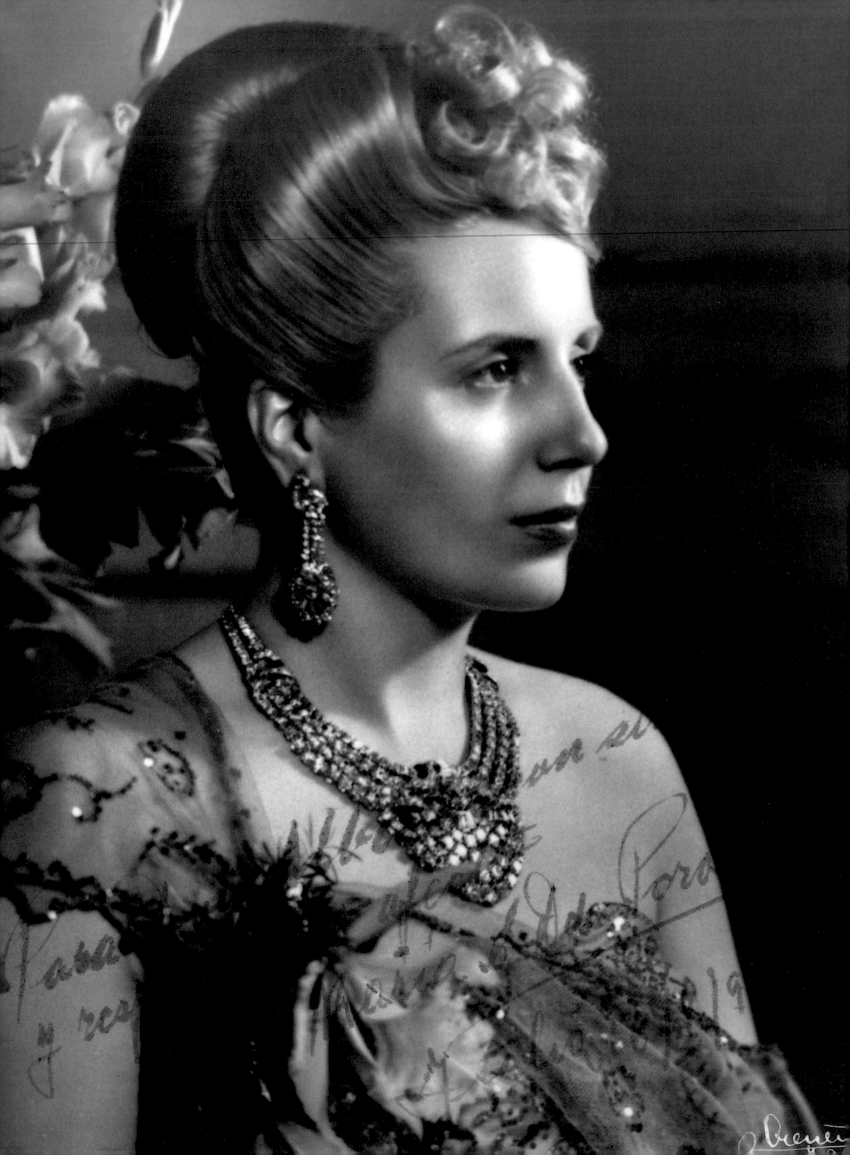

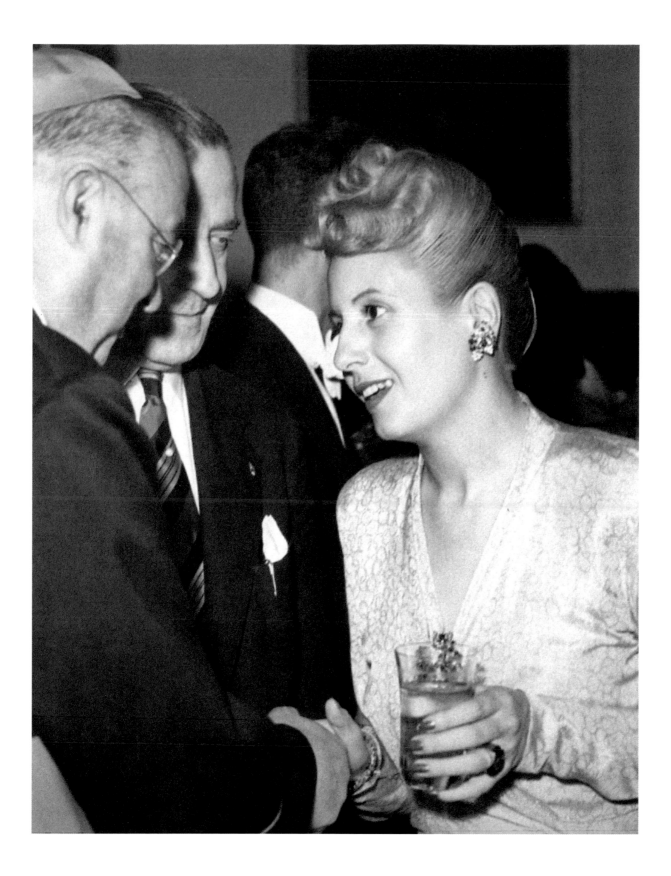

This stately portrait of Evita, taken in Rome, is inscribed to her friend Alberto Dodero,
a patron who sponsored her European trip—which far exceeded its original budget.
The necklace was a gift from Dodero.

Evita greets the Papal Nuncio, Monsignor Borgoncini Duca, at an official reception at the
Argentine embassy in Rome.

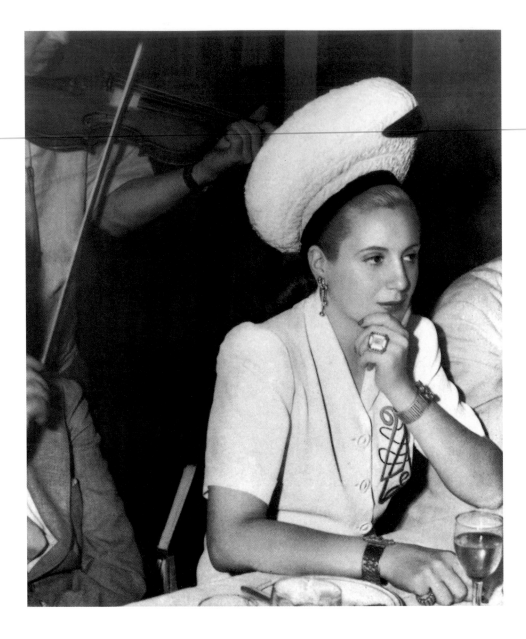

Evita in a pensive moment during a luncheon in Rome given in her honor. From Rome,
Evita went to Lisbon, where she was received by Prince Juan de Borbón, next in line
to the Spanish throne.

FACING PAGE

Evita is escorted to the Vatican Library for her audience with Pope Pius XII.
The Pope presented her with a gold rosary, the same one she held in her hands as she lay
dying in Buenos Aires five years later.

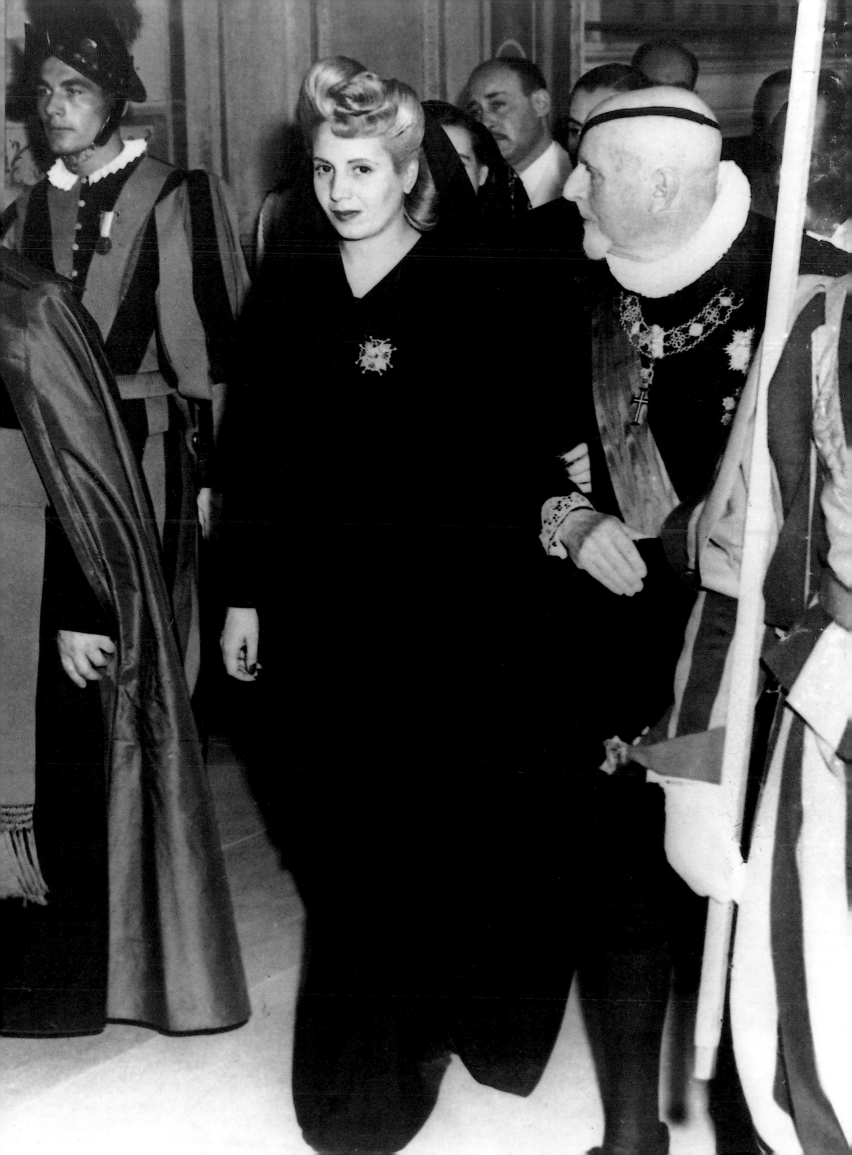

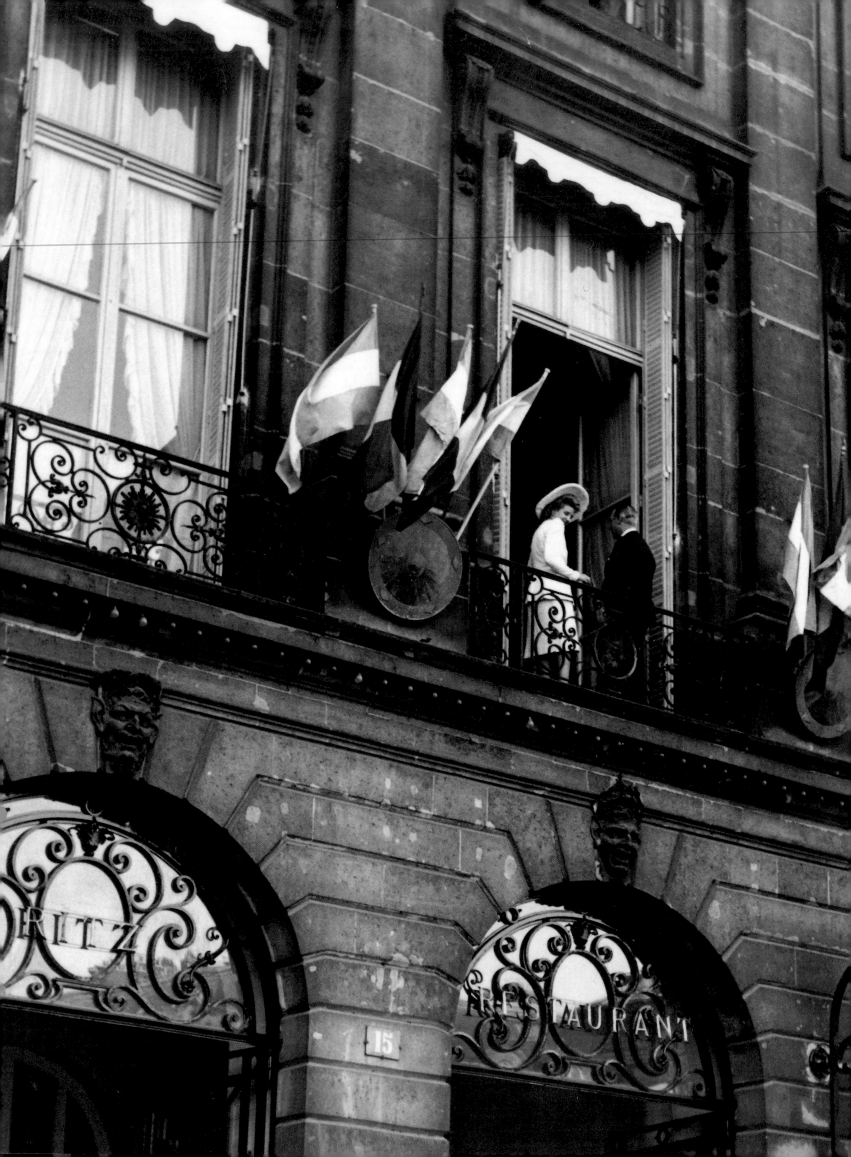

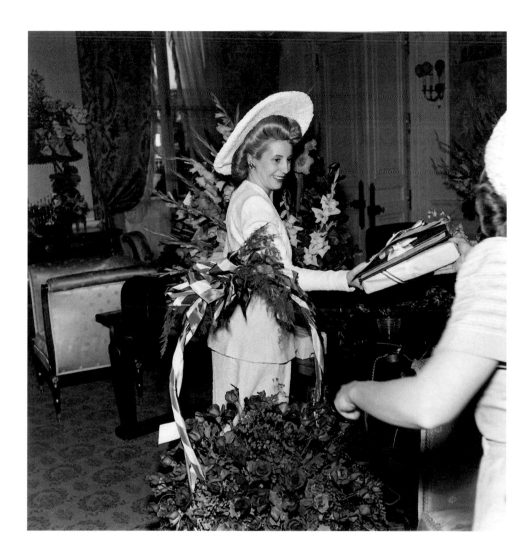

ABOVE AND FACING PAGE
Evita arrived in Paris in July, 1947, as an official guest of the French President,
Vincent Auriol. She stayed at the Hotel Ritz but rarely left her suite—her intense schedule
and the extreme summer heat had exhausted her. She received guests and gifts at the hotel,
and reportedly engaged in lively conversations with the maids about their working conditions.

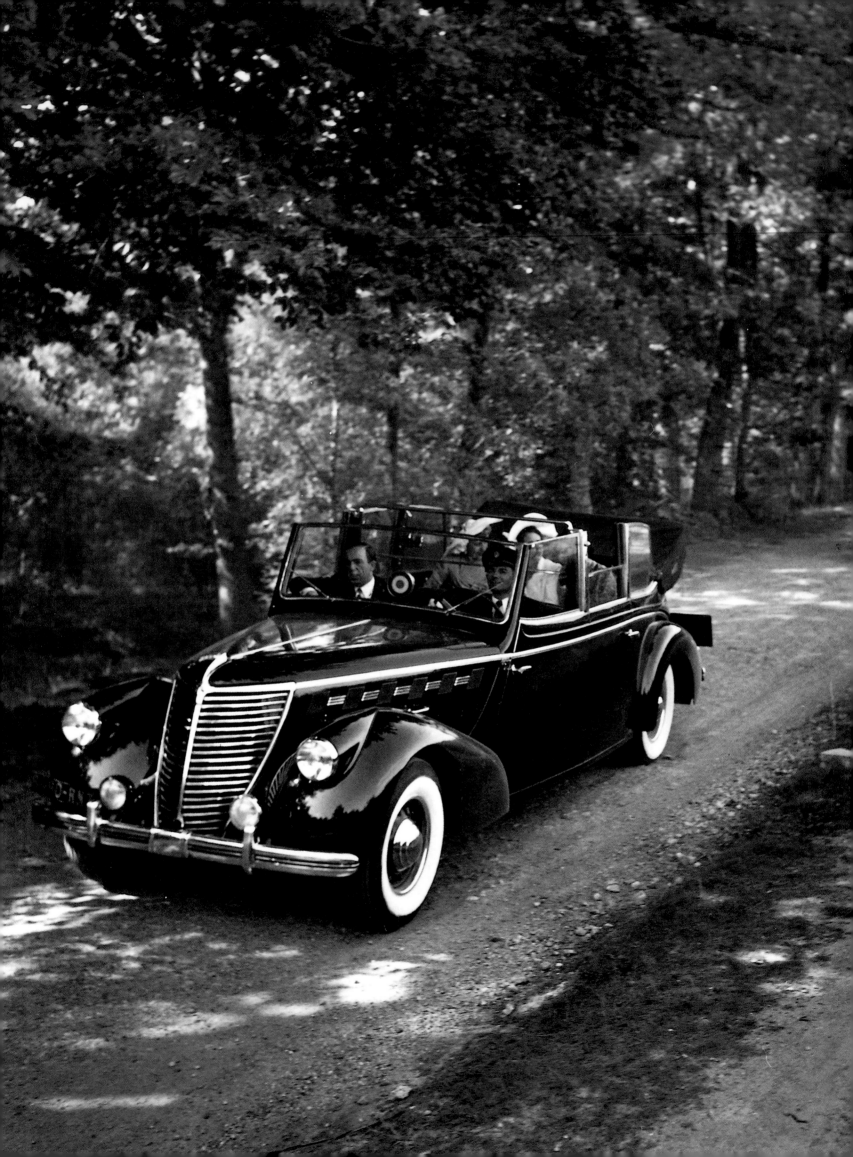

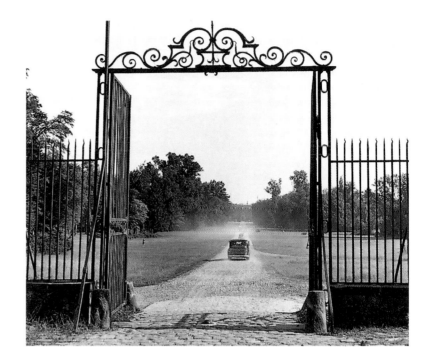

ABOVE AND FACING PAGE *A procession of open touring cars accompanied Evita to the Chateau Rambouillet outside Paris, where President Auriol held a luncheon in her honor. A few days later, Evita signed a treaty for a major loan to France from the Argentine government.*

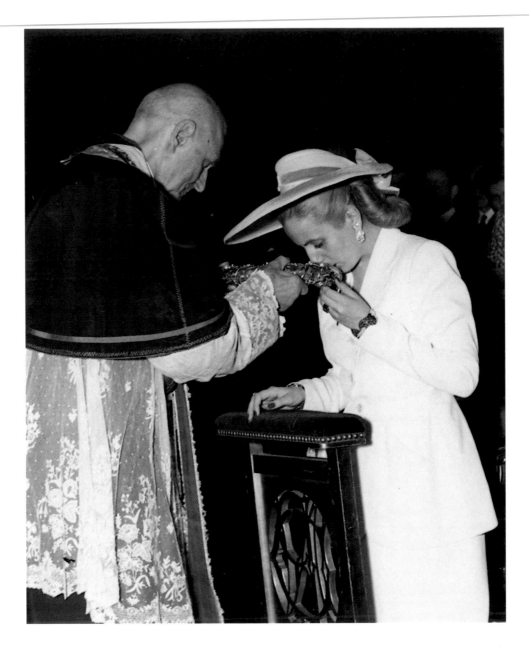

In Paris, Evita visited Nôtre Dame Cathedral with Cardinal Roncalli, then Papal Nuncio to
France and later Pope John XXIII.

FACING PAGE
With Evita at a reception at the Hotel Ritz in Paris are, from left, María Angélica (Beba)
Chevalier Luro de Victorica Roca, wife of the Argentine ambassador; Edouard Herriot,
President of the French National Assembly; and George Bidault, Chancellor of France.

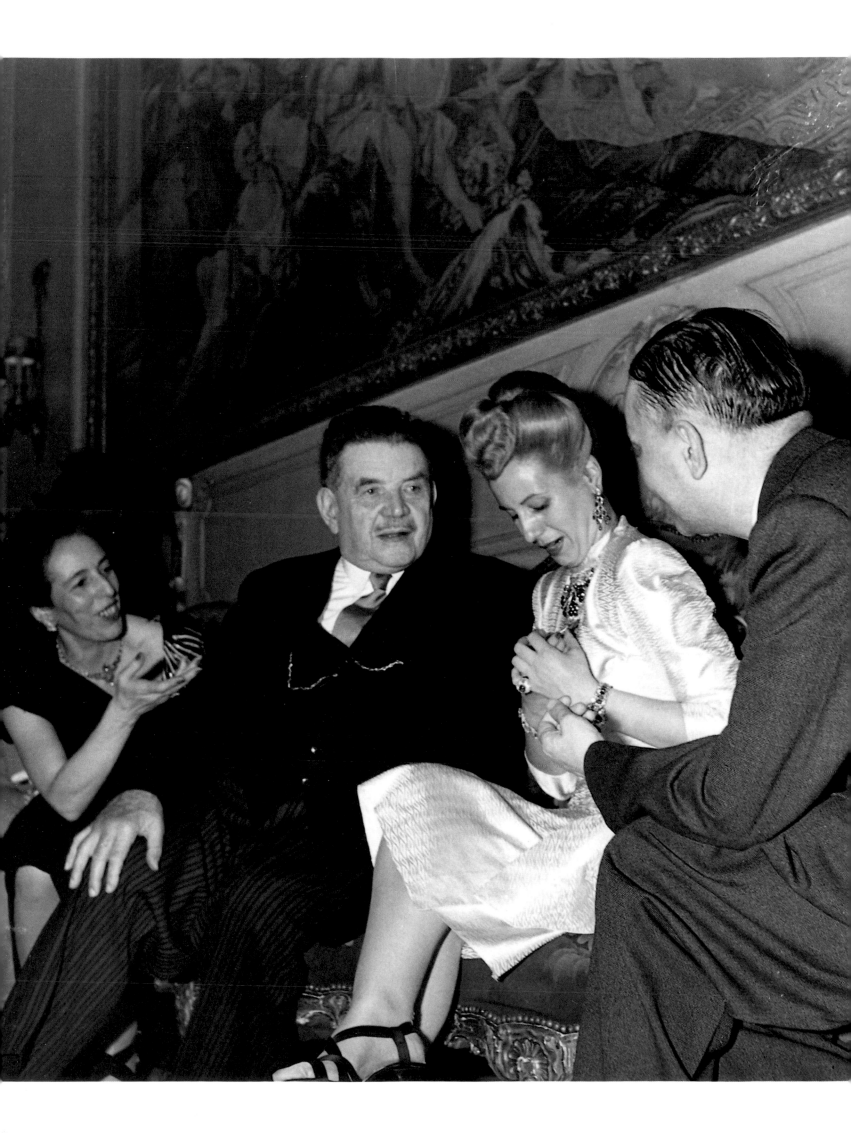

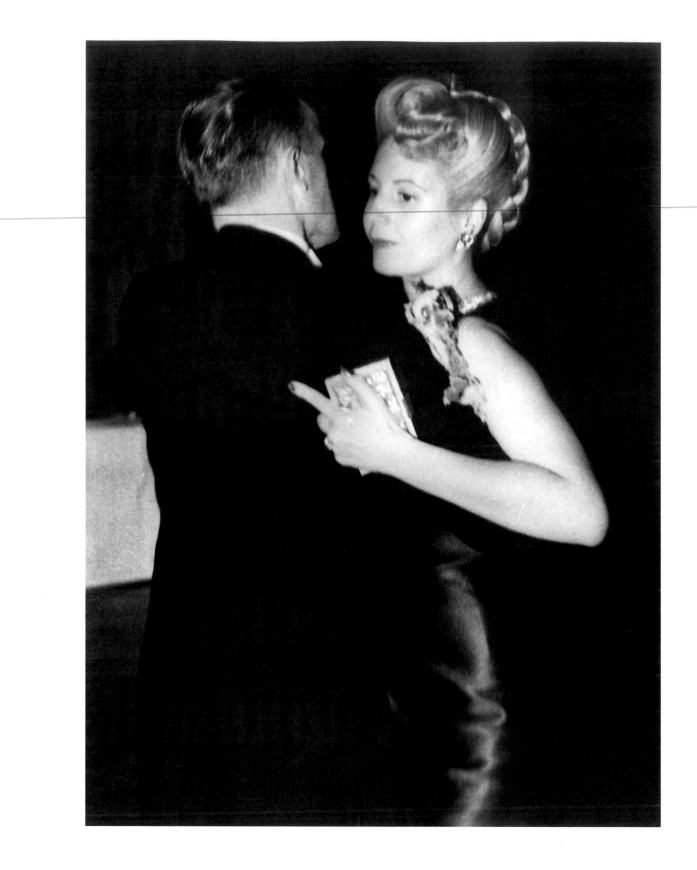

ABOVE
In Bern, Evita dances with the Swiss Foreign Minister, Max Petitpierre, at a reception at
Bern Palace given by the Swiss President.

FACING PAGE
Evita took time out of her busy schedule for a walk in the Alps with fellow Argentines:
the ambassador to Switzerland, Benito Llambí (at Evita's side), her friend Lillian Guardo,
and members of the diplomatic corps.

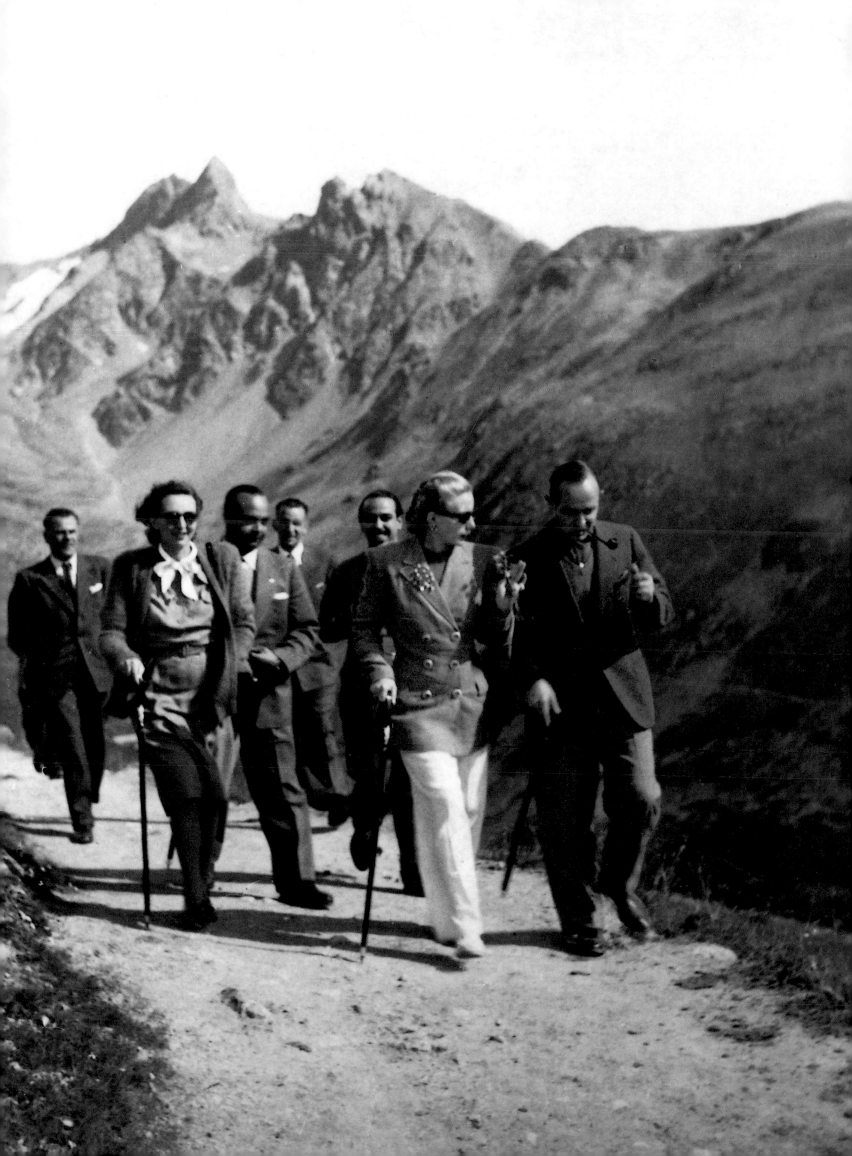

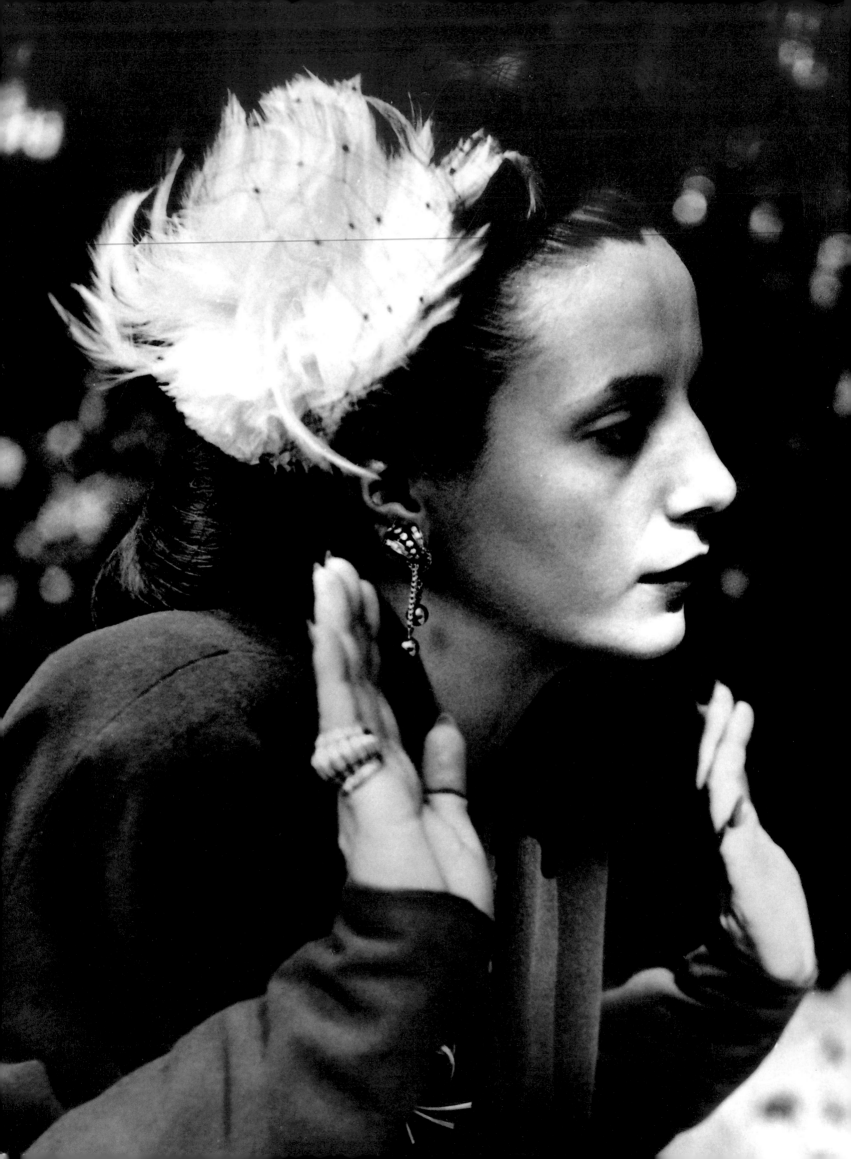

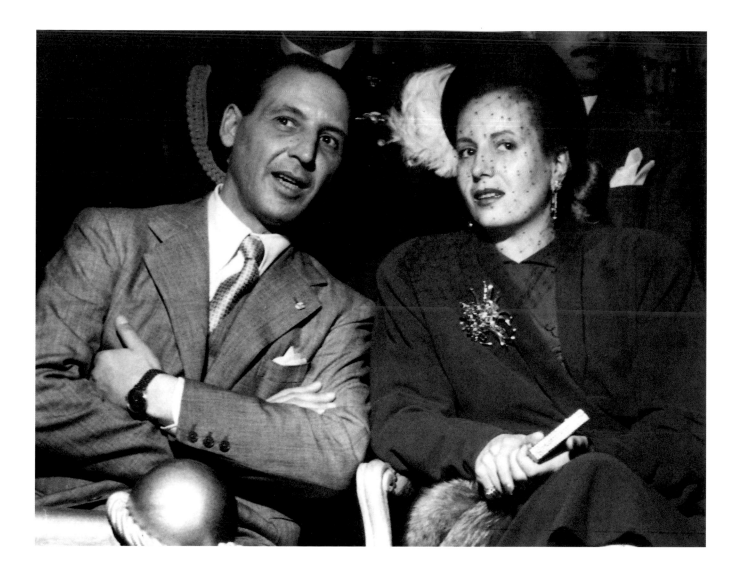

*En route back to Argentina, Evita stopped in Rio de Janeiro to attend the Inter-American
Conference on Peace and Security, where she is seen here beside the Argentine Minister,
Juan Bramuglia, listening to a speech by United States Secretary of State George Marshall.*

*By the time Evita returned to South America in August 1947, she had polished her
public appearance considerably. Her presence in Rio de Janeiro provoked pandemonium in
the streets as throngs of admirers competed with journalists and paparazzi for her attention;
her bodyguards never left her side.*

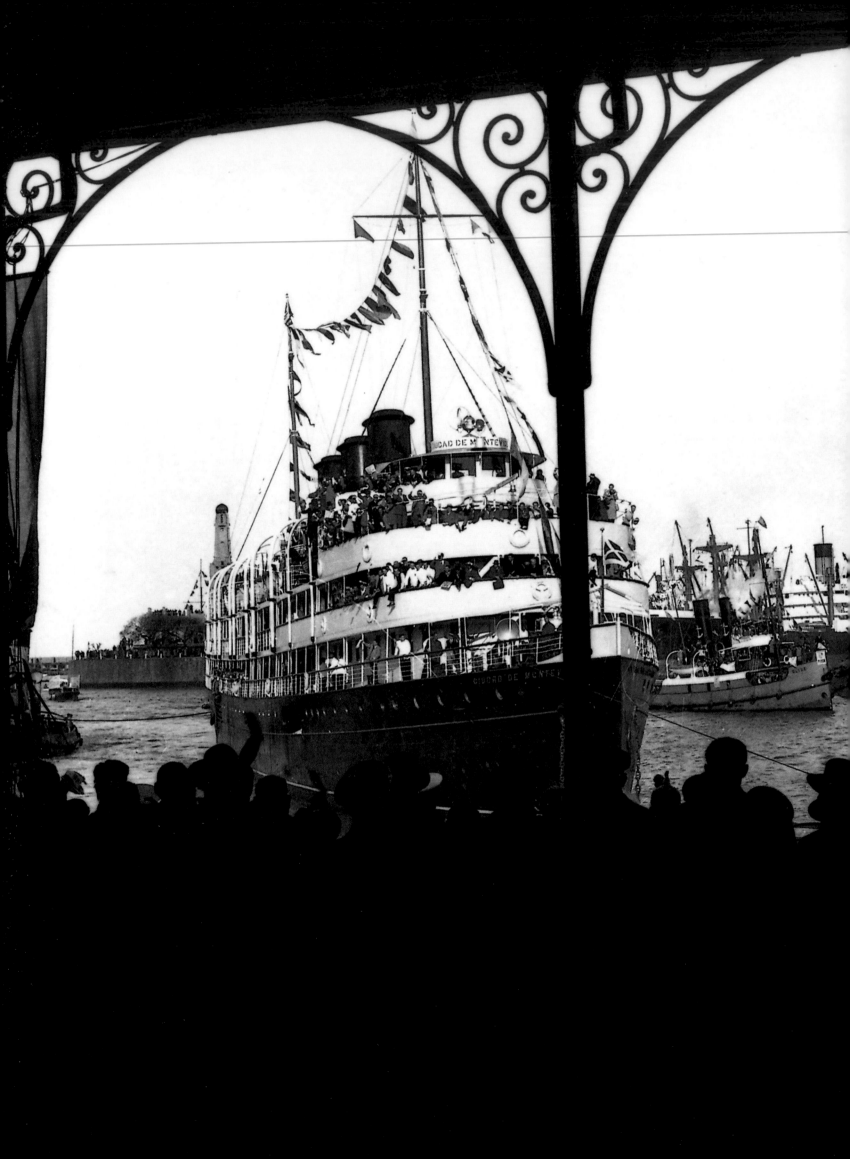

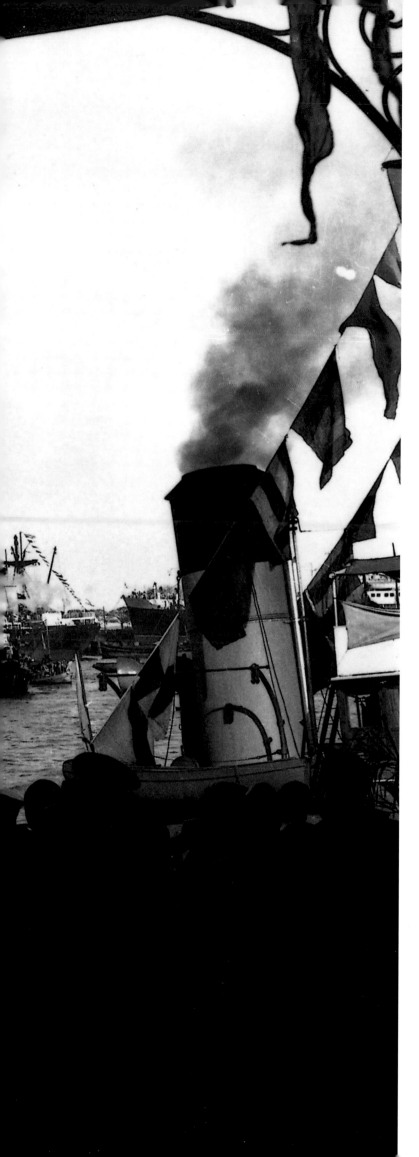

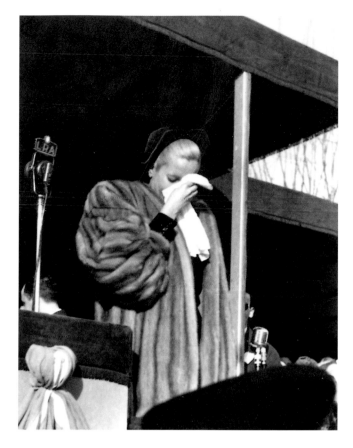

ABOVE AND LEFT *On the final leg of her return from Europe, Evita sailed from Montevideo, Uruguay, to the Port of Buenos Aires on the* CIUDAD DE MONTEVIDEO. *Along with her husband and members of her family, thousands of citizens turned out on the red-carpeted dock to welcome the First Lady home. Evita was overcome by emotion.*

The Rise to Power

Upon her return from Europe in 1947, Evita dedicated herself to politics and public service.
Because her public appearances drew enormous, often unruly crowds, Juan Perón assigned
her a permanent bodyguard. During this factory visit in Avellaneda, a working-class district
of Buenos Aires, she was accompanied by a police escort.

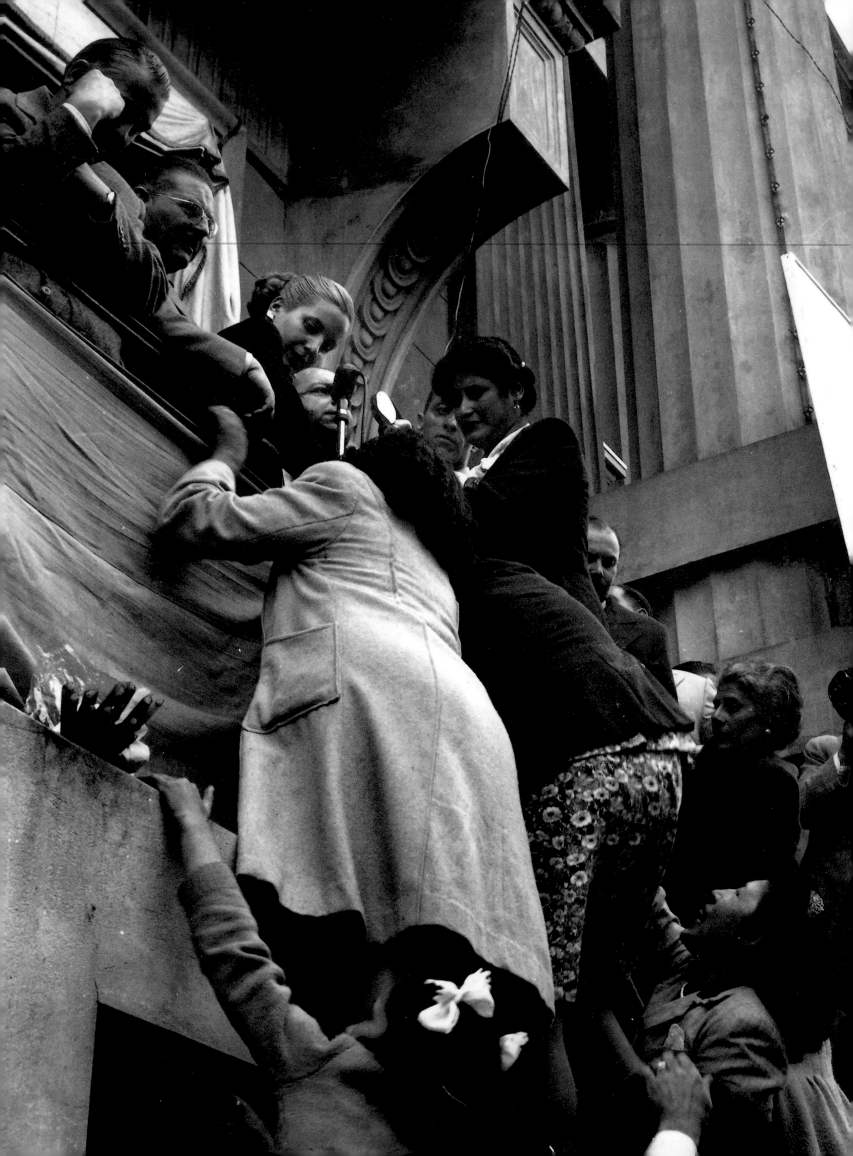

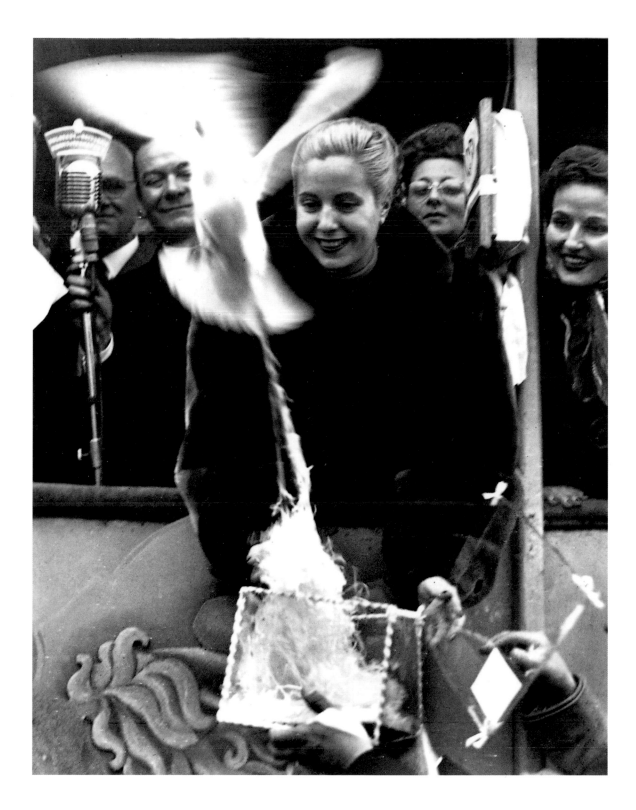

PRECEDING PAGES
Shortly after her return from Europe, Evita (right) enjoys an elegant meal in Buenos Aires with her American friend Betty Sundmarck de Dodero, wife of the shipping magnate Alberto Dodero, who financed her trip to Europe.

ABOVE
The First Lady releases a symbolic white dove during a ceremony opening a communal potable water facility in a poor district of Buenos Aires in 1948.

FACING PAGE
During Evita's visit to the city of Rosario in October 1948, adoring citizens clambered over one another to present the First Lady with flowers and personal notes requesting her assistance.

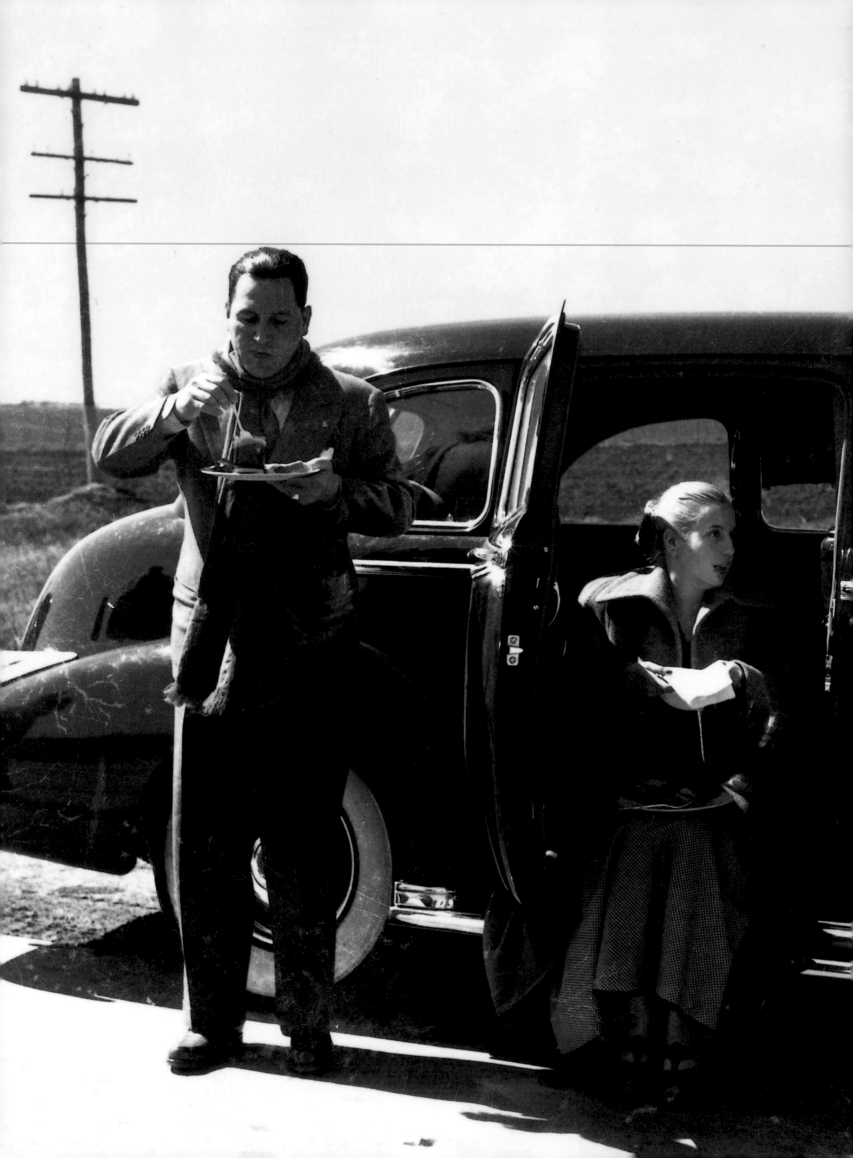

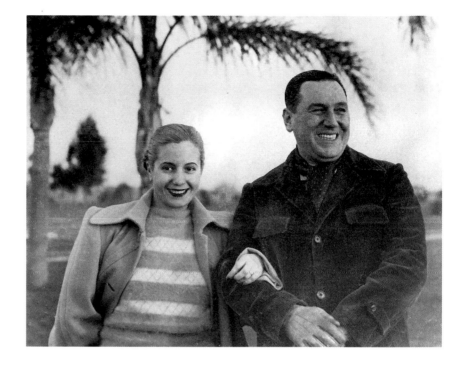

ABOVE Whenever their schedules permitted, Evita and Juan Perón escaped to their small country house, San Vicente, an hour outside of Buenos Aires. As the years went by, however, the couple had less and less time for relaxation, since Evita insisted on working late into the night and on weekends.

FACING PAGE The First Lady and the President stop for a picnic lunch on the way to the dedication of a hospital in the province of Santa Fe. Shortly after returning from Europe, Evita decided to change her hairstyle and wardrobe in favor of a more minimalist, businesslike fashion. Her neat chignon became a signature look.

OVERLEAF Surrounded by leaders of the CGT, the national labor federation, Evita speaks to workers assembled at a late-night meeting in November 1948. Through these speeches and appearances, the First Lady became the personal link between Perón and the country's laborers, whom she beseeched to remain loyal to the President who would defend their interests. "Perón is everything," she exclaimed. "He is the soul, the nerve, the hope, and the reality of the Argentine people."

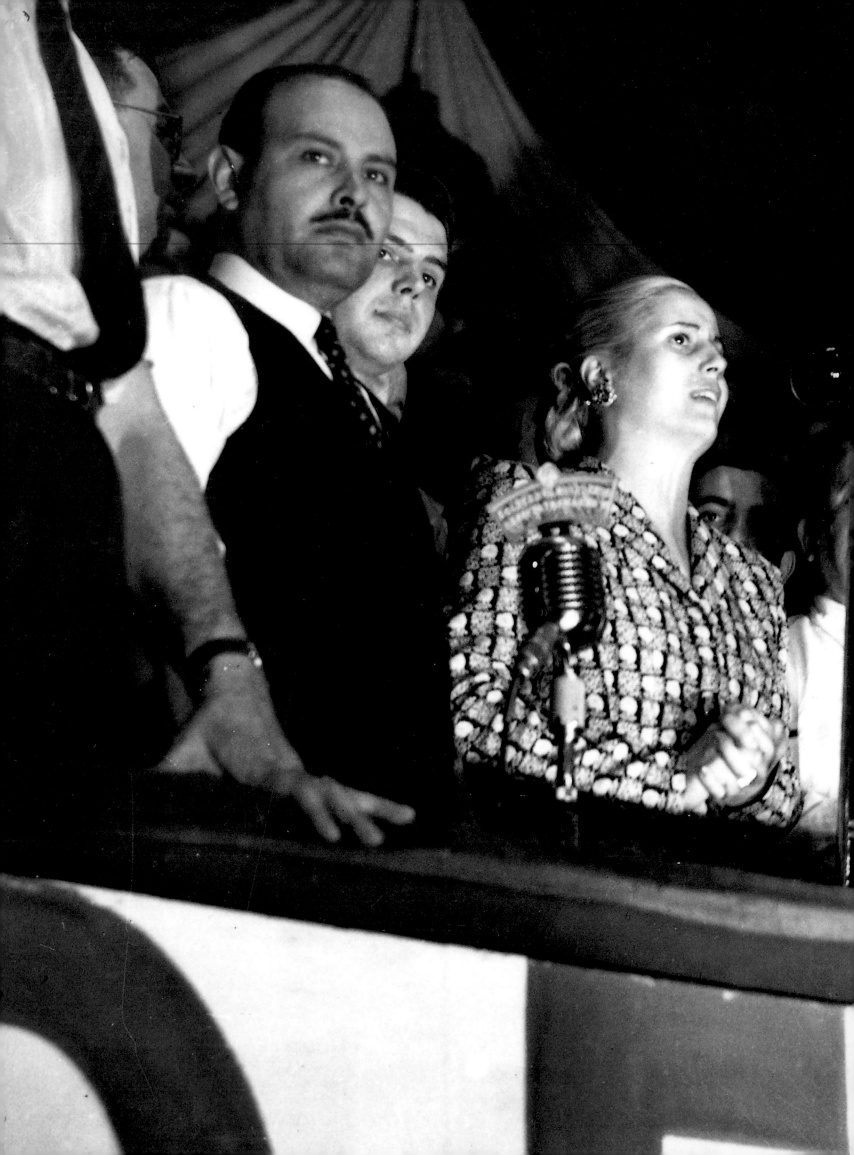

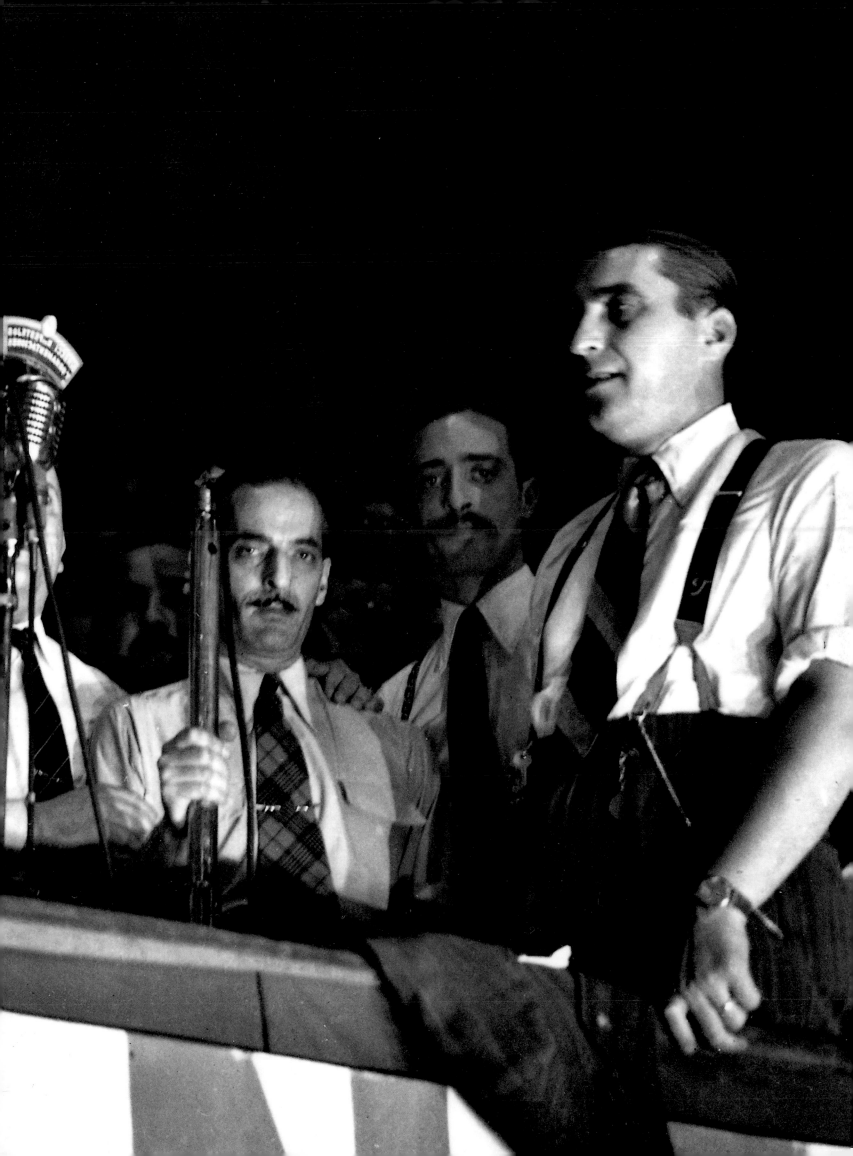

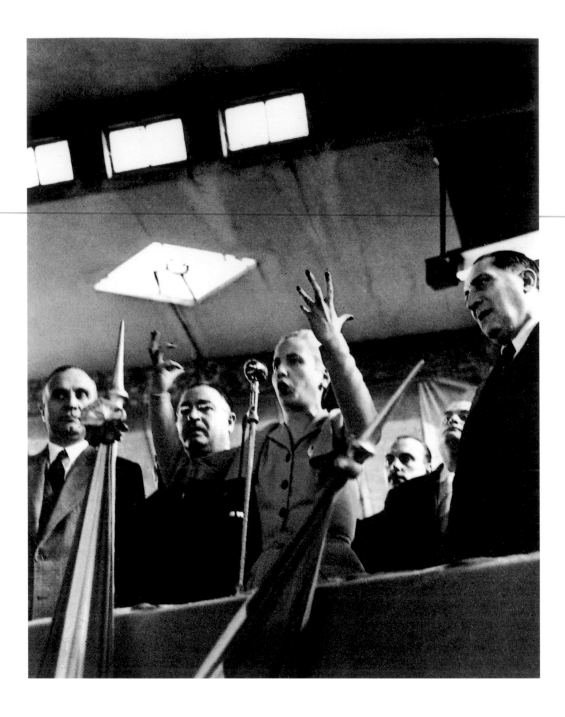

Evita gives a dramatic speech to the Peronist Party Congress assembled
in the Parque Norte, the main park in Buenos Aires, in July 1949. The First Lady's position
in the nation's power structure was rising rapidly; she was more prominent at public
functions than the Vice-President.

FACING PAGE
In 1949 the Argentine congress ratified a new National Constitution that would permit the
President to run for a second term in 1952. At the acceptance ceremony, Evita is flanked by
Perón (right) and an unidentified official.

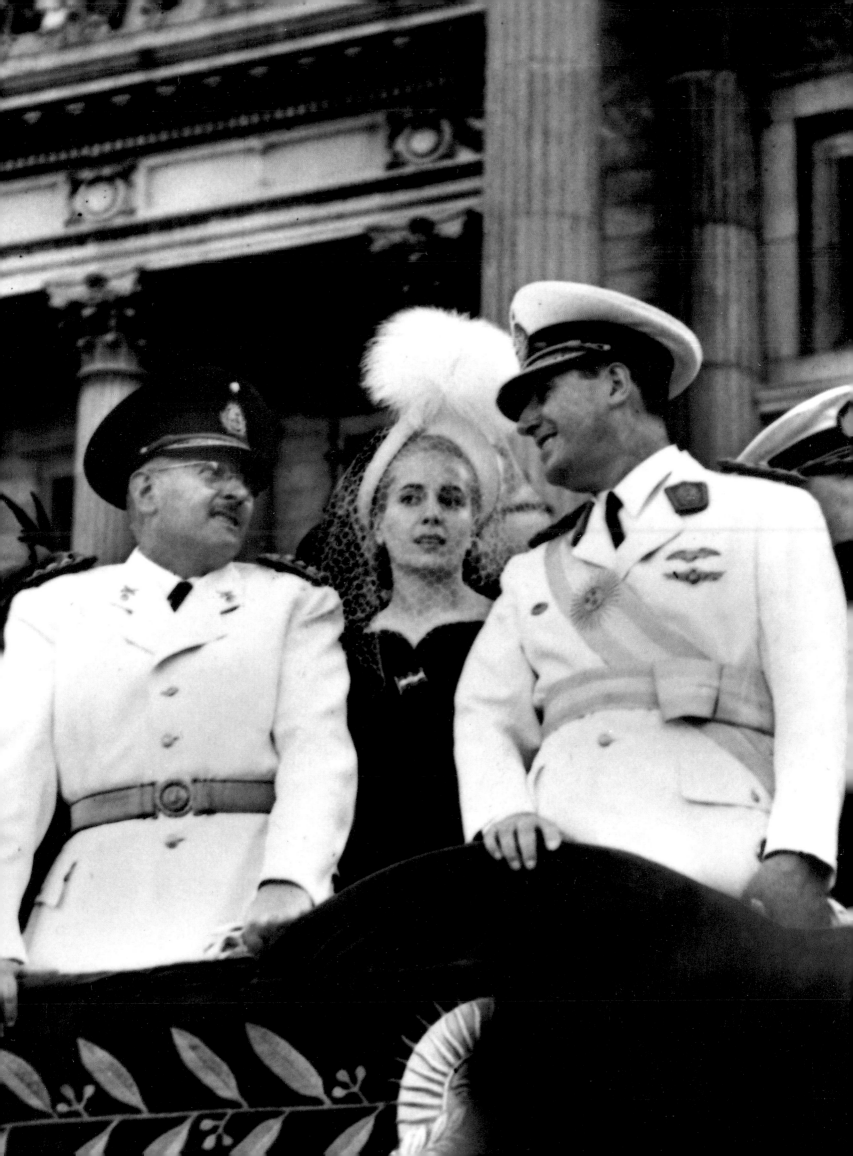

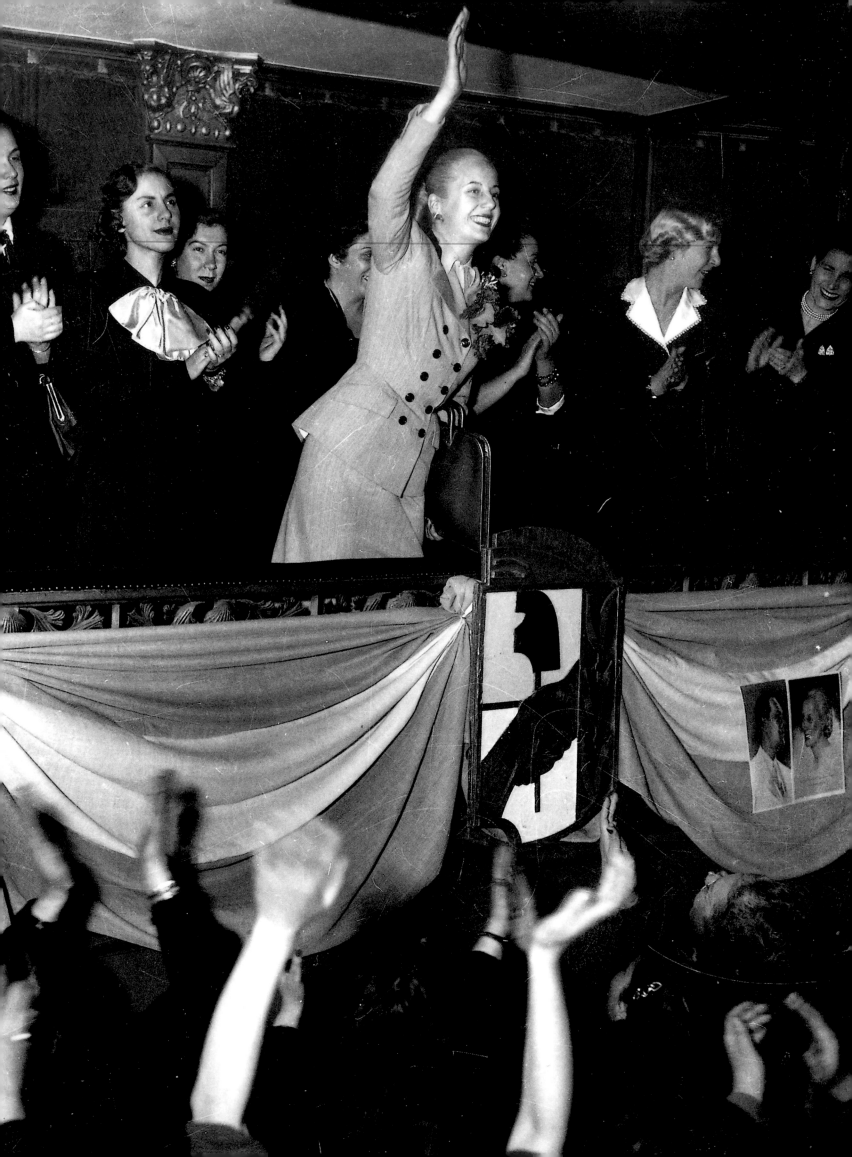

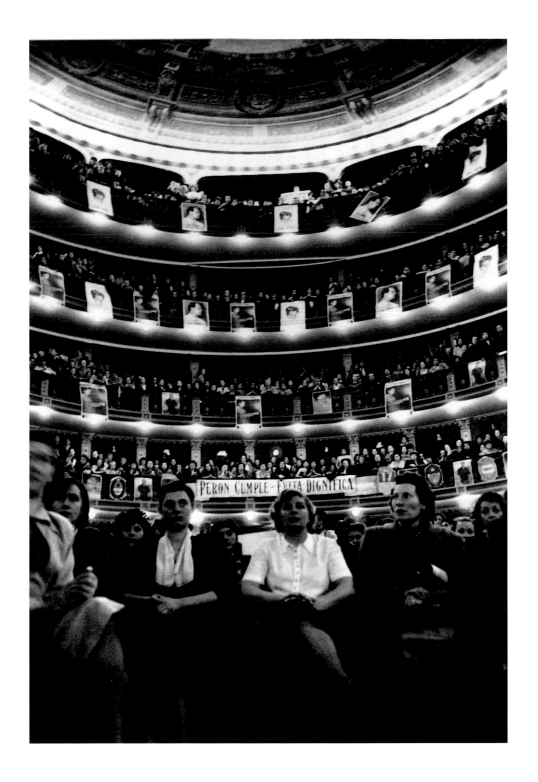

*At the First National Assembly of the Peronist Women's Movement, held at the Teatro
Nacional Cervantes in Buenos Aires in July 1949, thousands of delegates listen enraptured as
Evita addresses them from the balcony: "To be Peronist is, for a woman, to be loyal and to
have blind confidence in Perón."*

*Evita flashes a smile of contentment and relief during the closing ceremony of the First
National Assembly of the Peronist Women's Movement. Organizing the Peronist Women's
Party was one of the most difficult tasks of her political career.*

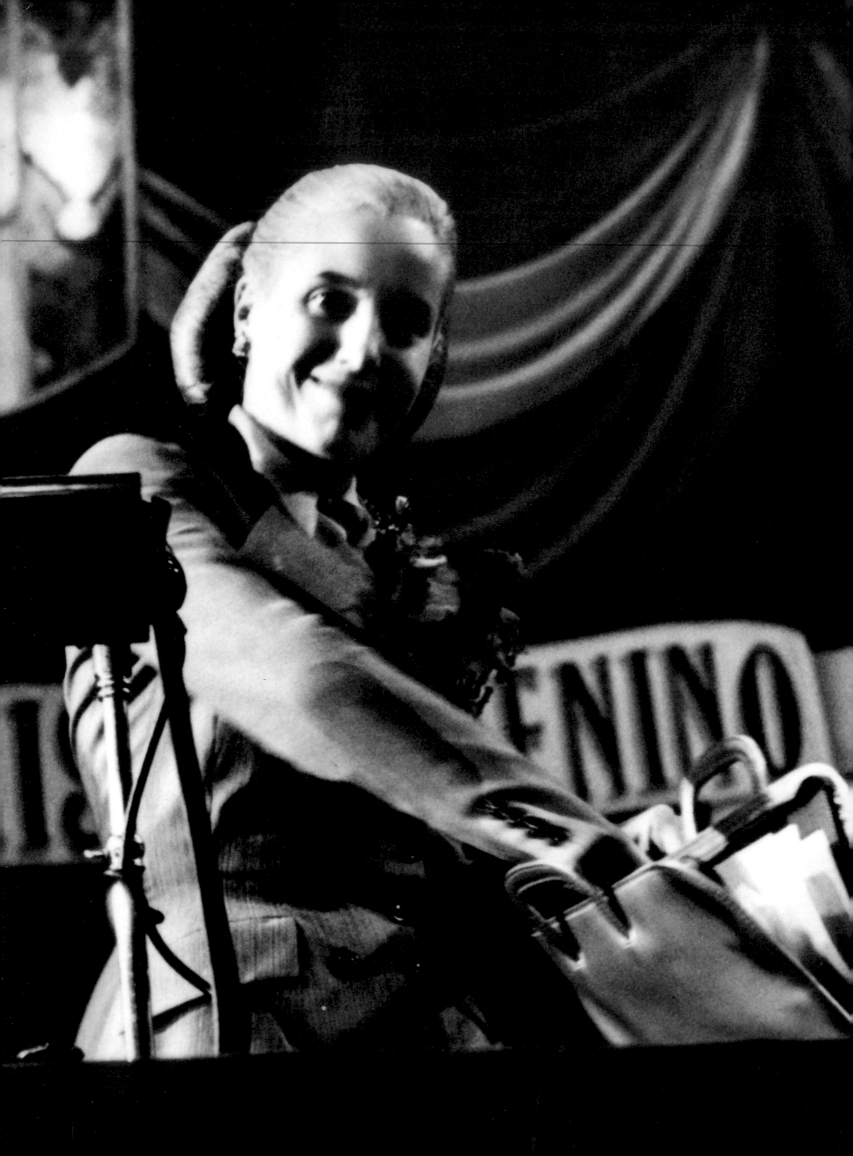

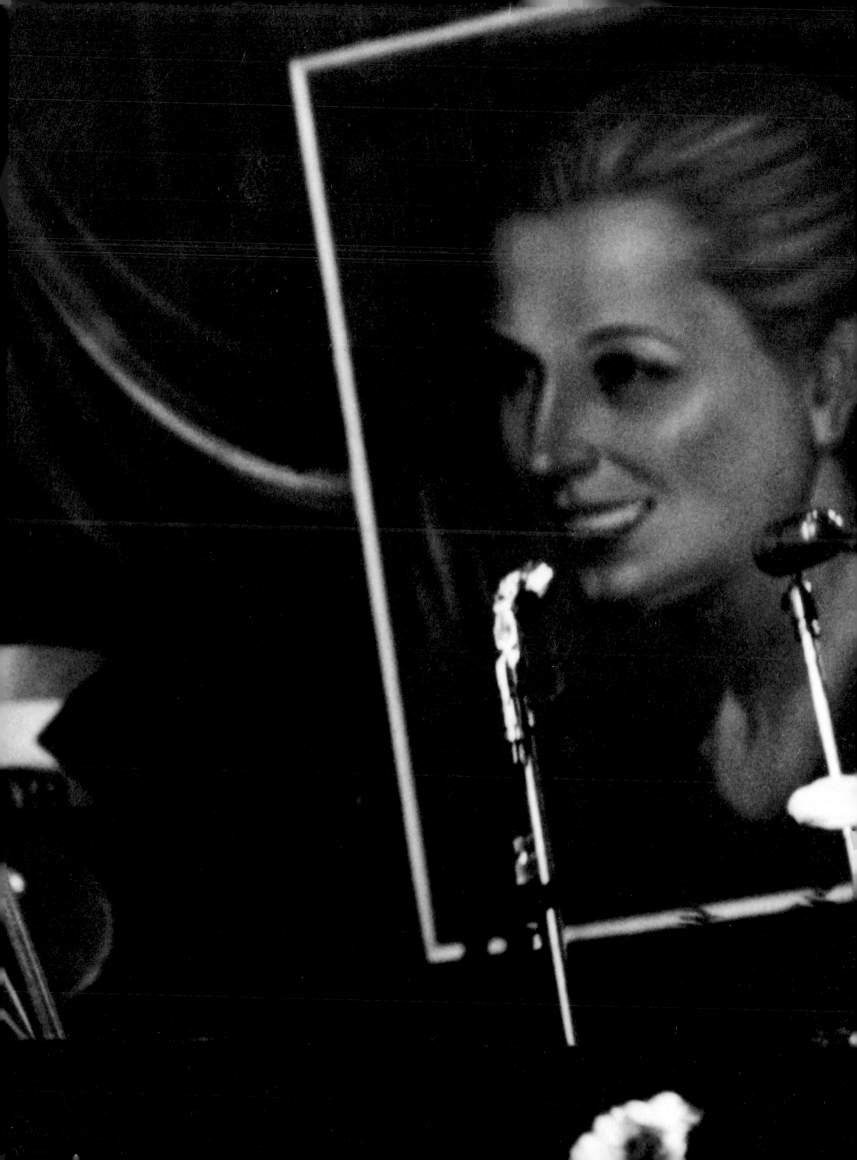

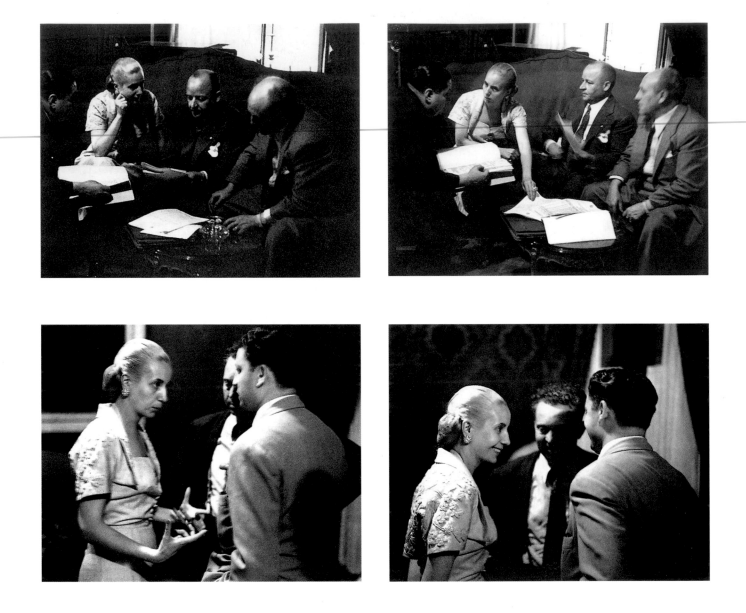

Evita dedicated long hours to resolving conflicts between unions, the government, and industry. Here she meets with executives from the refrigeration industry and with heads of government labor unions to discuss salary increases for employees of the Municipality of Buenos Aires.

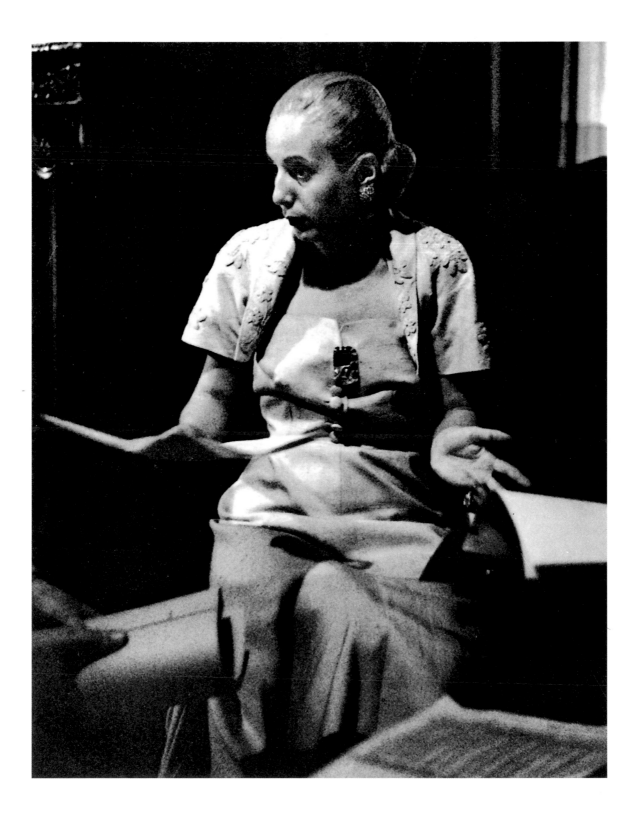

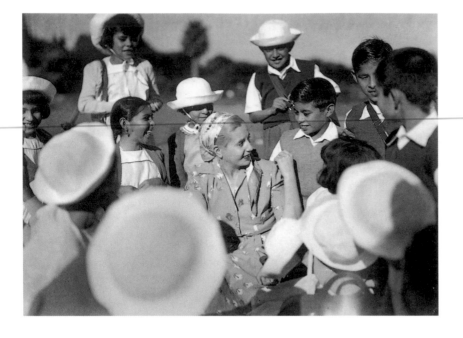

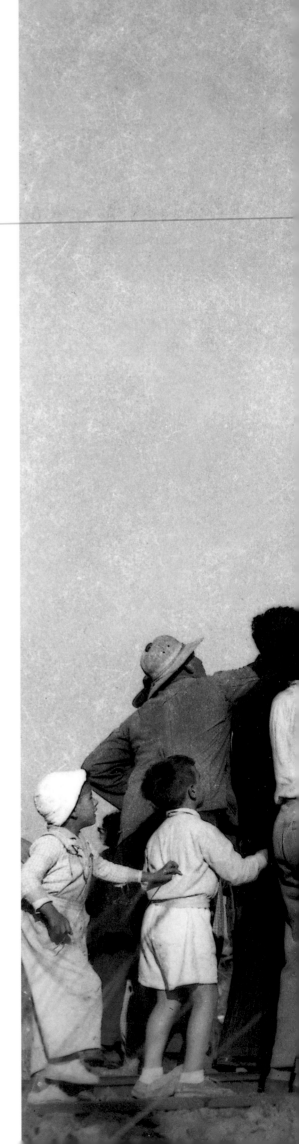

ABOVE *Evita bids farewell to a group of children in the province of Santiago del Estero.*

FACING PAGE AND OVERLEAF *In 1950 Evita took a train tour through the southern half of Buenos Aires province, stopping along the way to distribute food and clothing. Although her staff tried to prevent it, Evita frequently left the train to visit pueblos and ranches where she could talk freely to the workers. Often large crowds swarming around the tracks forced the train to stop unexpectedly.*

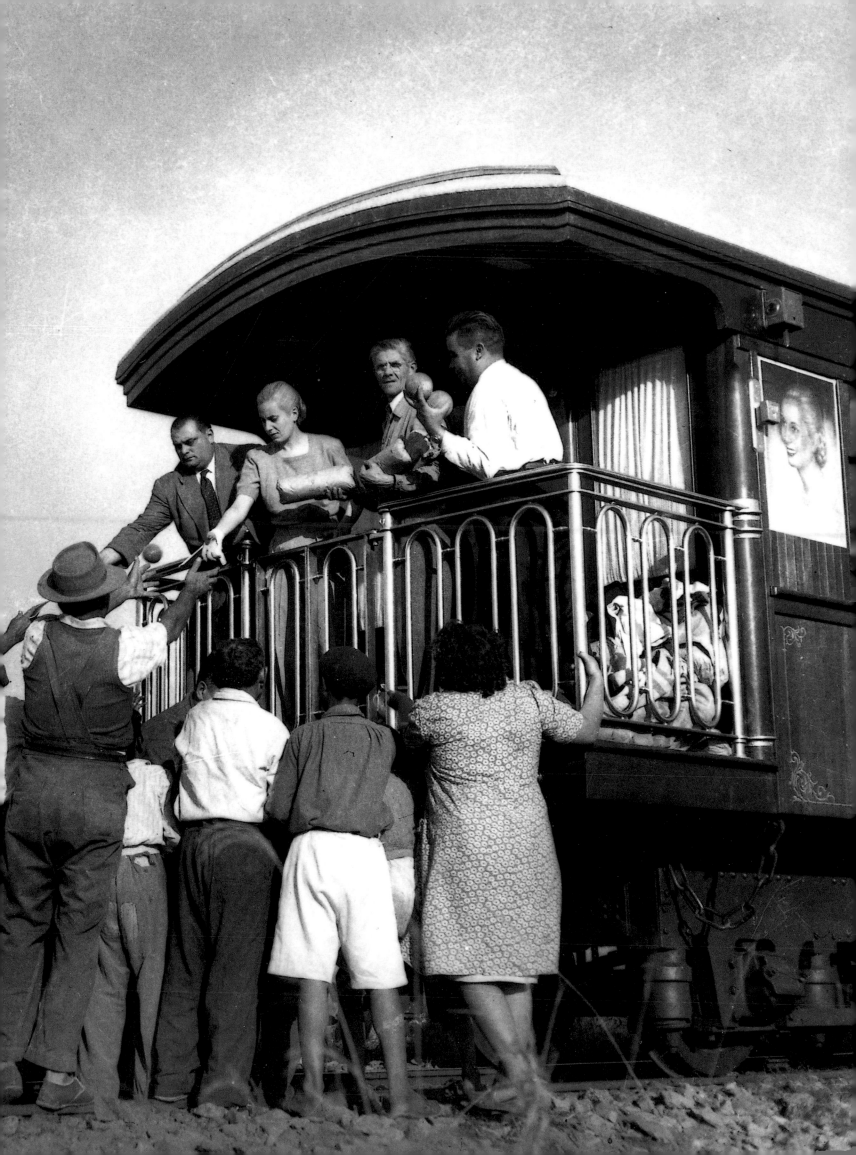

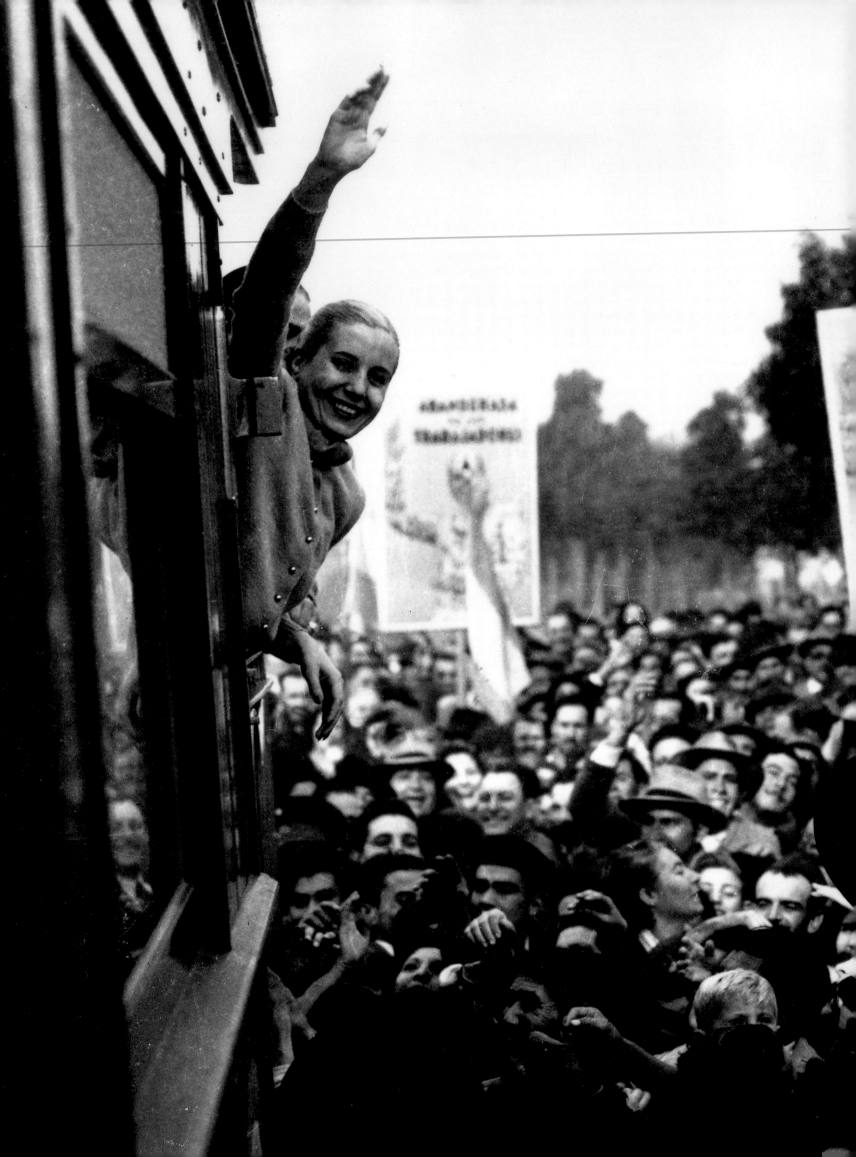

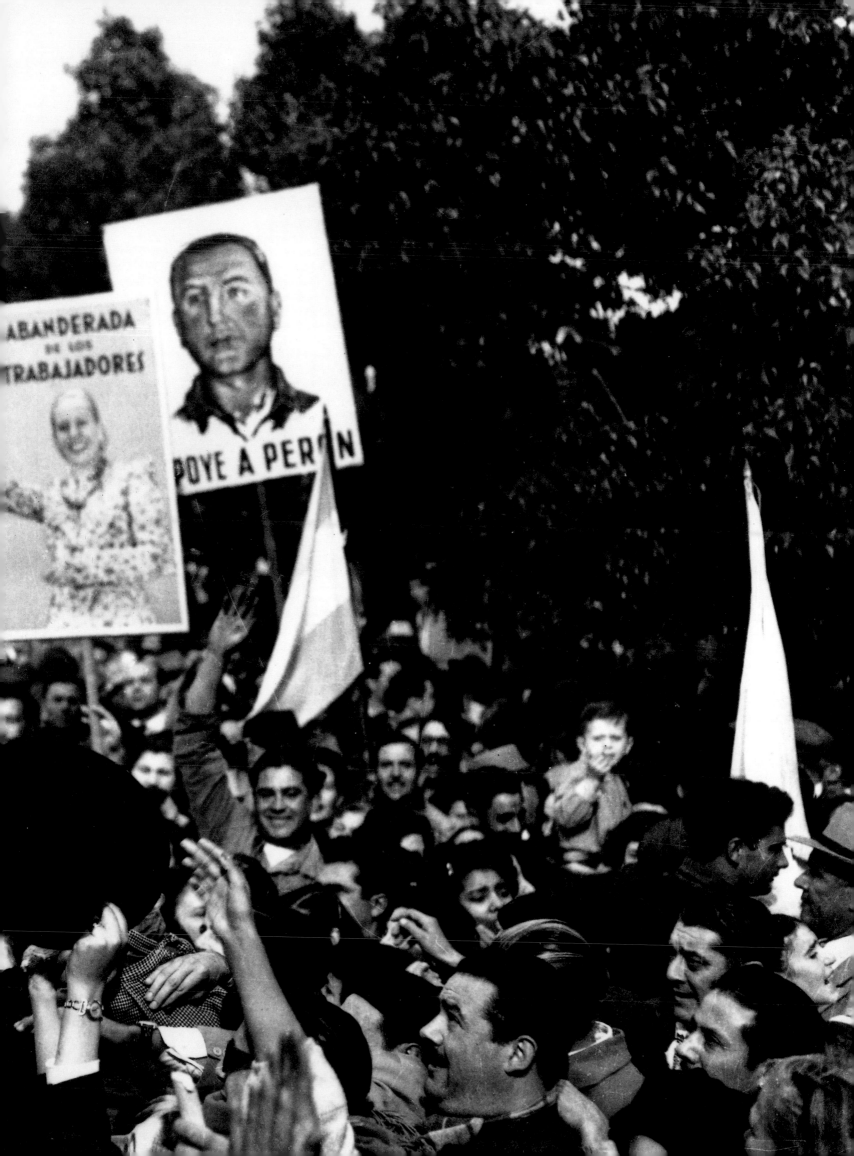

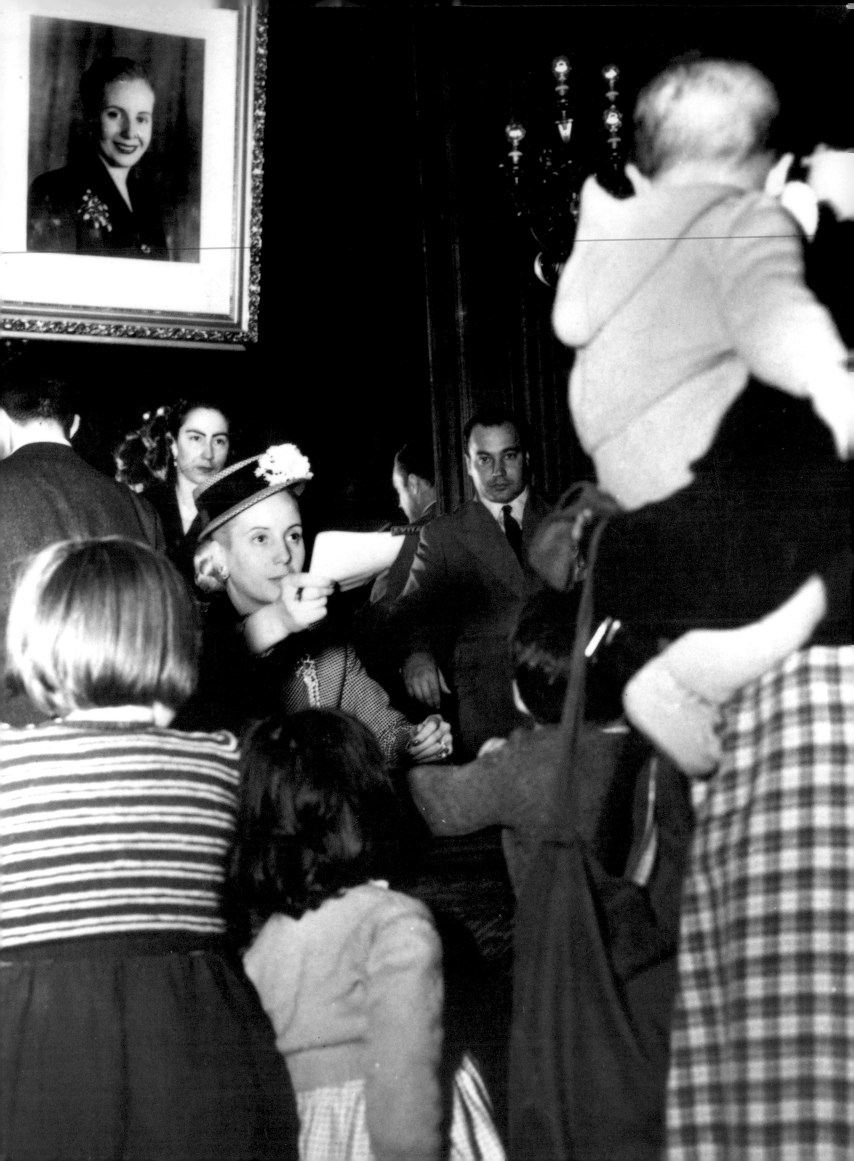

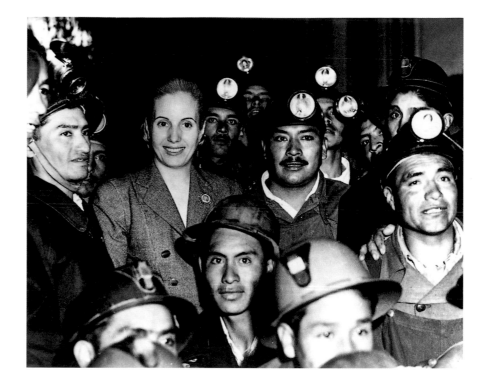

RIGHT *One of Evita's highest priorities was improving working conditions in Argentina's mines. Her direct and unpretentious way of speaking earned her widespread support among laborers; she once convinced railroad workers to end a strike by visiting every union headquarters involved and negotiating with the strikers.*

RIGHT *Evita felt particularly close to the nurses working with the Eva Perón Foundation, a state-run organization founded to assist primarily women, children, and the elderly. At one time more than 800 nurses worked in Argentine hospitals supported by the Foundation.*

FACING PAGE *The First Lady attends to a poor family in her office at the Ministry of Labor. From morning to night she was surrounded by dozens of petitioners seeking help of all kinds— from a hospital bed to a new house. Evita refused to leave the office until she had seen everyone waiting, which often kept her there past midnight.*

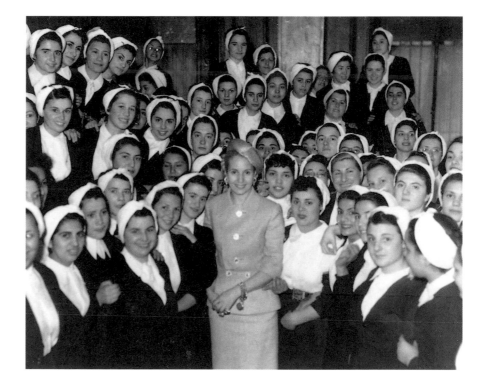

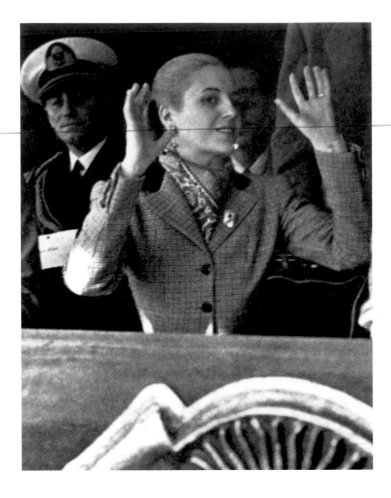

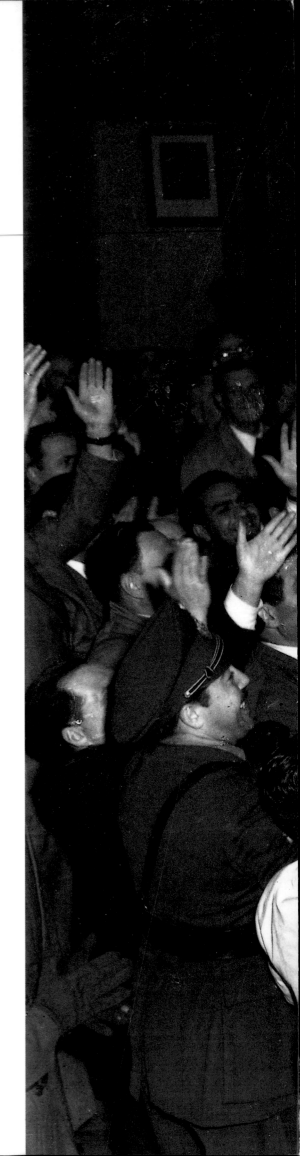

ABOVE *Evita celebrates a soccer goal at the Evita Youth Championship, which she attended with Perón.*

FACING PAGE *The President and First Lady salute a crowd of dockworkers on their way to visit a ship owned by Alberto Dodero at Port Madero in Buenos Aires in the early 1950s.*

OVERLEAF *The sumptuous, turn-of-the-century Unzué Palace was converted into the official Presidential Residence in the 1930s. Evita lived here with Juan Perón from 1946 until her death in 1952. The First Lady kept a storeroom in the palace for clothing and food to be distributed to the poor, and sometimes offered temporary shelter here to homeless people she met in the street.*

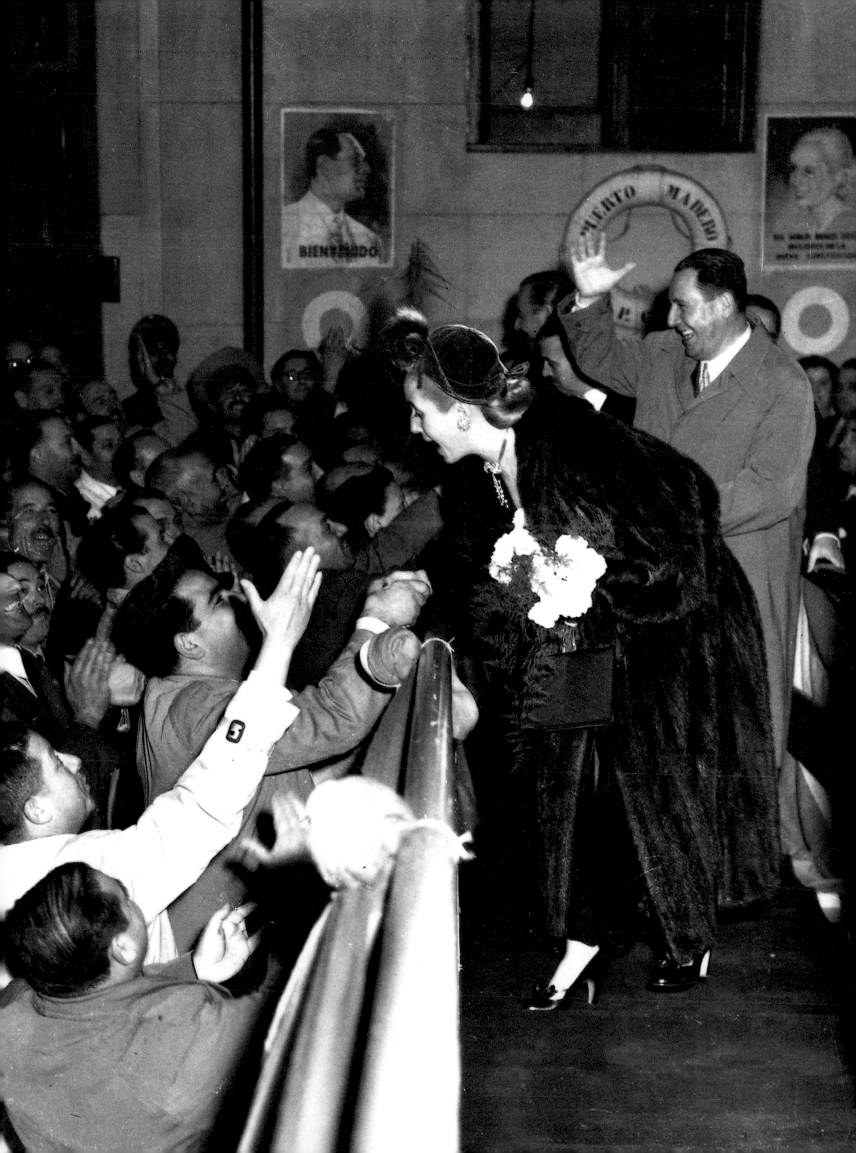

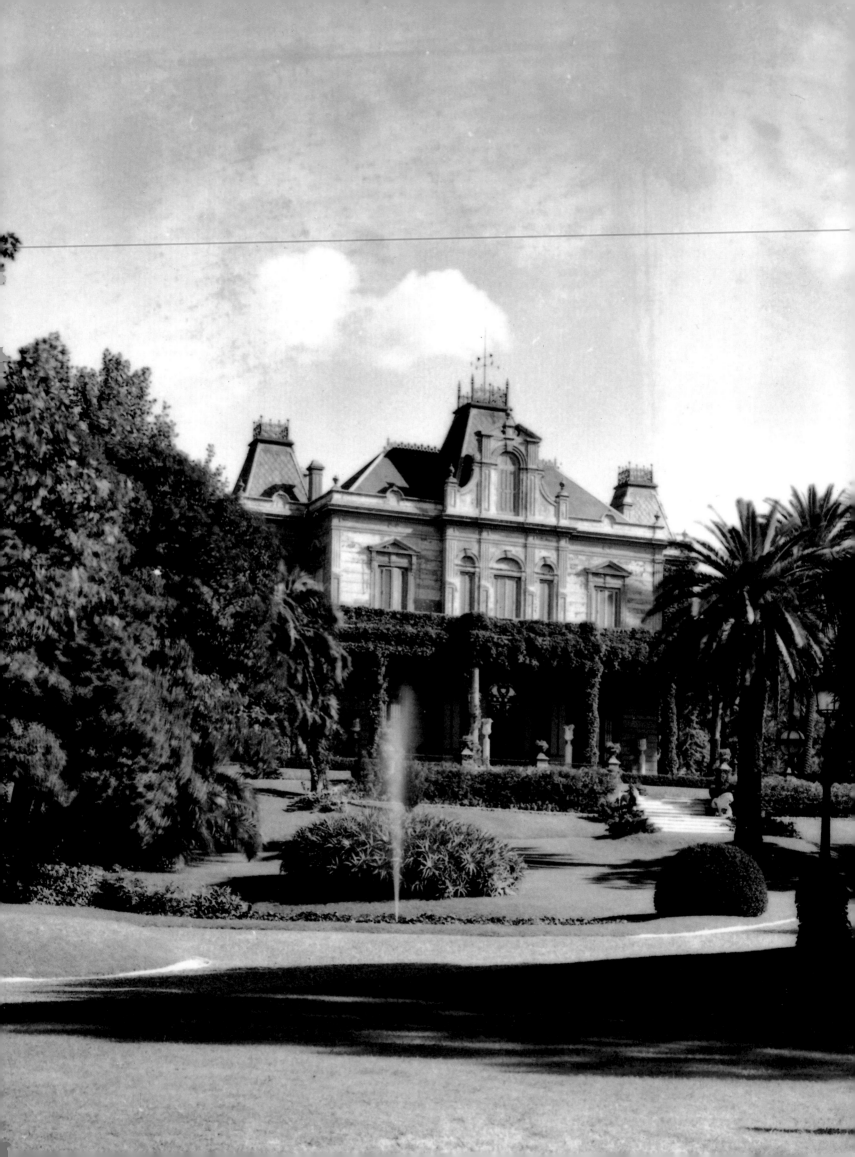

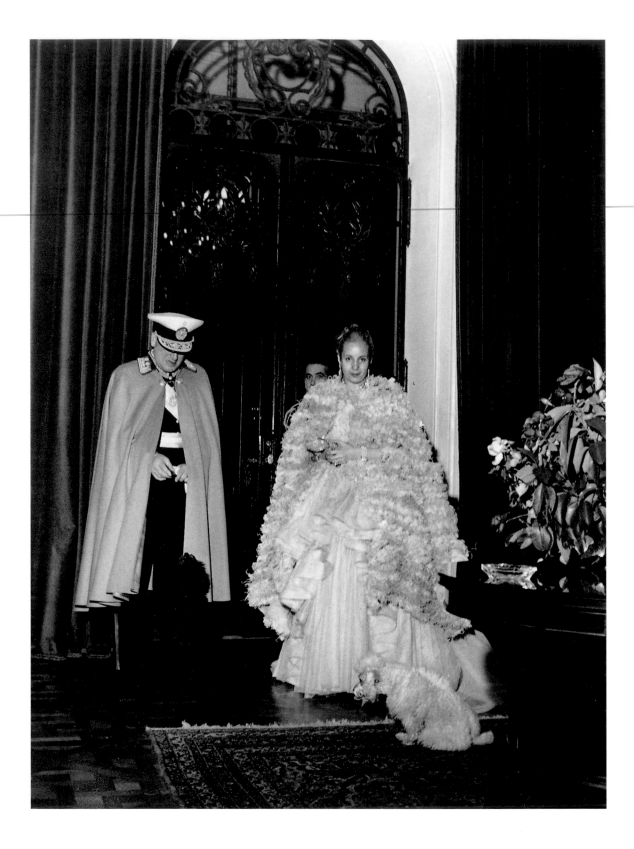

The President and First Lady prepare to leave the Presidential Residence for an evening at the Teatro Colón opera house in July 1950.

In July 1950, Evita agreed to pose for a series of informal photographs in the Presidential Residence taken by the acclaimed German photographer Gisèle Freund. According to popular accounts Evita later decided that she did not want the photographs made public and ordered Freund's negatives destroyed, but the prints were hidden and saved.

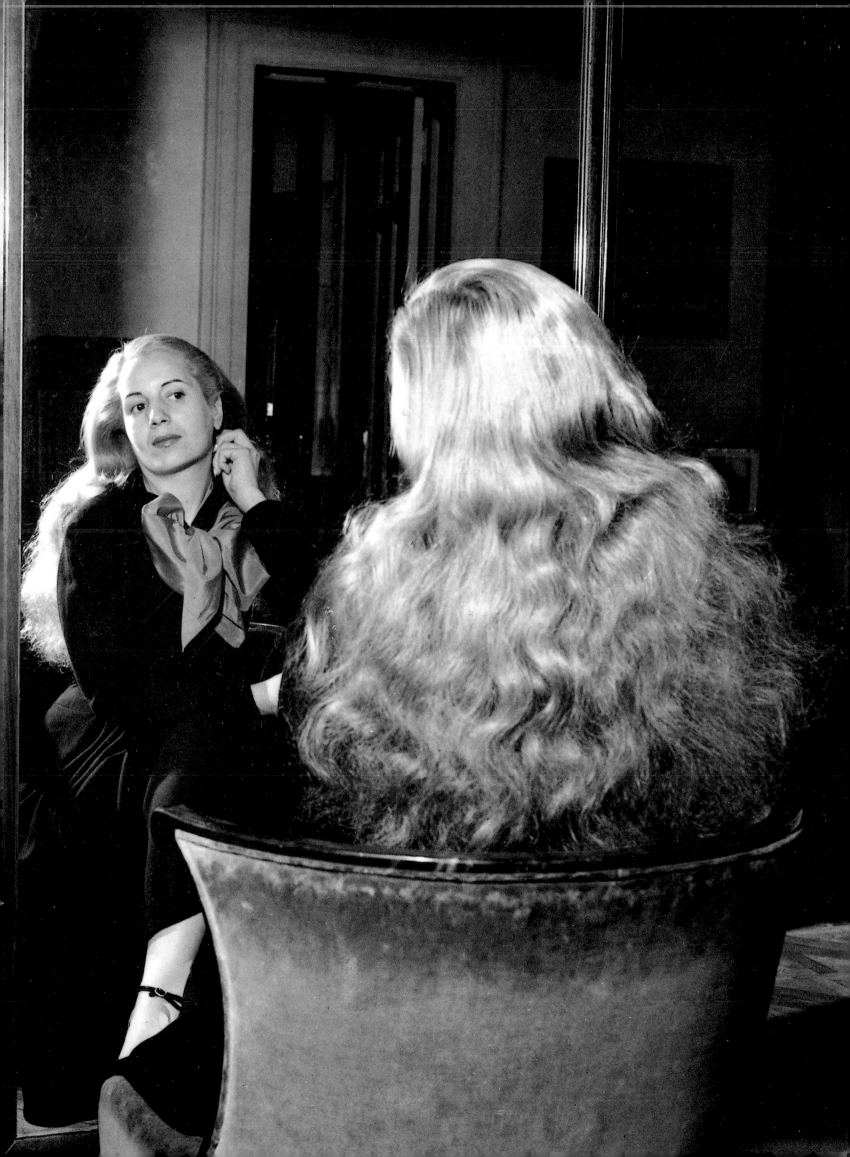

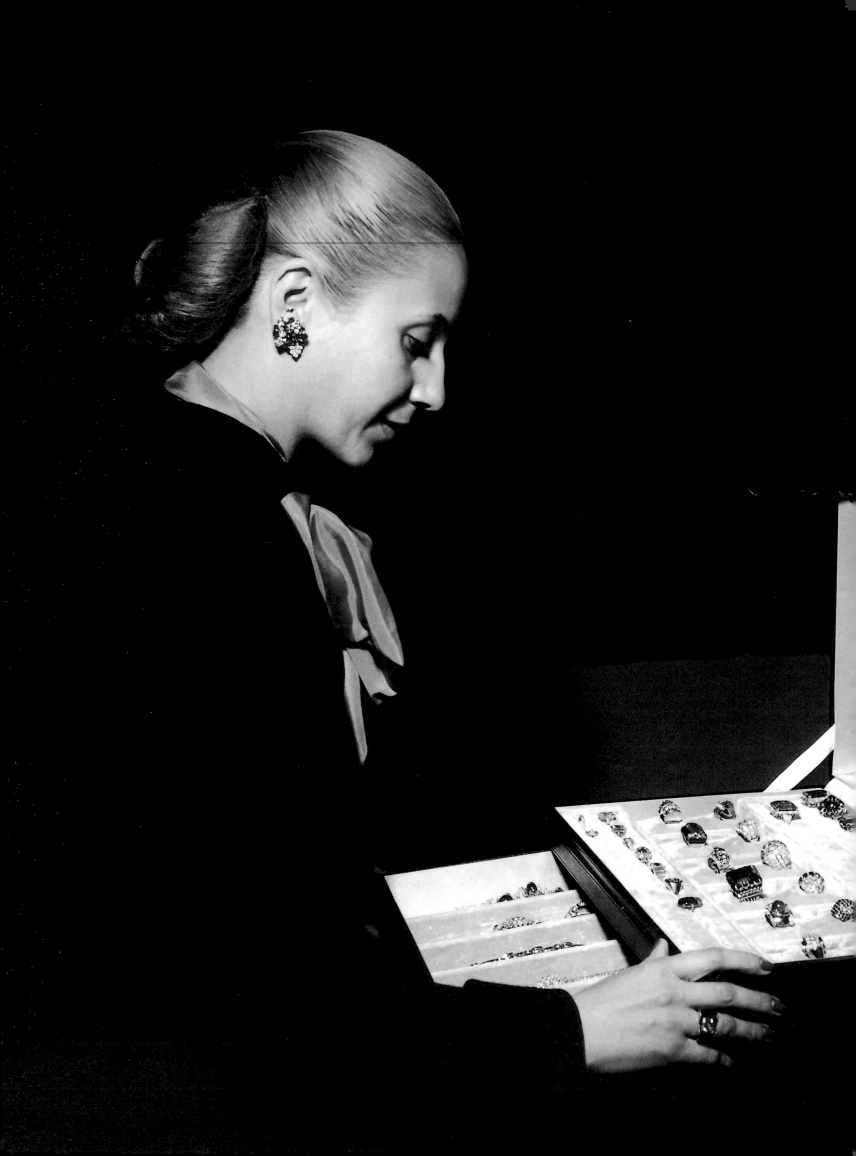

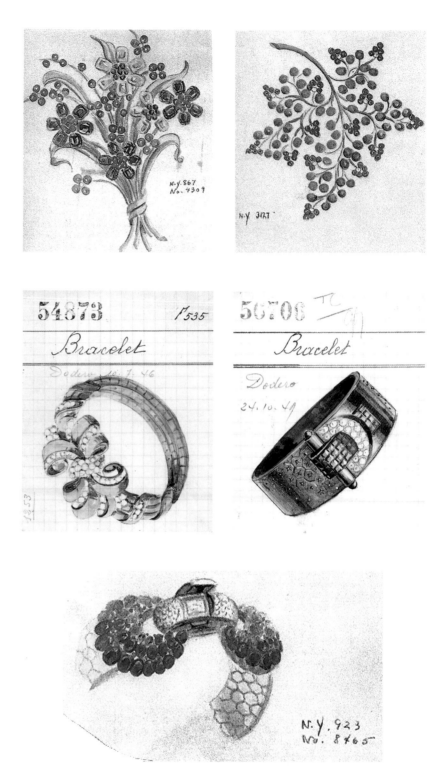

ABOVE *These sketches from Van Cleef & Arpels show jewelry designs for Evita ordered by shipping magnate Alberto Dodero.*

FACING PAGE *Evita loved jewelry and had an extensive collection of rings. During the day she usually wore a single Peronist medallion of precious stone.*

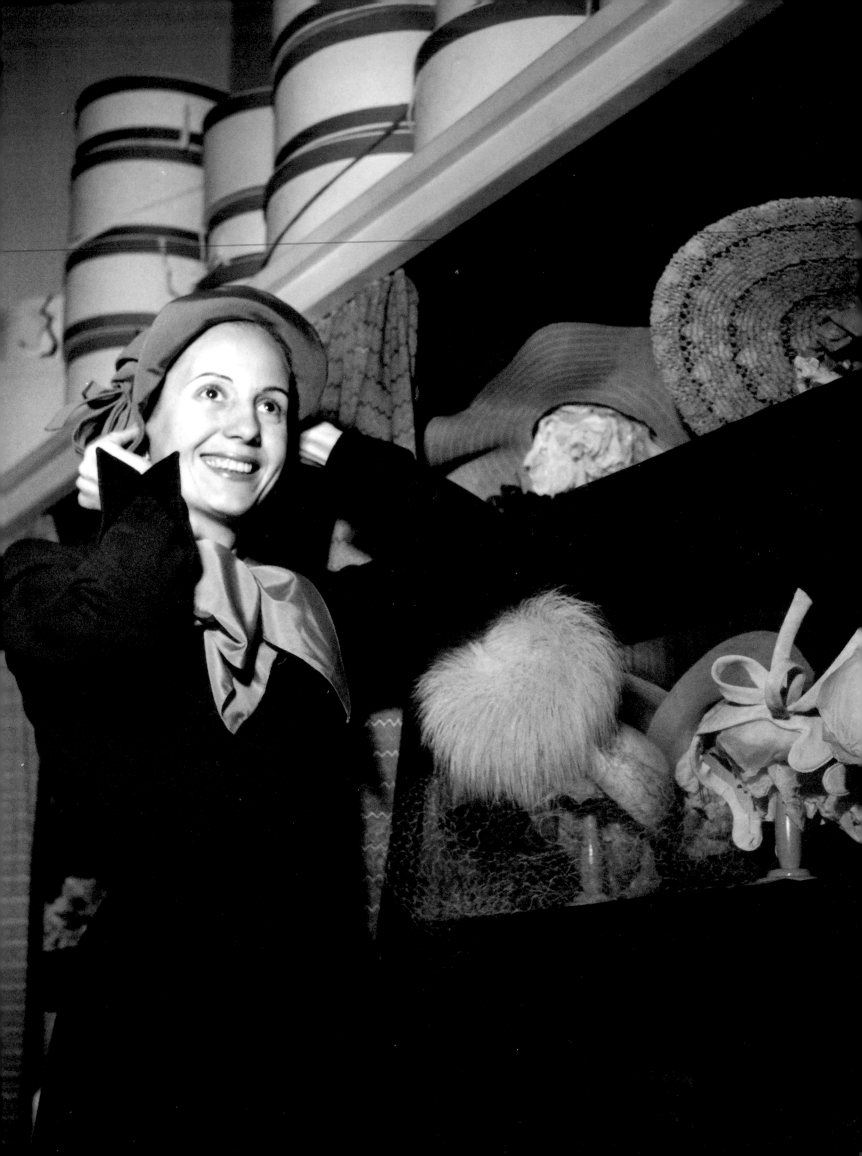

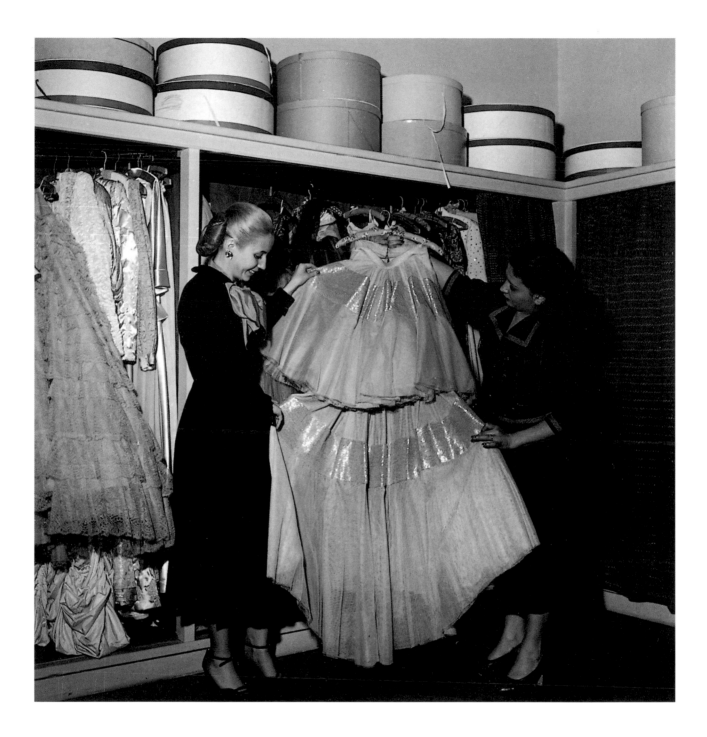

ABOVE AND FACING PAGE

*The First Lady models a hat in one of her spacious closets and shows off her extensive
collection of evening gowns. Following the Liberating Revolution of 1955, opposition leaders
invaded the Presidential Residence and put Evita's wardrobe and jewelry on display, with
signs declaring them symbols of Peronist decadence.*

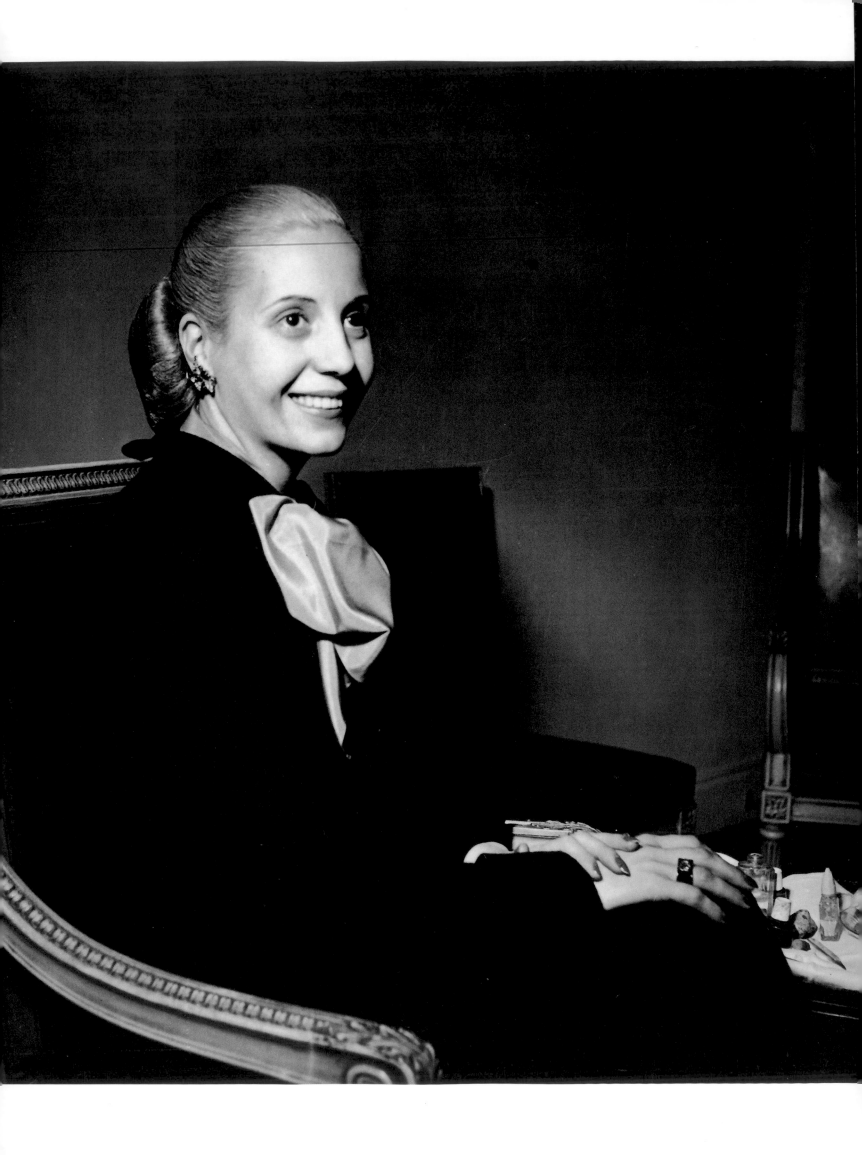

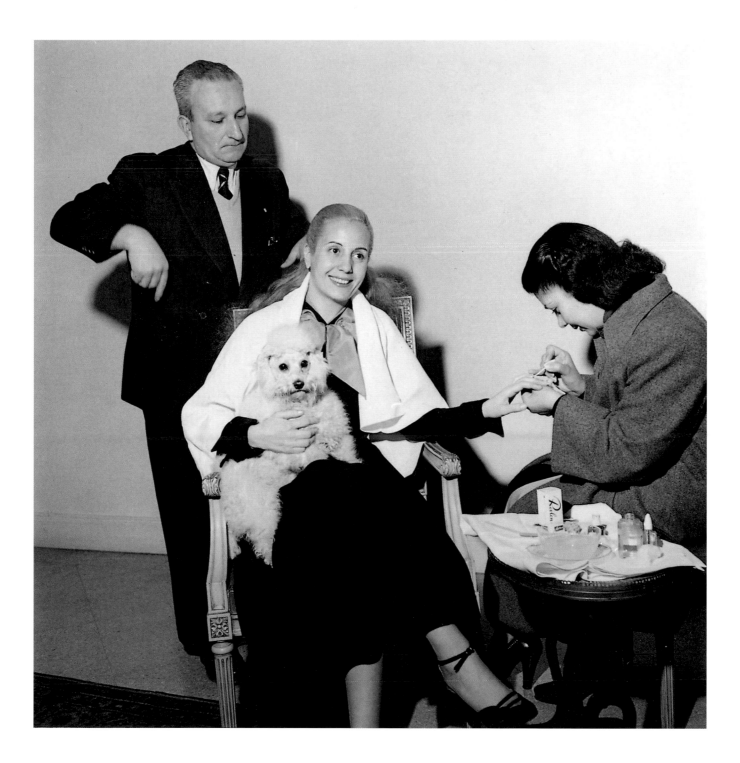

ABOVE AND FACING PAGE:
Two photographs from the Freund series: Attended by her hairdresser, Julio Alcaráz, her manicurist, Sarita Gatti, and her poodle Canela, Evita prepares for her workday; freshly manicured and simply dressed, Evita sits for a portrait before leaving for work.

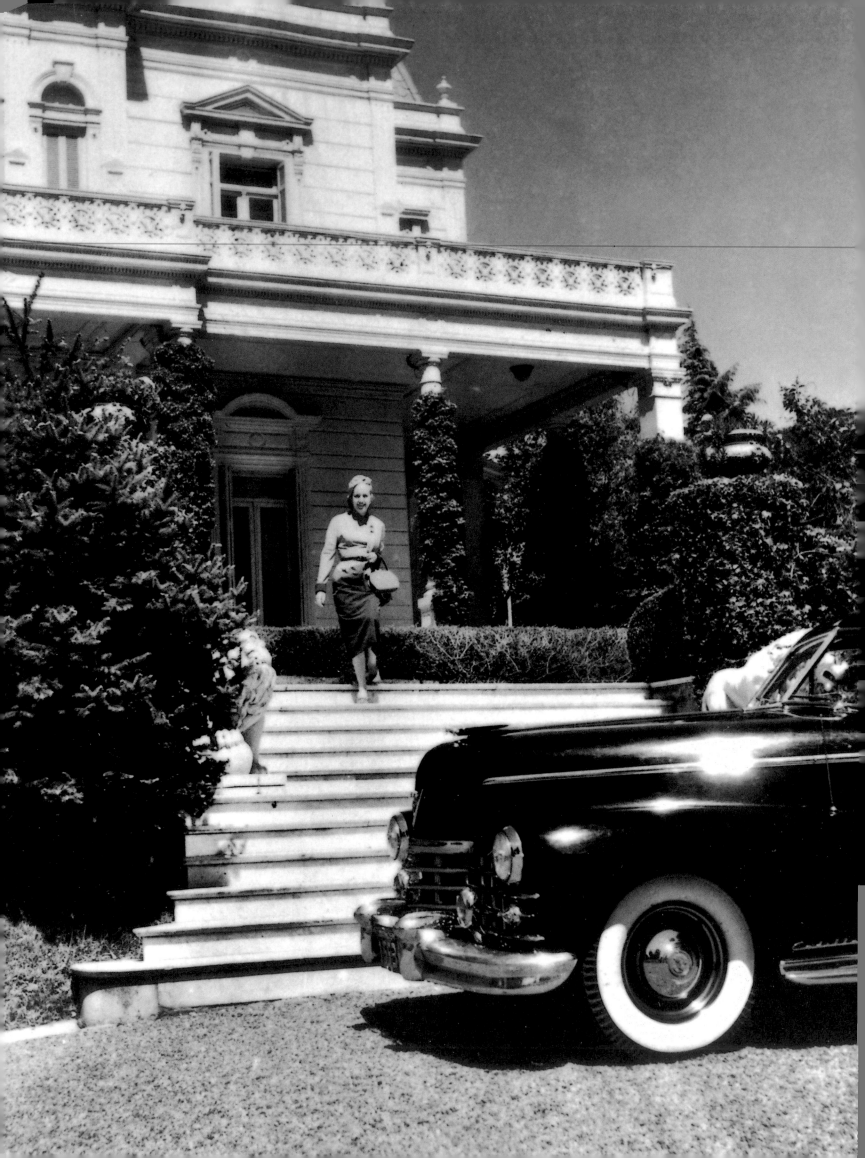

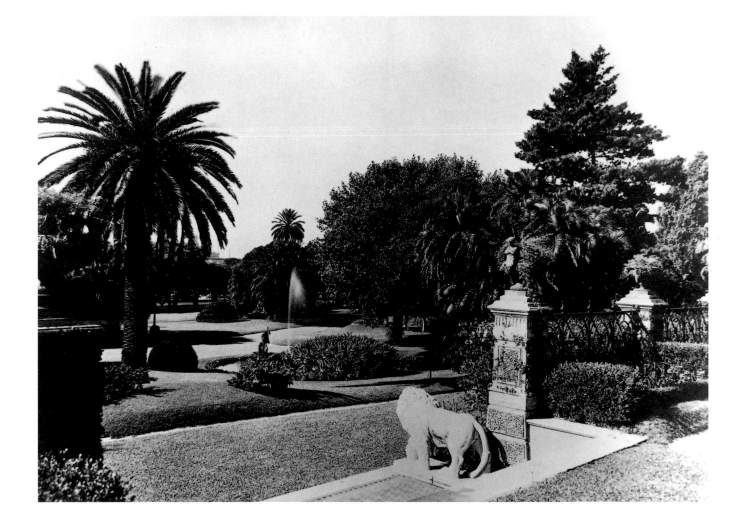

The magnificent grounds of the official Presidential Residence in Buenos Aires extend from the palace entrance to the elegant Avenida Alvear.

Evita descends the front steps of the Presidential Residence, where her car and driver are waiting to take her downtown to the Ministry of Labor. On a typical day she rose early, ate a light breakfast, and attended to urgent matters at the Residence before leaving for her office.

133

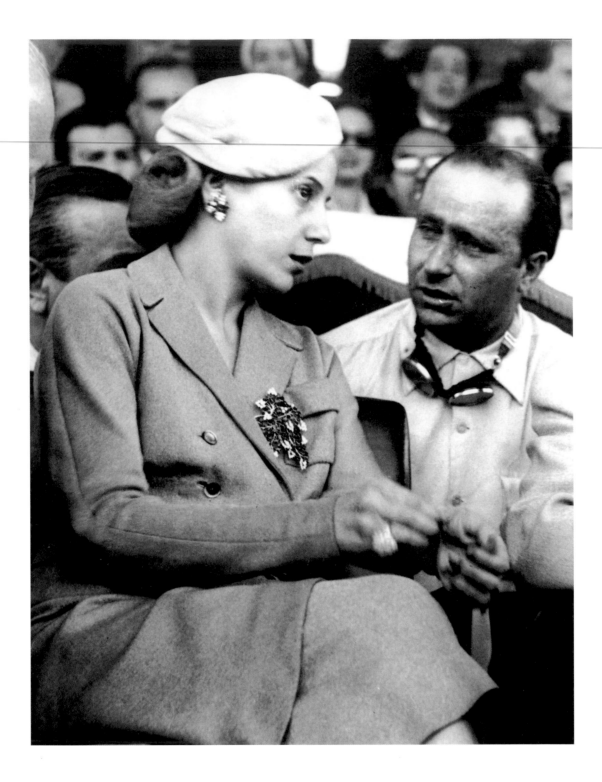

At an automobile race in 1951, the First Lady confers with Juan Manuel Fangio, five-time Formula One champion. At times Evita seemed ubiquitous; no occasion was too trivial for her presence.

During his visit to Argentina in April 1951, Prince Bernhard of the Netherlands films a performance of traditional Argentine dance at a dinner given in his honor. The prince decorated Evita with the Cross of the Order of Orange Nassau on behalf of his wife, Queen Juliana.

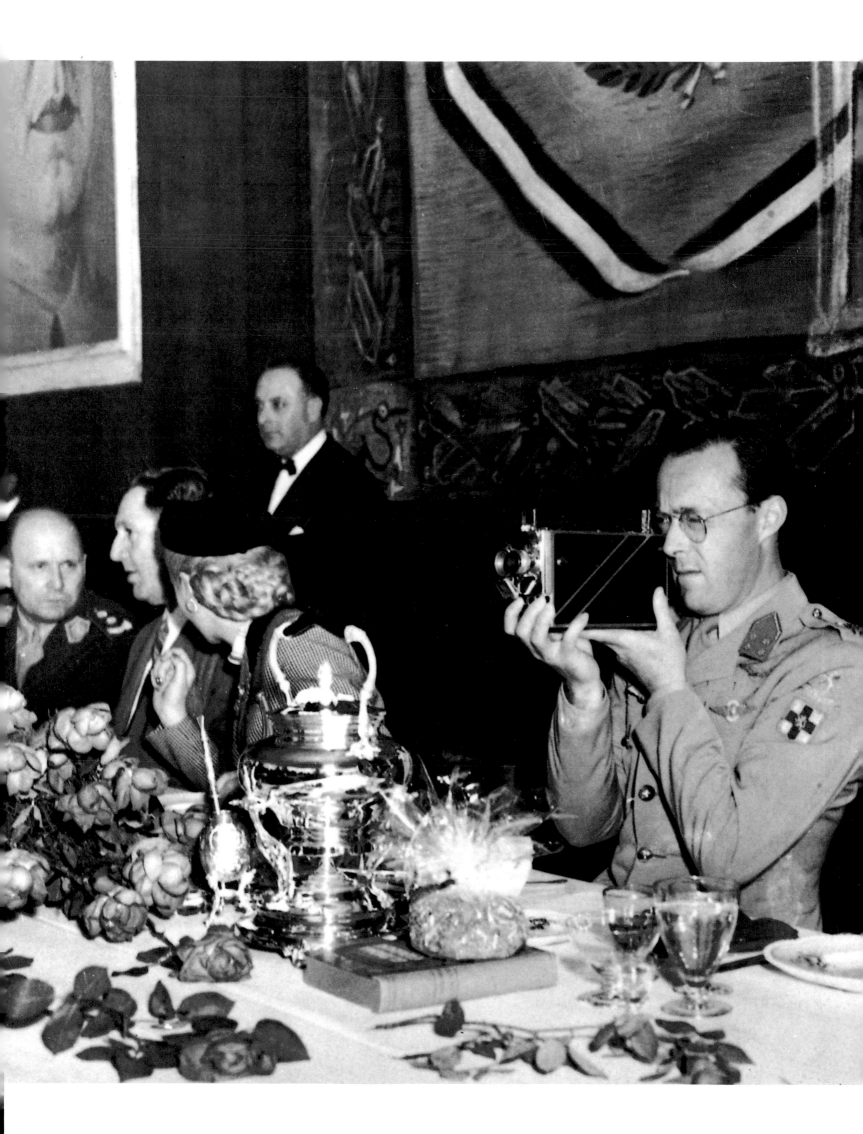

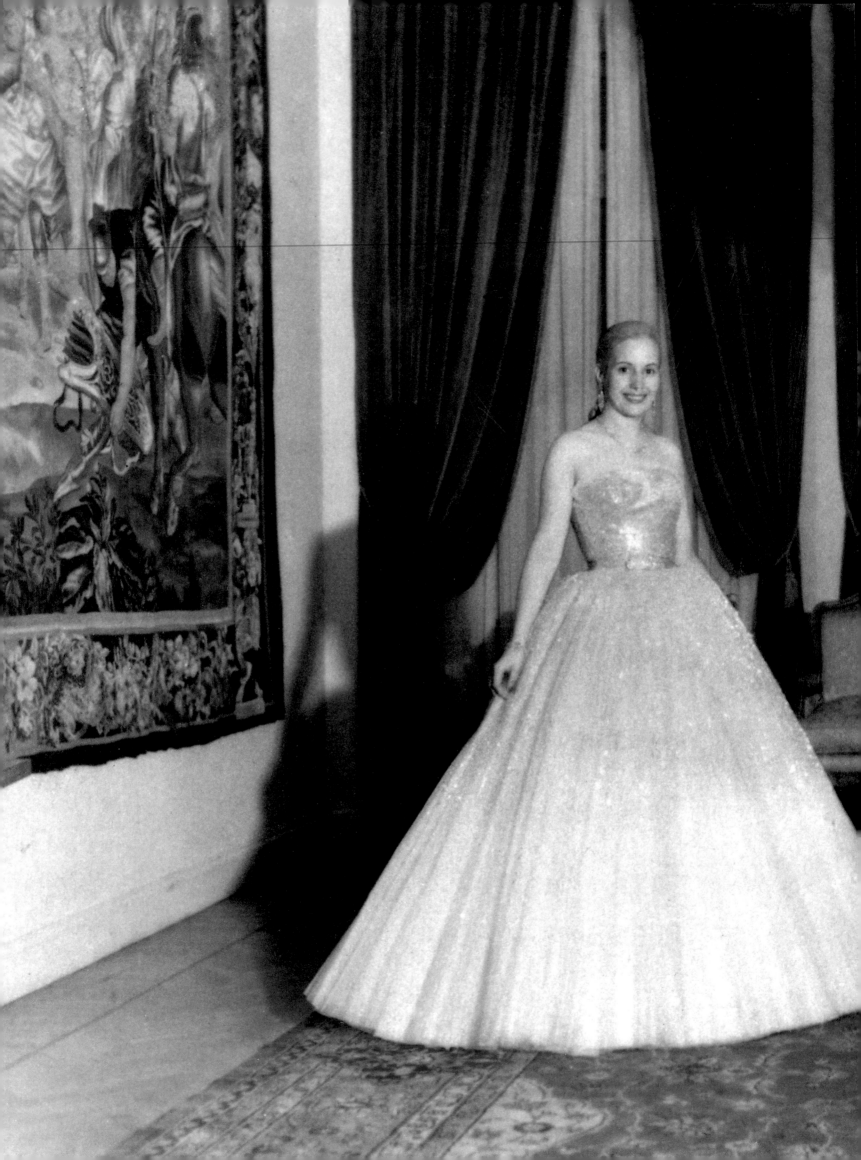

LEFT *Evita poses in a Christian Dior gown in the Presidential Residence before attending a gala reception to celebrate Argentine Independence Day on July 9, 1951.*

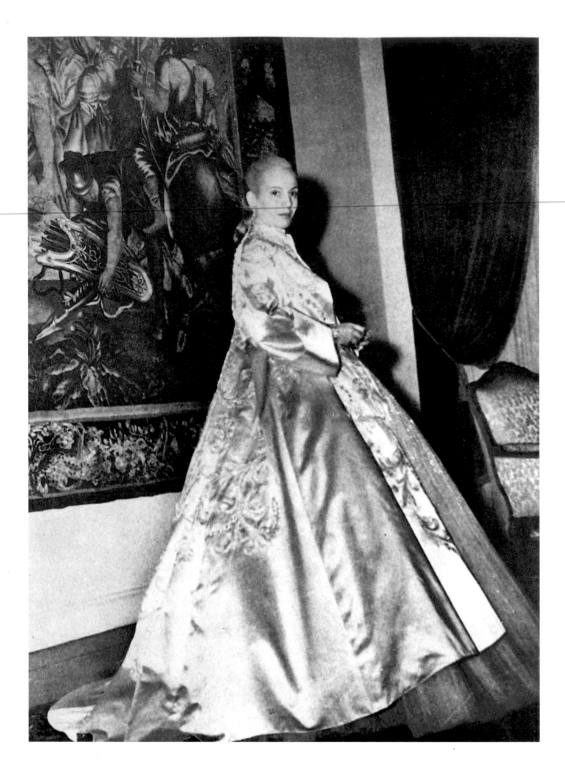

ABOVE
In another photograph taken on Argentine Independence Day in 1951, Evita displays the
luxurious Dior cape she wore to the celebratory ball in the Teatro Colón.

FACING PAGE
In her private box at the Teatro Colón, Evita always sat next to Georgina Acevedo de
Cámpora, wife of the President of the Chamber of Deputies.

138

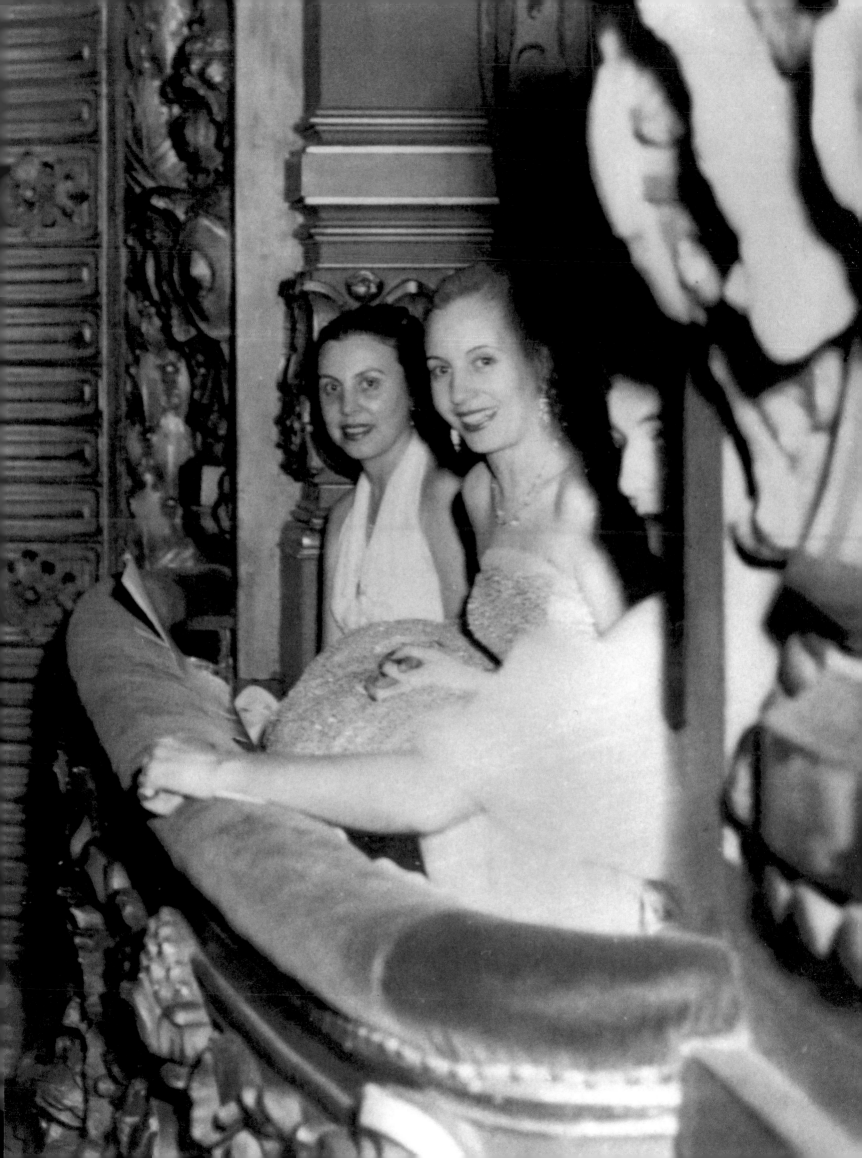

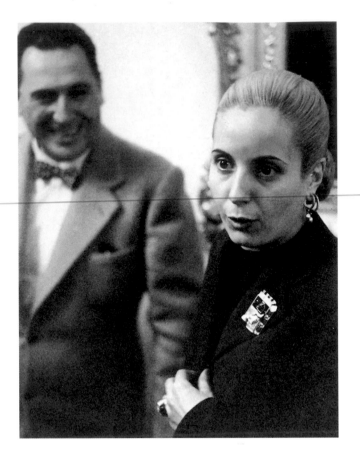

ABOVE *By July 1951, Evita's power and influence were soaring, and support for the First Lady as a vice-presidential candidate in the 1952 elections was widespread. This suggestion greatly disturbed the military, which would never accept a woman in this position, especially since, in the event of Perón's death, Evita would become not only President but Chief Commander of the Armed Forces. During this period she was rarely photographed without the Peronist medallion displayed prominently on her lapel.*

RIGHT *Evita and Perón, to her right, at a boxing match in Luna Park stadium. Evita never missed a match featuring her friend Gatica. At far right is her brother, Juan Duarte, whom Perón had appointed Private Presidential Secretary.*

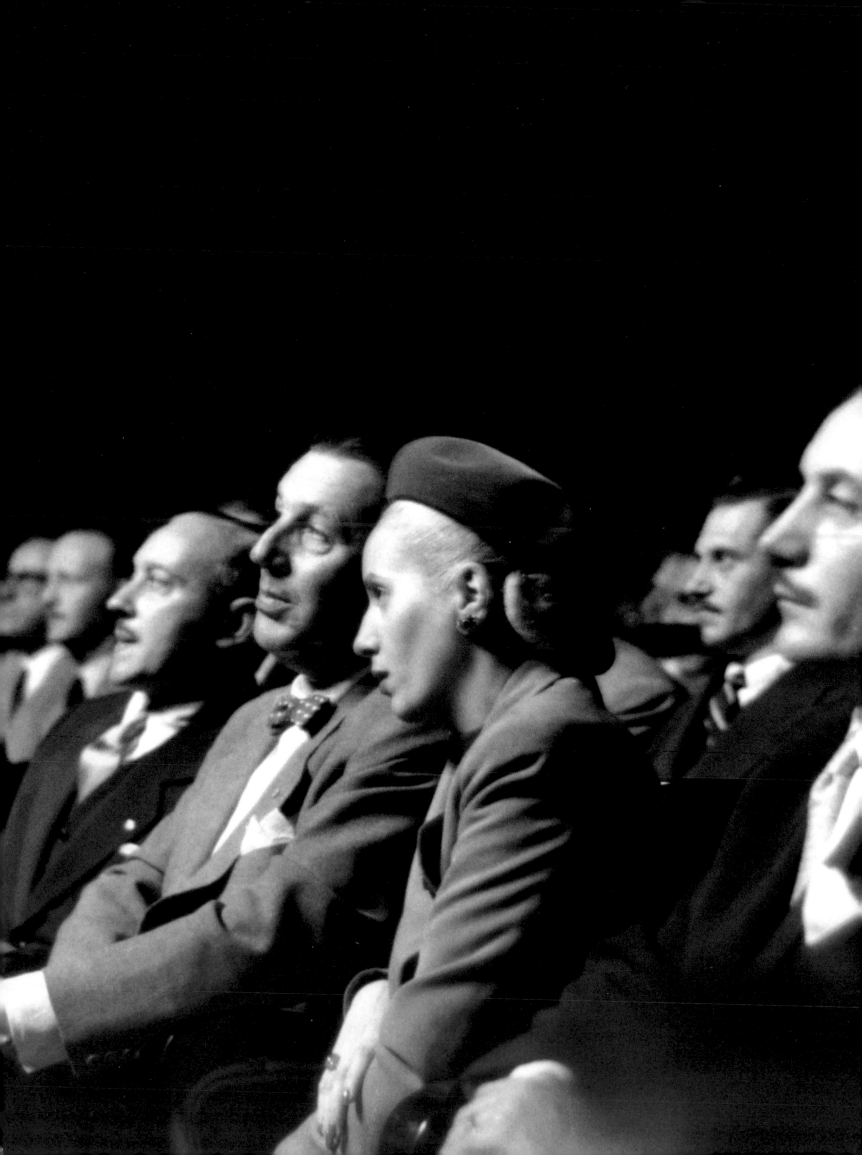

The Final Months

On August 22, 1951, Evita addressed a crowd of more than a million at the Cabildo Abierto del Justicialismo, a major labor party rally in downtown Buenos Aires. Popular support for her vice-presidential candidacy was at its height, but military leaders were adamantly opposed. When Evita tried to refuse the nomination, the chanting crowd demanded her acceptance and would not let her leave the stage. A few days later, in a radio broadcast, she announced her final decision, explaining, "I am renouncing the honor, but not the fight."

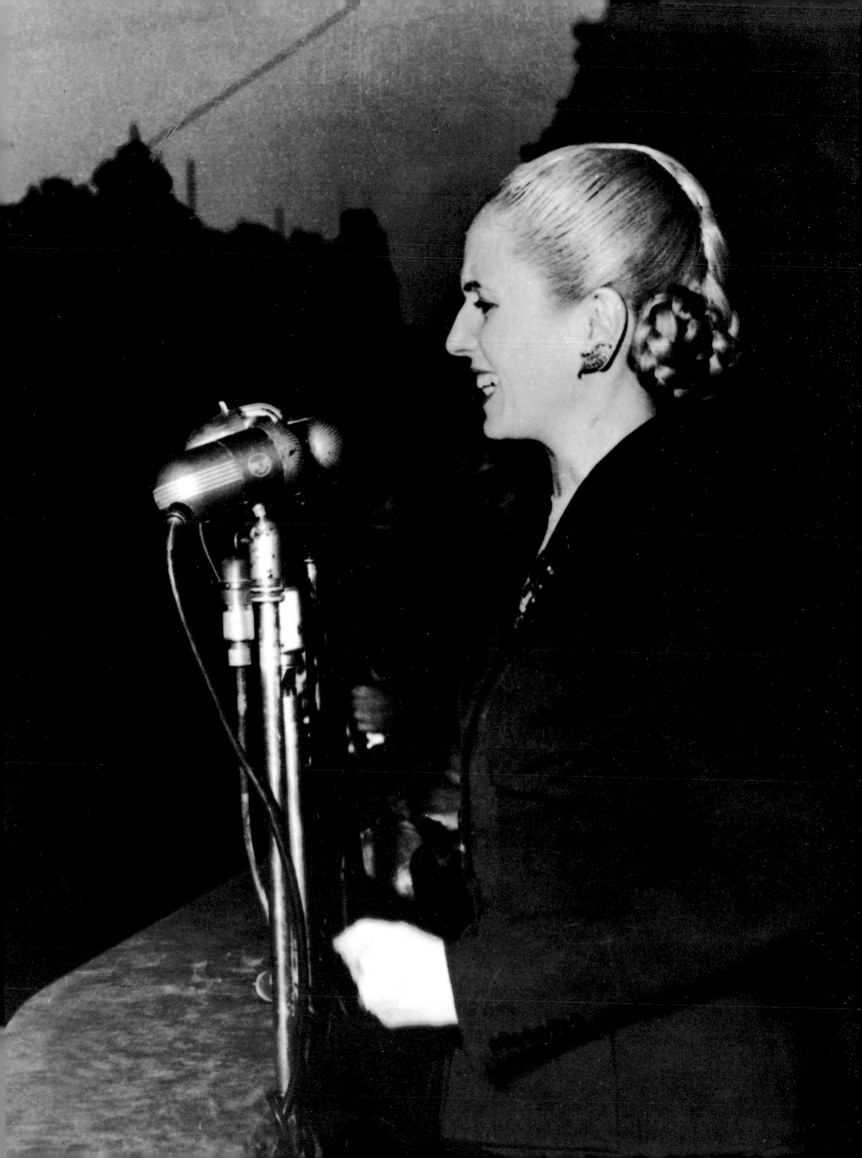

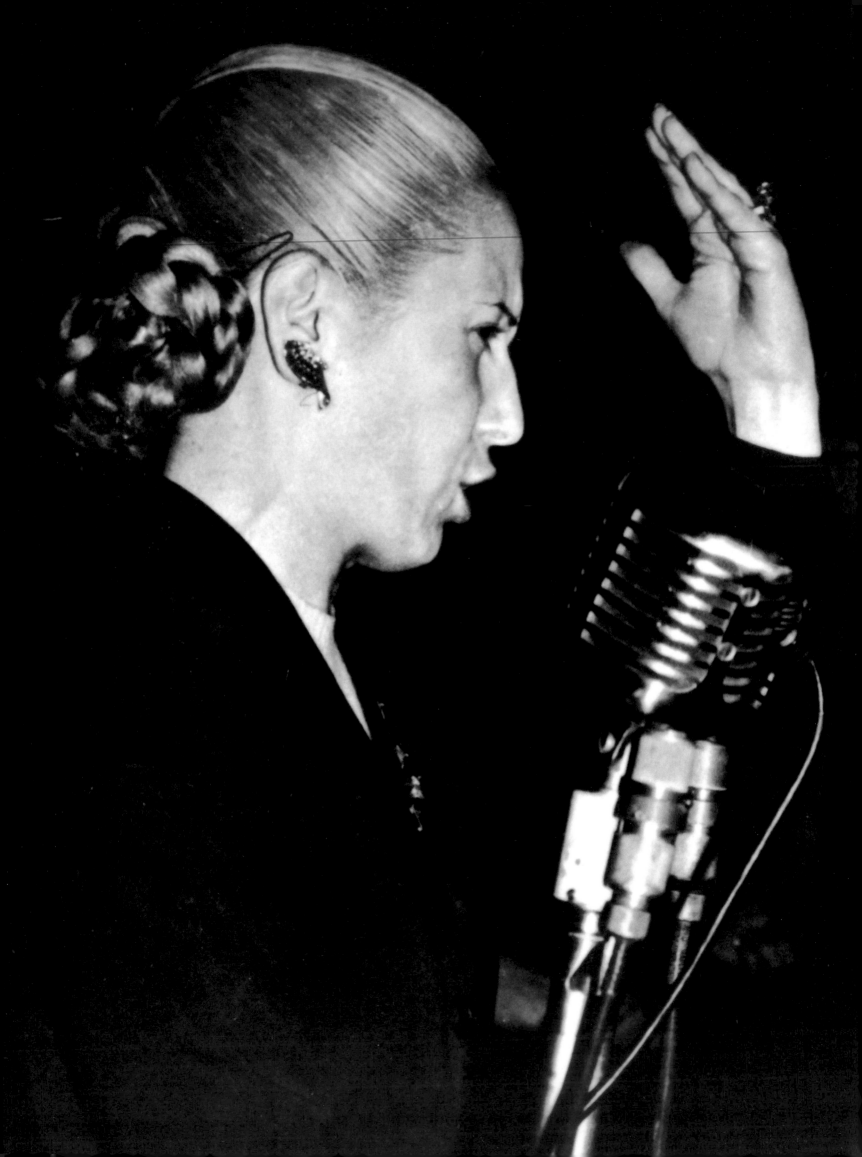

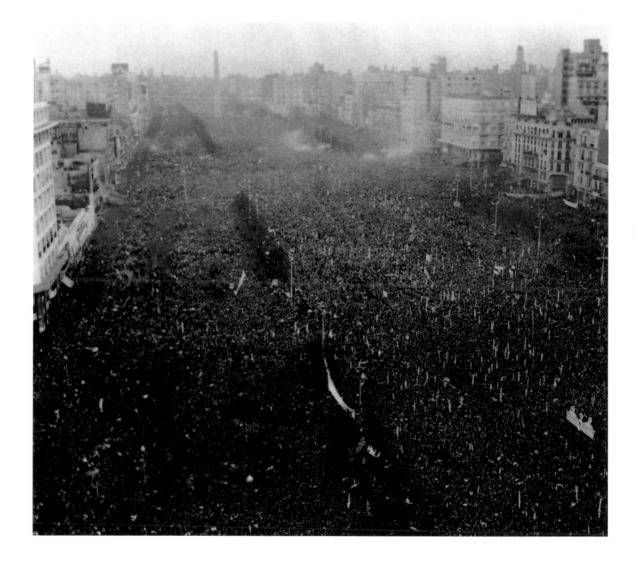

*As night fell on the Avenida 9 de Julio, thousands of improvised torches and candles
illuminated the scene. Never in history had a female political figure drawn so
many supporters—by some estimates, two million people.*

*In an impromptu speech Evita harshly criticized the oligarchy, and even Juan Perón
was surprised by her powerful words. "My General," she said at one point, "here today, as
they were yesterday, are your vanguard* descamisados. *The oligarchy, the mediocrity, the
traitors of the country have not been overthrown yet, and from their lairs they are
plotting against the people and the nation."*

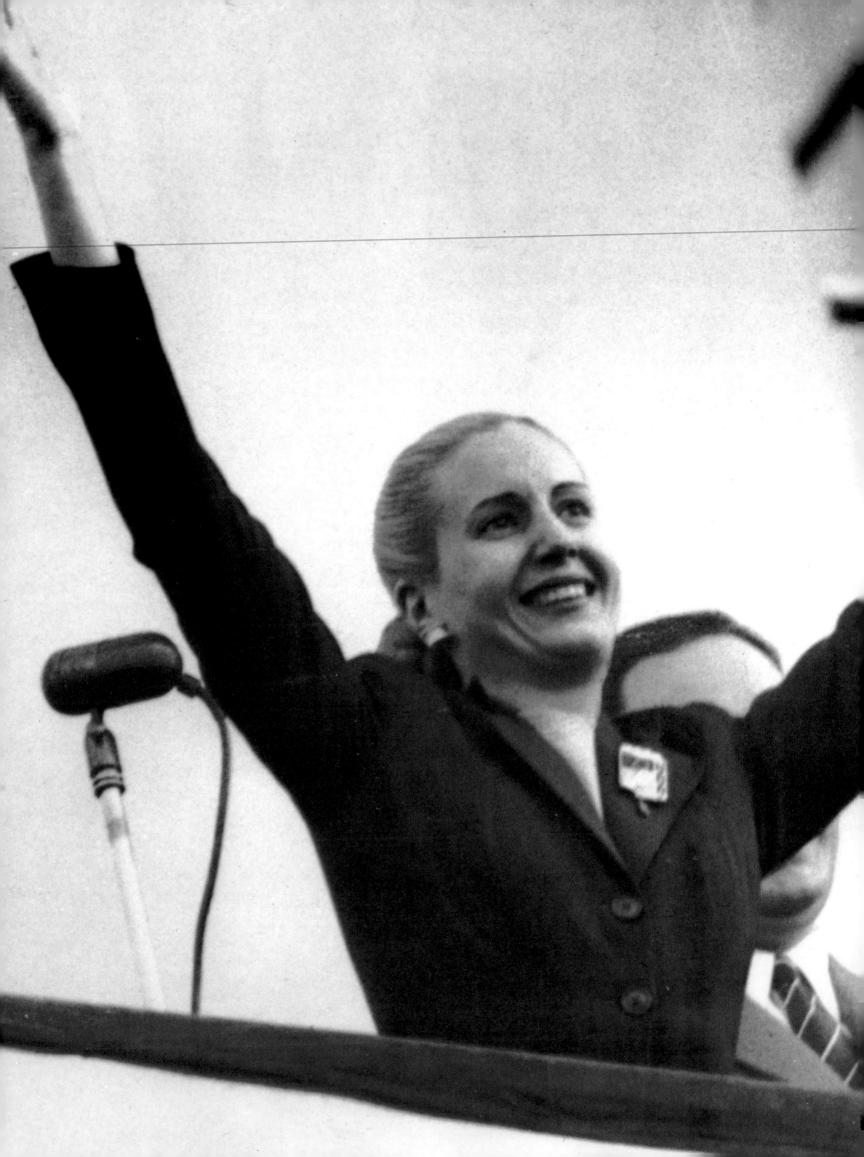

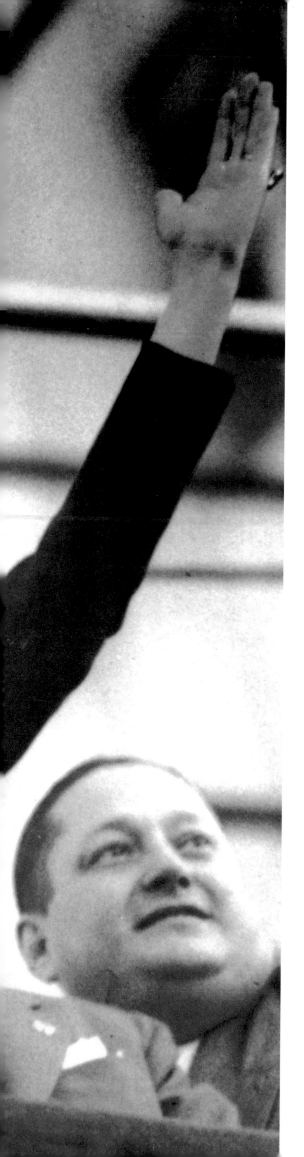

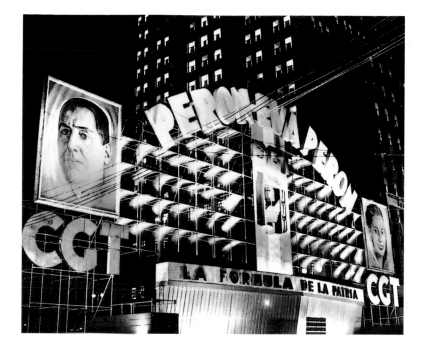

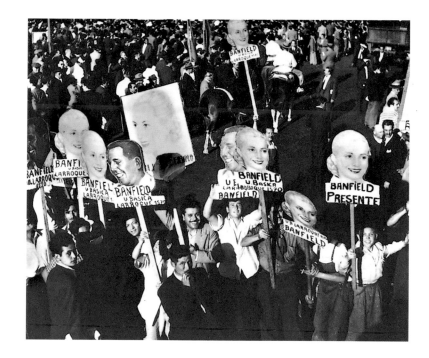

TOP *An enormous stage was erected in front of the Ministry of Public Works in Buenos Aires for the August 22 rally. To accommodate the record crowd, CGT leaders decided to hold the rally on the Avenida 9 de Julio, the world's broadest street, rather than in the Plaza de Mayo.*

ABOVE *A cheering crowd in the Avenida 9 de Julio awaits Evita's appearance. Thousands of workers, senior citizens, women, and children began arriving in the capital the day before and camped out in front of the stage for the best view of the First Lady.*

FACING PAGE *Shortly after 5 o'clock, with the impatient crowd chanting her name, Evita mounted the stage. To her right is an official of the CGT, the national labor confederation that organized the meeting.*

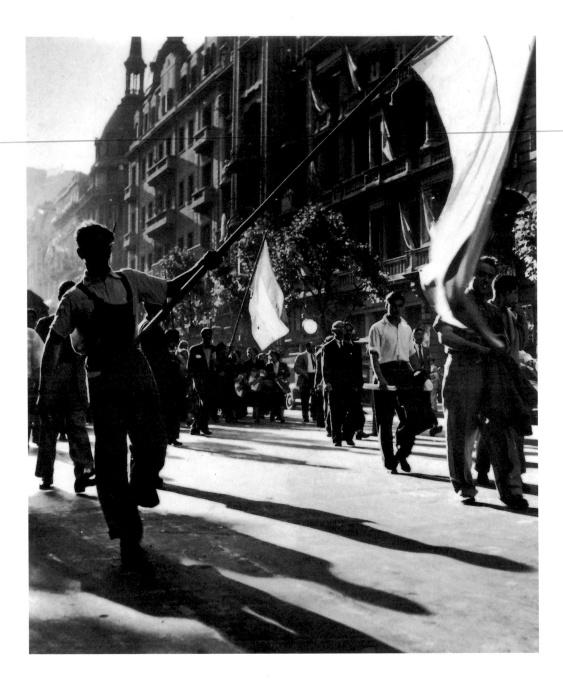

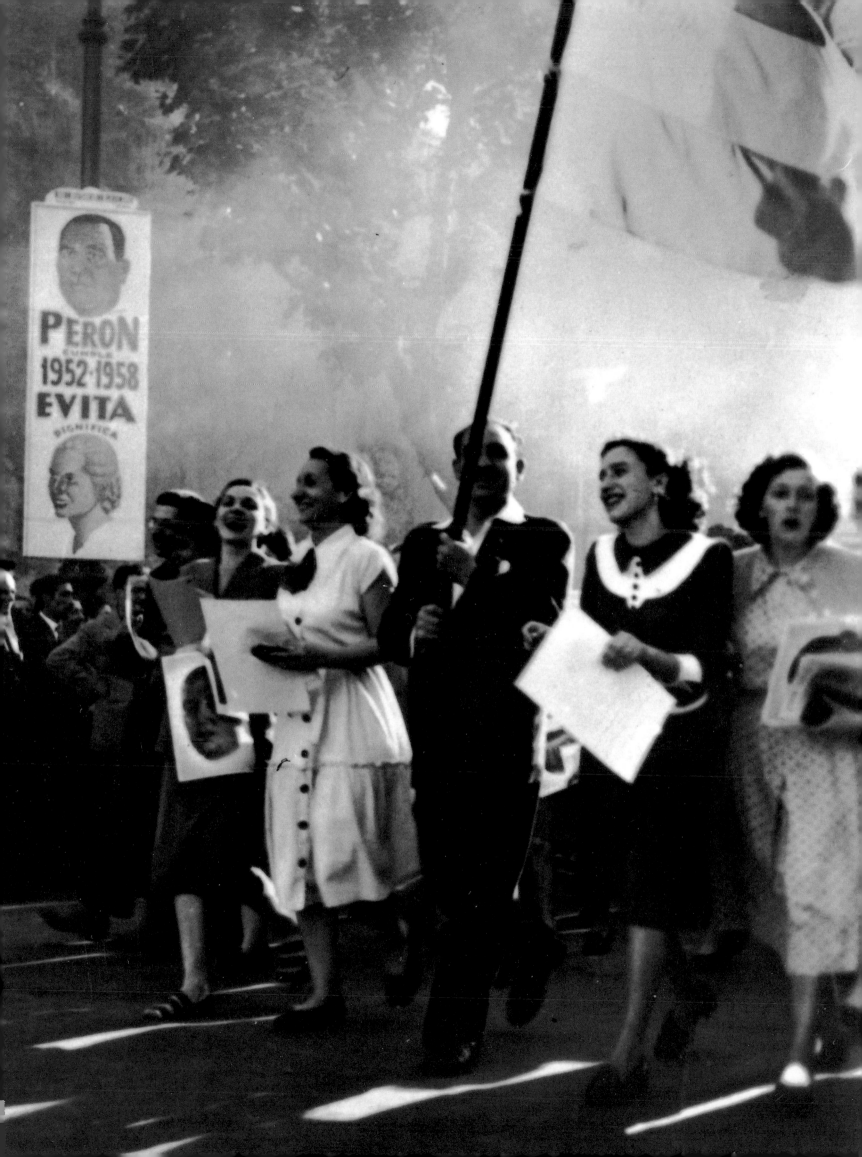

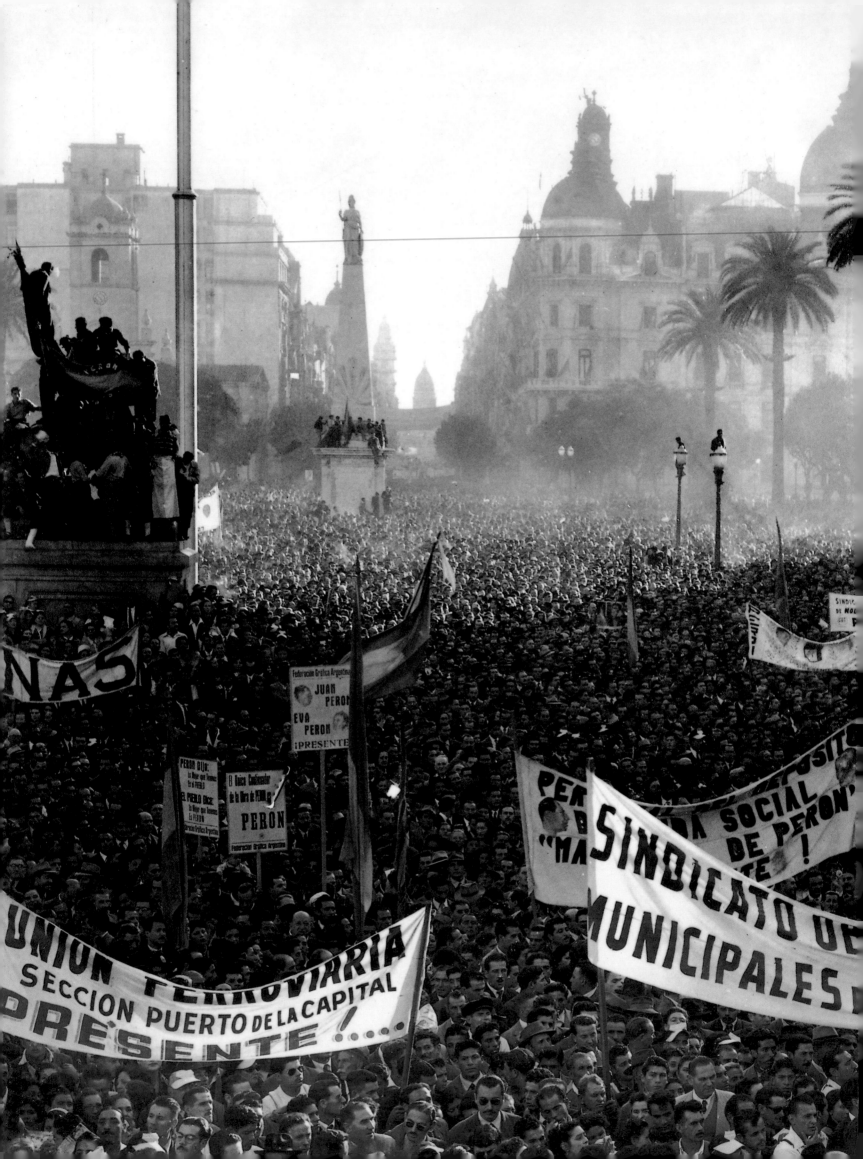

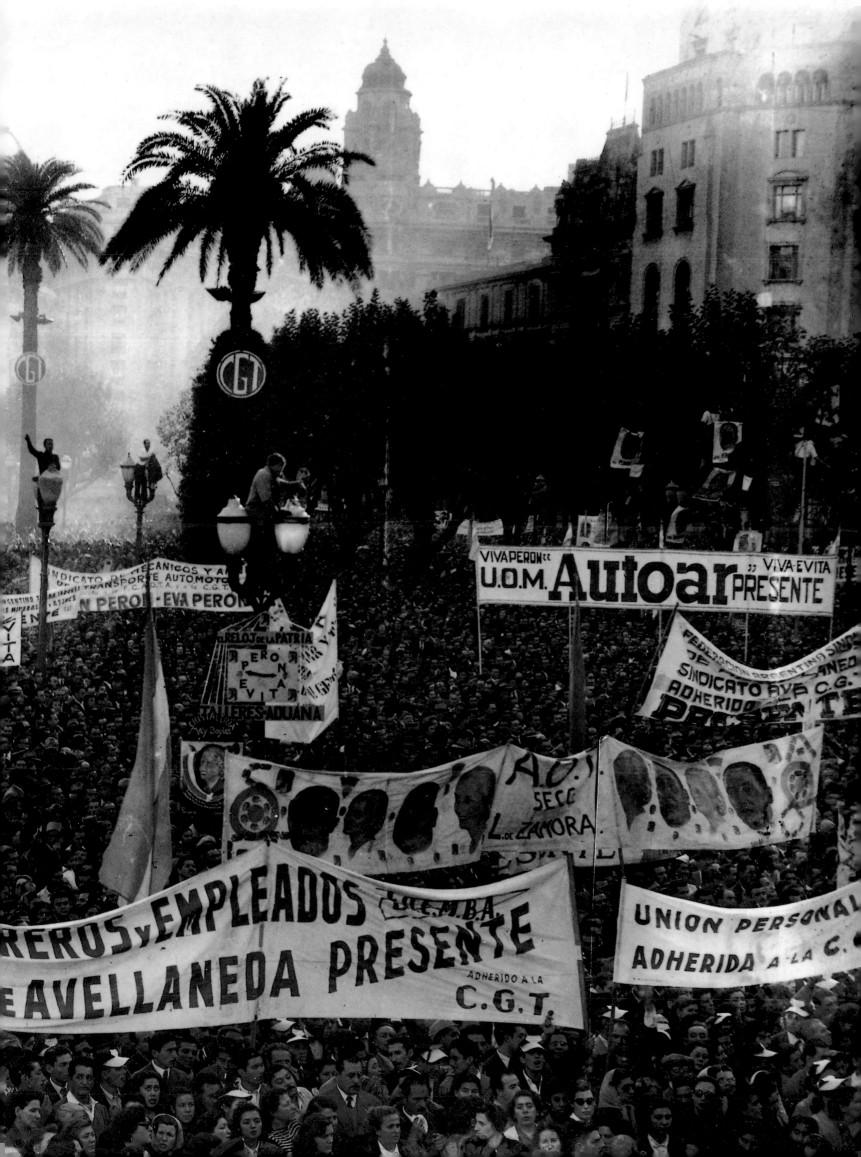

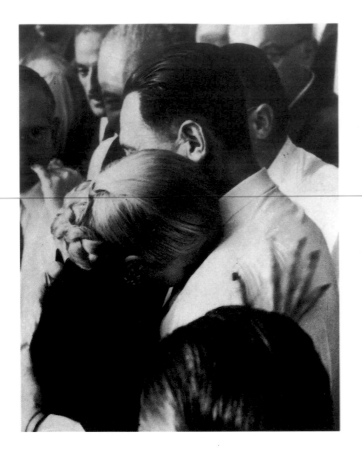

ABOVE *Crying and visibly shaken, Evita slumps into Perón's arms on the balcony of the Casa Rosada on October 17, 1951. She had just been decorated with two Peronist medals of distinction, but advancing cancer had weakened her so severely that she was unable to speak immediately to the crowd.*

RIGHT *Evita offers a parting gesture after giving what would become her most quoted speech. Evita's words were greeted at first with reverential silence, but she soon stirred the crowd:*

"I have but one thing that counts, and it is in my heart; it burns in my soul, it aches in my flesh, and it ignites my nerves: that is my love for you the people and for Perón....I never wanted nor do I now want anything for myself. My glory is and always will be Perón's shield and my people's flag, and although I may leave tatters of my life along the road, I know that you will take up my name and wave it aloft like a victory flag...."

Despite the deliberate tone of sacrifice in her speeches, Evita demanded unconditional loyalty to Peronism:

"I ask you one single thing today, comrades, just one thing: that we swear, all of us, in public, to defend Perón and to fight for him even unto death, and we will shout our pledge for an entire minute so our cries will reach the remotest corner of the world: My life for Perón!"

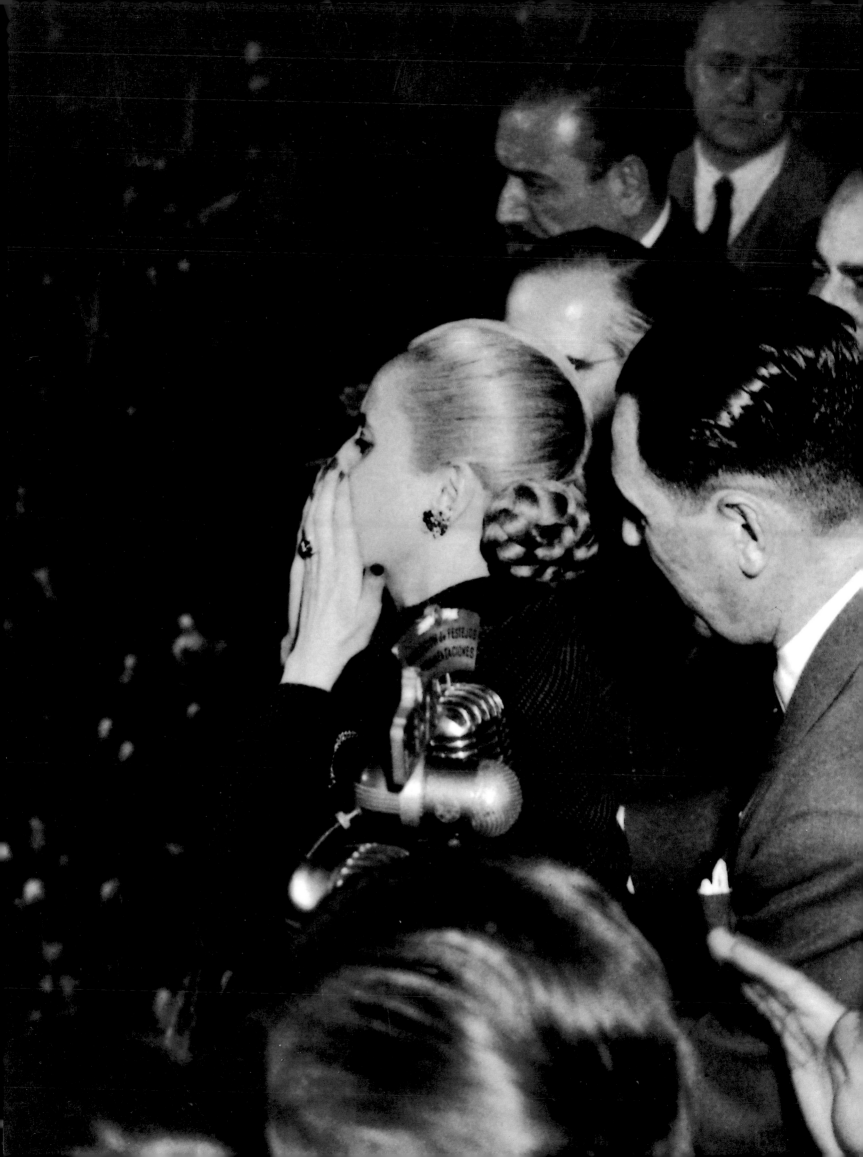

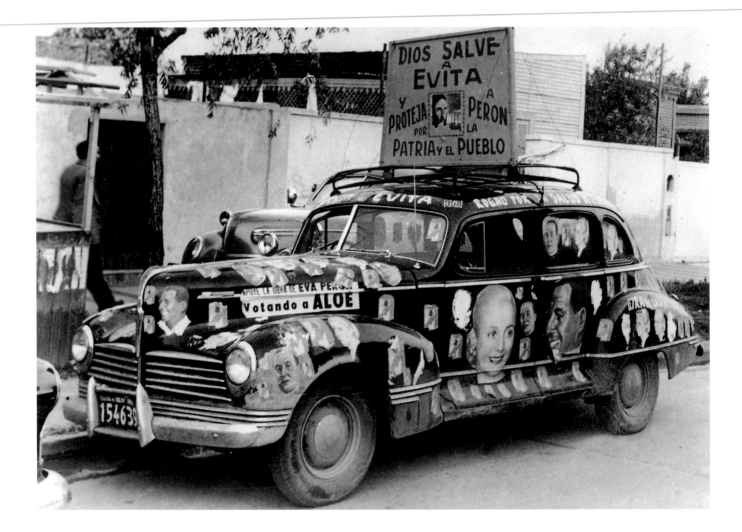

As word of Evita's illness spread, public expressions of sympathy and altars of all kinds began to appear throughout the country. The poster mounted on this car reads "God save Evita and protect Perón for the country and the people."

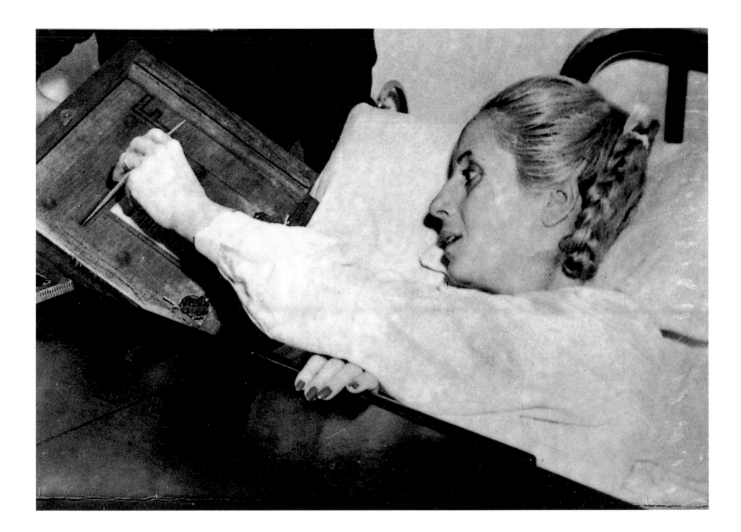

With hundreds of thousands of Argentine women, Evita voted for the first time in her life on November 11, 1951. She was hospitalized in the Policlínico Presidente Perón, a hospital built by the Eva Perón Foundation, following surgery to contain her uterine cancer.

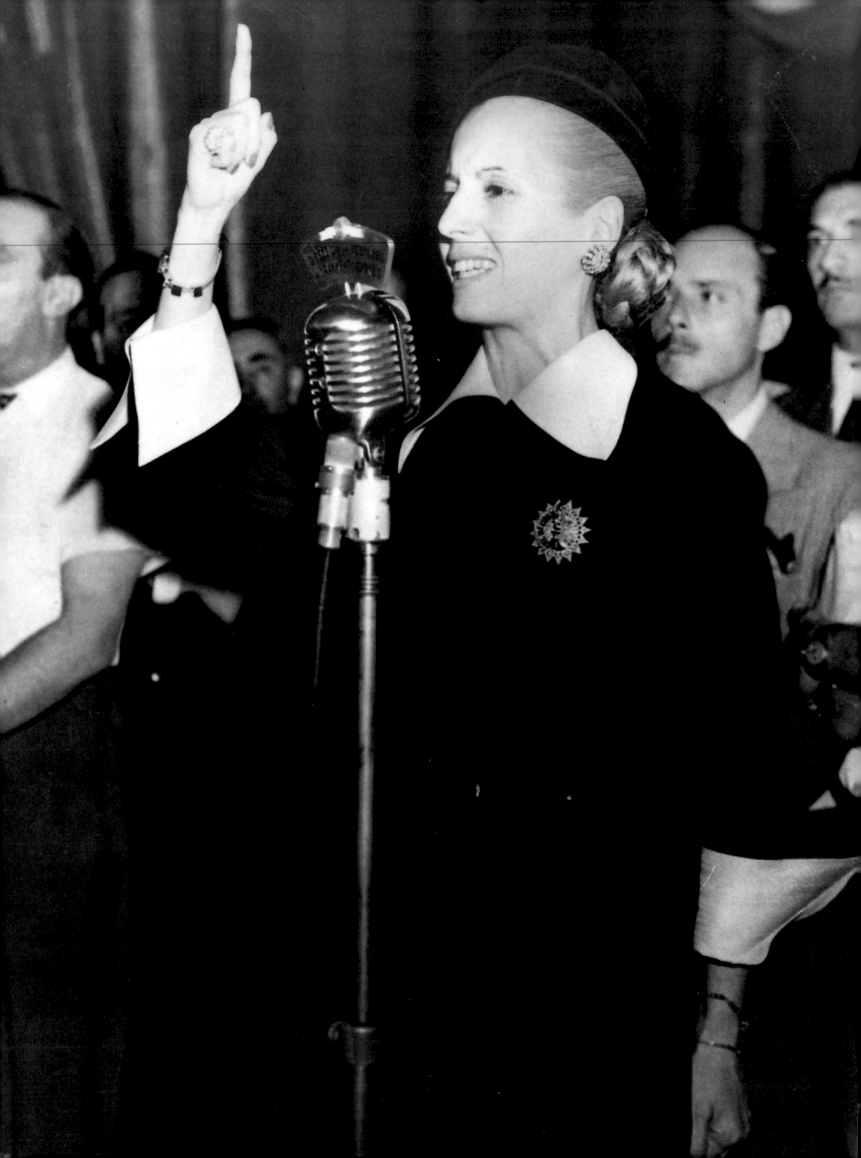

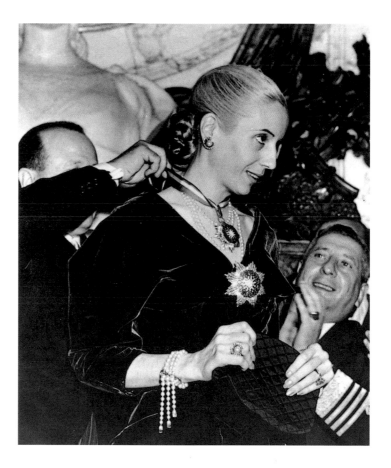

ABOVE *Splendidly dressed and radiant despite her advanced cancer, Evita was decorated with a medal of the Order of the Umayyads, the highest honor bestowed by the Syrian government, on April 17, 1952. By this time Evita was so ill that she was rarely able to leave her bed in the Presidential Residence; her mother and sister remained at her bedside around the clock.*

LEFT *Although her pale, drawn face spoke of illness and pain, Evita was determined to follow through with her public appearances, such as this speech to rural workers assembled at the Teatro Enrique Santos Discépolo in Buenos Aires in March 1952.*

RIGHT *Against her doctor's orders, Evita insisted on speaking to the massive Labor Day crowd assembled in front of the governmental palace on May 1, 1952. Her frail body—she weighed merely 77 pounds by this time—and hollow cheeks contrasted with the violent, almost surreal words of her speech:*

"My dear descamisados*…The working people, the humble people of this nation, are those who, here and throughout the country, are on their feet ready to follow Perón, the Leader of the people and the Leader of humanity, because he has raised the banner of redemption and justice for the masses of laborers who will follow him to defy the oppression of traitors here and abroad; those who, like vipers in the dark of night, wish to leave their venom in Perón's heart and soul, the heart and soul of the people of this country. But they will not know such success, just as the toad cannot silence the songbird, nor vipers hinder the condor's flight….*

"I beg God not to allow these lunatics to raise a hand against Perón, because woe be that day!…That day, my general, I will go with the working people, I will go with the women of this country, I will go with the descamisados *of our nation, dead or alive, to make sure that the only bricks left standing are Perónist. Because we will never allow ourselves to be crushed by the boot of the oligarchical traitors who have exploited the working class; because we will never allow ourselves to be exploited by those who, having sold out for four cents, are slaves to their masters from foreign metropolises and who would turn in their country's people as calmly as they did their country and their consciences…."*

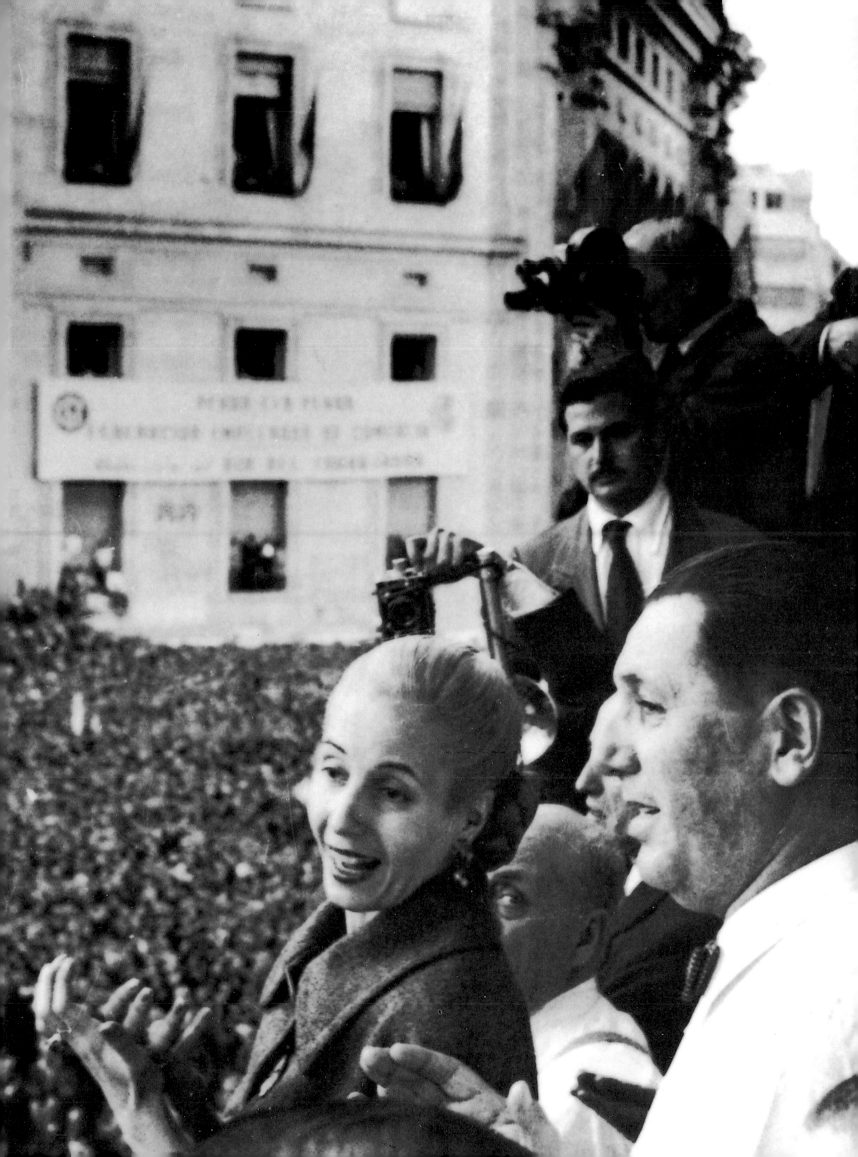

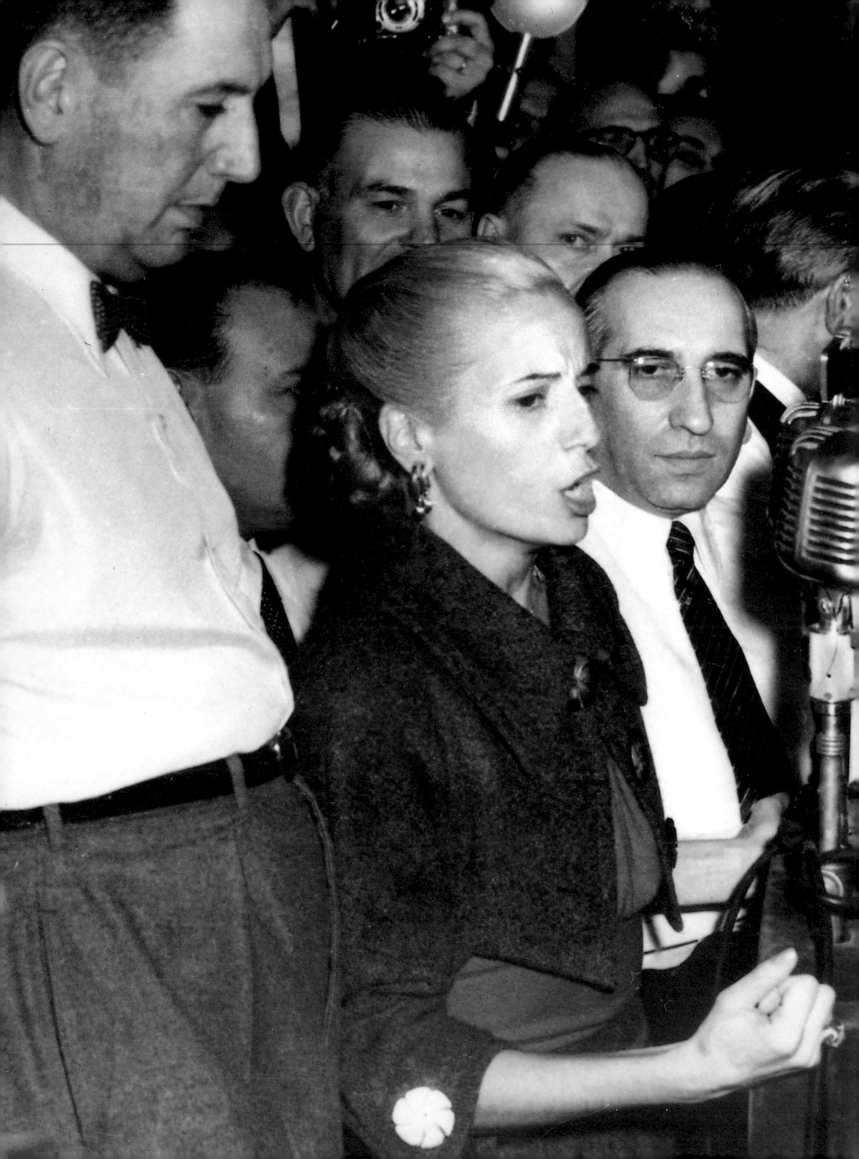

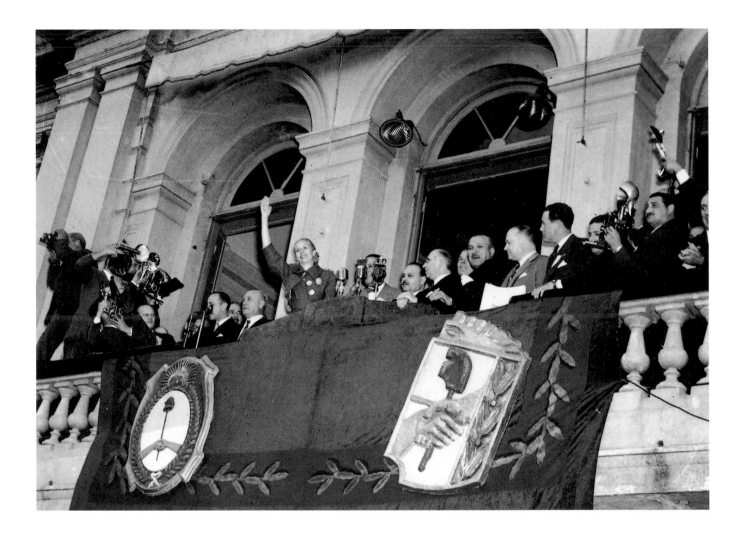

FACING PAGE
Evita's clenched fist, furrowed brow, and strained voice reflected the intense physical pain she was suffering by May 1952, as well as her political preoccupations: the Peronist government had thwarted an attempted coup d'état the previous September.

"I want to speak today," she declared, "even though the General [Perón] asks that I be brief, because I want my people to know that we are all prepared to die for Perón, and I want the traitors to know that we will come here no longer to declare ourselves present for Perón…unless we come to take justice into our own hands…."

ABOVE
Evita waved goodbye to the crowd from the balcony of the governmental palace after her speech and was immediately carried away in Perón's arms. This would be her last public address to the workers of Argentina before she died in July.

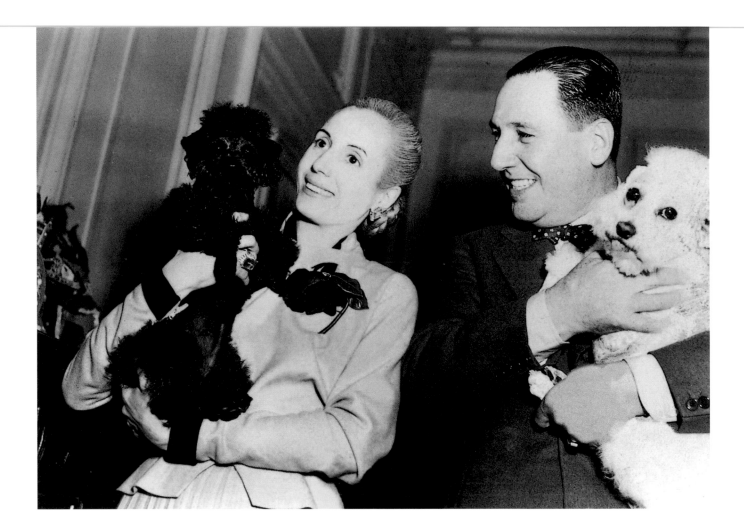

ABOVE AND FACING PAGE
Evita celebrated her thirty-third birthday on May 17, 1952, with Perón and her dogs,
Negrita and Canela, in the Presidential Residence. A few days later, despite her weakness,
Evita appeared briefly in public to greet a crowd of women, children, and senior citizens
gathered to wish her well.

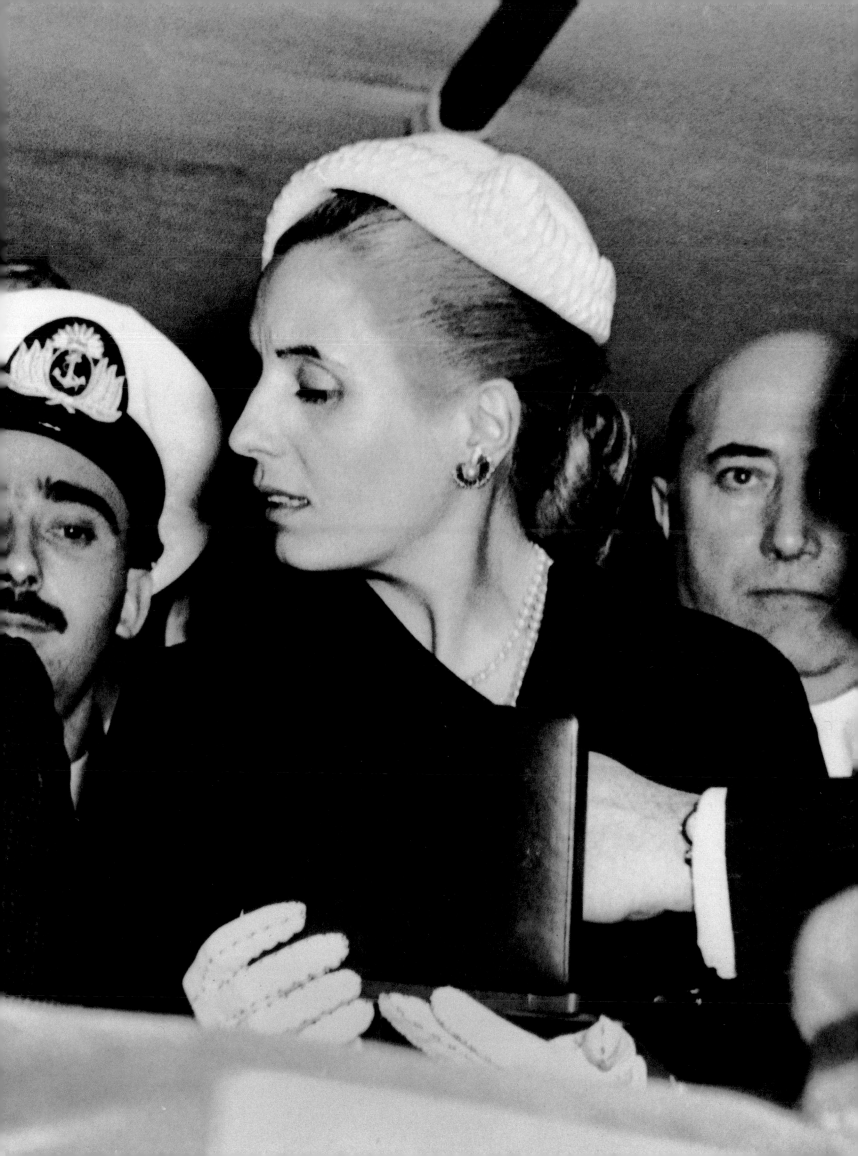

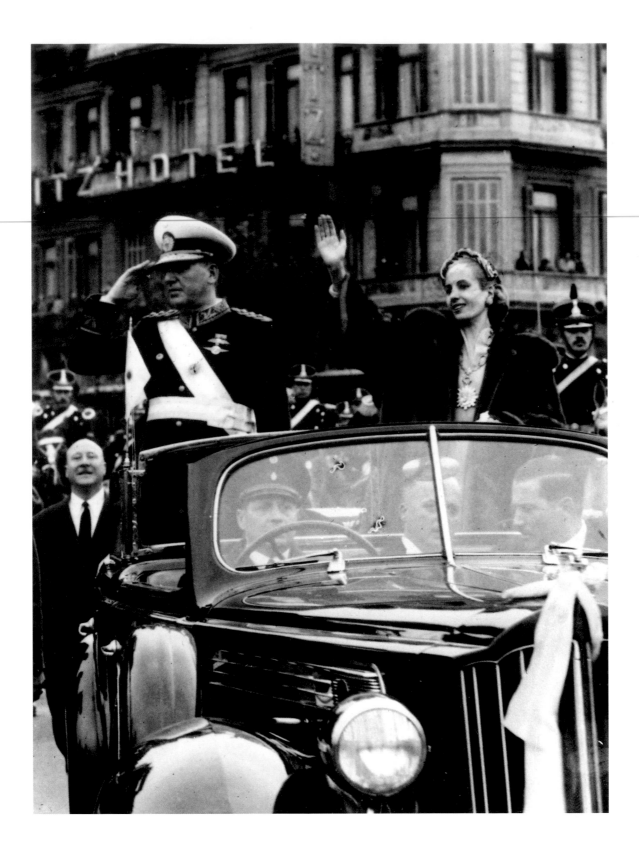

Evita appeared in public for the last time at the Presidential Inauguration on June 4, 1952. Though she was given a strong dose of tranquilizers, she insisted on standing next to Perón and waving to the crowd as the official motorcade traversed the Avenida de Mayo. Too weak to stand on her own, she was supported by a specially devised wooden plank hidden underneath her fur coat.

The last photographs ever taken of Evita record her farewell to the National Congress during Perón's second inaugural ceremony. She died six weeks later at the age of 33.

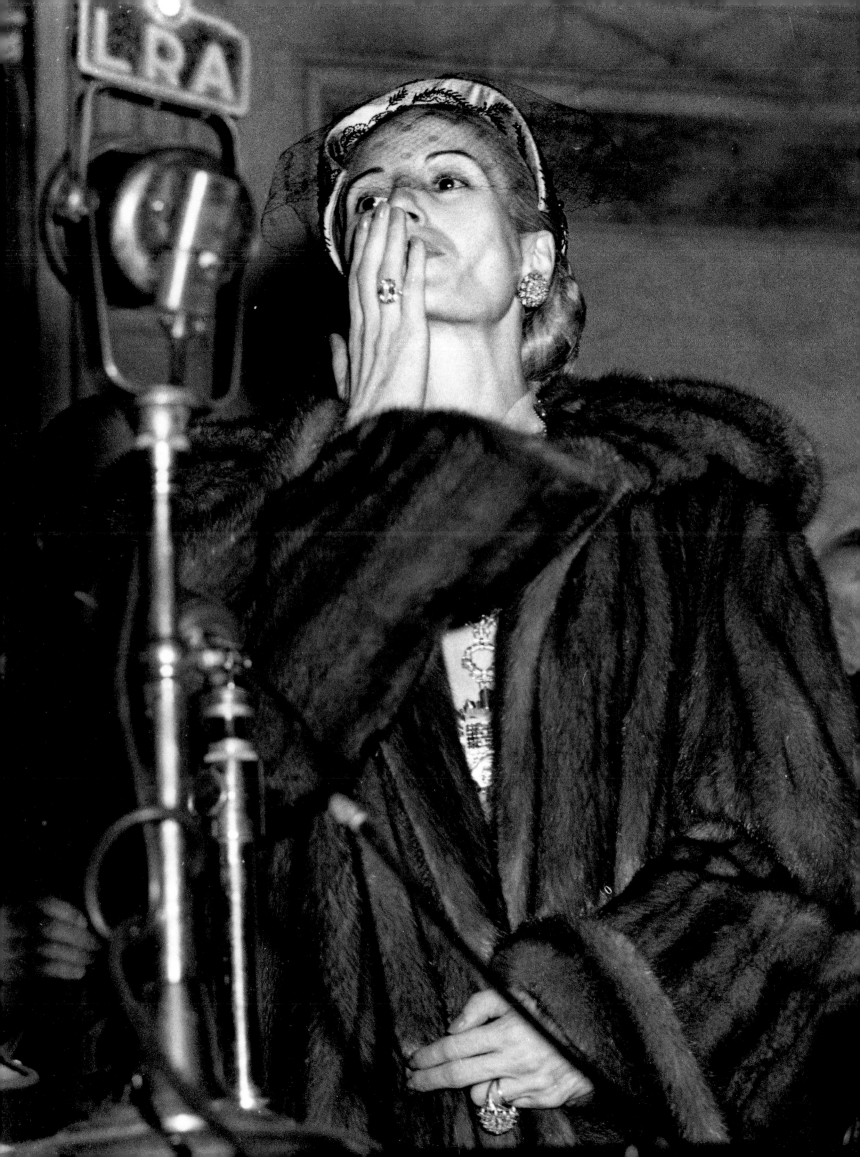

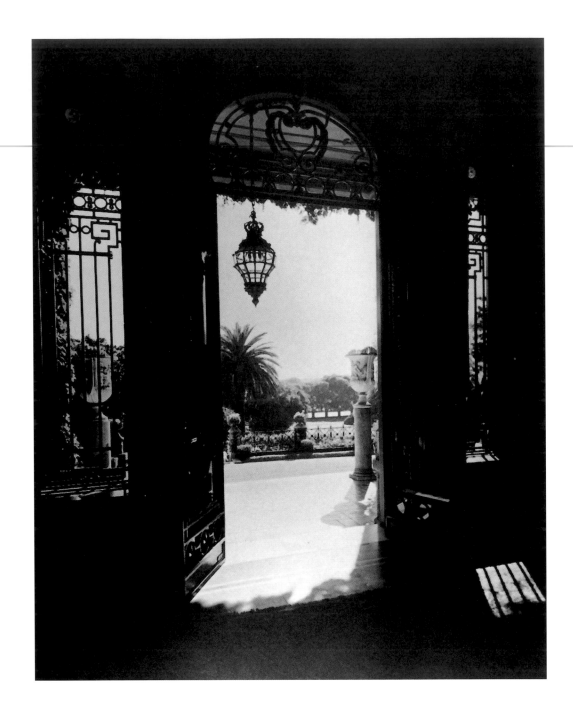

On the day of Evita's death, July 26, 1952, thousands of supporters gathered in the gardens of the Presidential Residence, seen here in an earlier view through the front door, and in the surrounding streets to pray for the First Lady. The national radio network broadcast updates on her condition from a remote hook-up in the Residence. After the announcement of her death at 8:25 PM, an eerie silence enveloped the city.

FACING PAGE

Evita fell into a coma in her bedroom at 11 o'clock on the morning of July 26, surrounded by her family and senior members of the Peronist government, and received the last sacraments from her priest, Father Hernán Benítez, later that afternoon. From her bed the day before her death she whispered to Perón, "I ask only one thing of you. Never abandon the poor— they are the only ones who know how to be loyal."

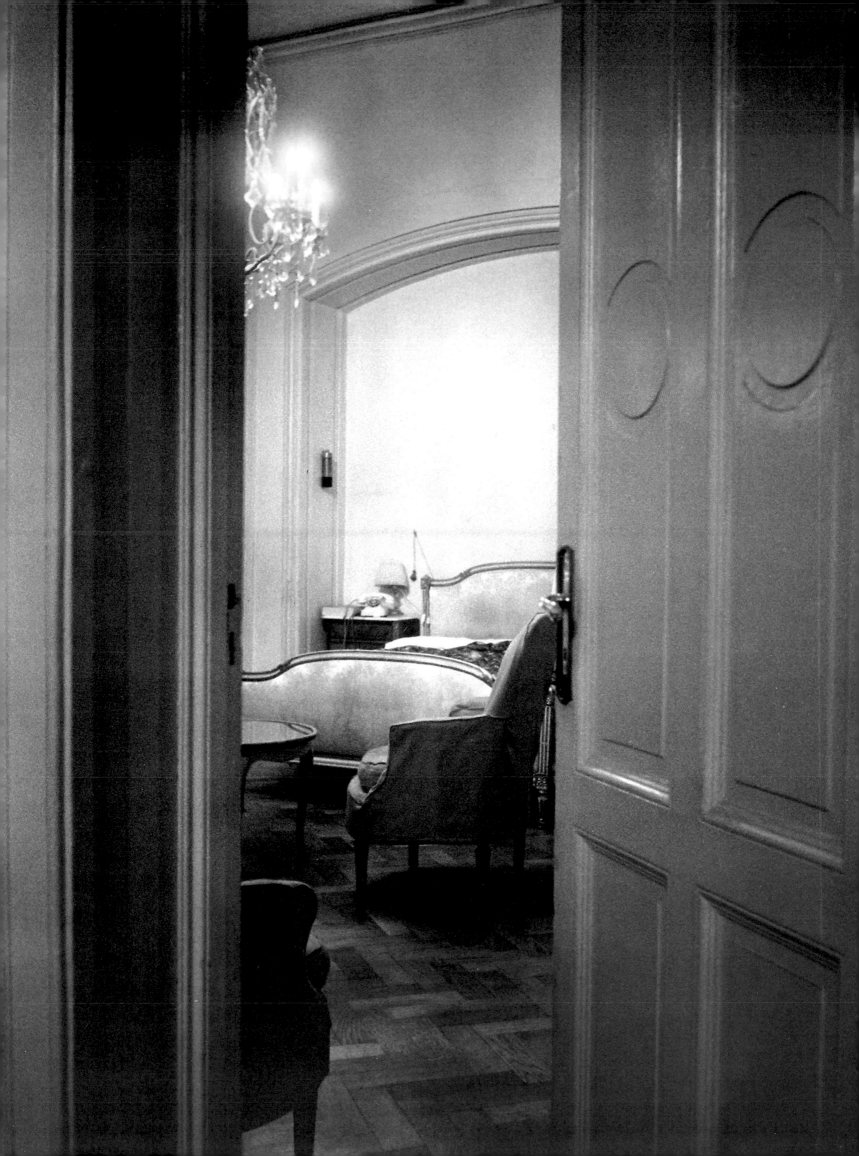

A Nation Mourns

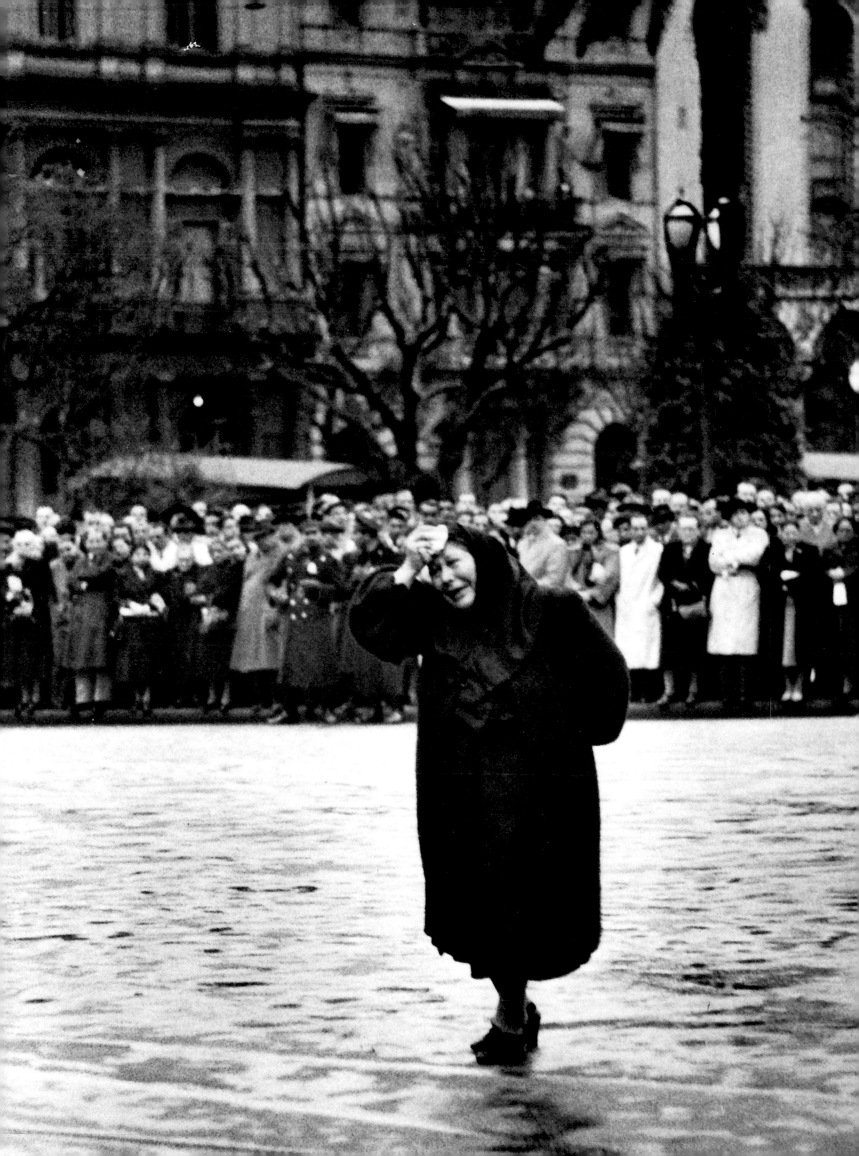

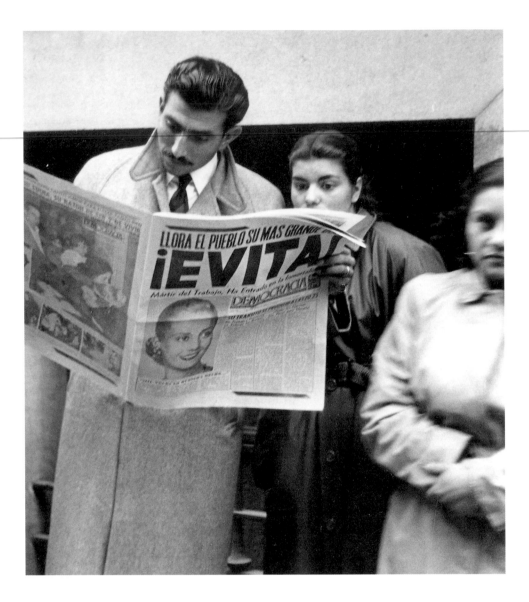

As the world clamored for details of Evita's last days, the Argentine newspaper
DEMOCRACIA *proclaimed "The People Mourn With Deepest Sorrow: EVITA,*
Martyr of Labor, Attains Immortality."

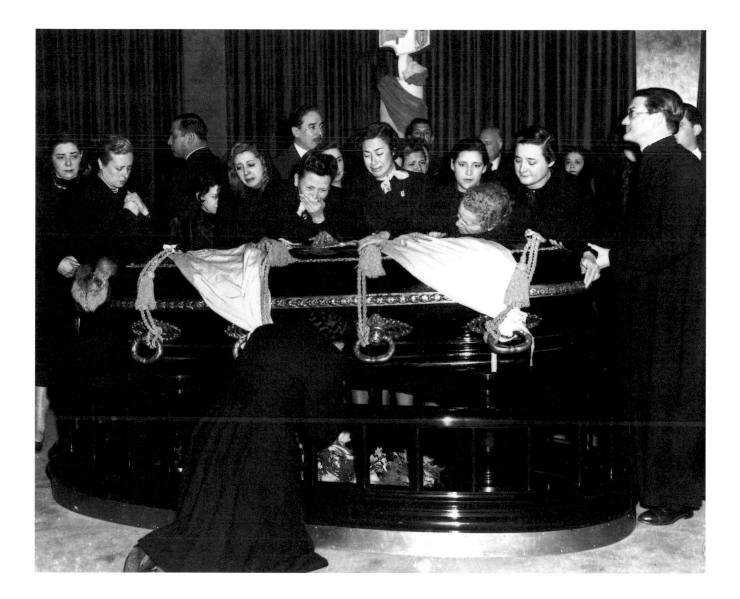

ABOVE
A group of women pay their last respects to the First Lady; at far right is Father Hernán Benítez, Evita's priest and friend. The outpouring of public grief and unforeseen hordes of people lined up outside the Ministry of Labor forced the government to extend the viewing period from two days to fifteen.

OVERLEAF
Lines of mourners stretched from the Ministry of Labor through the surrounding streets. An estimated one million people, standing patiently around the clock in a steady rain, eventually filed past Evita's coffin. Except for the sounds of shuffling feet and intermittent sobs, a strange silence pervaded the streets.

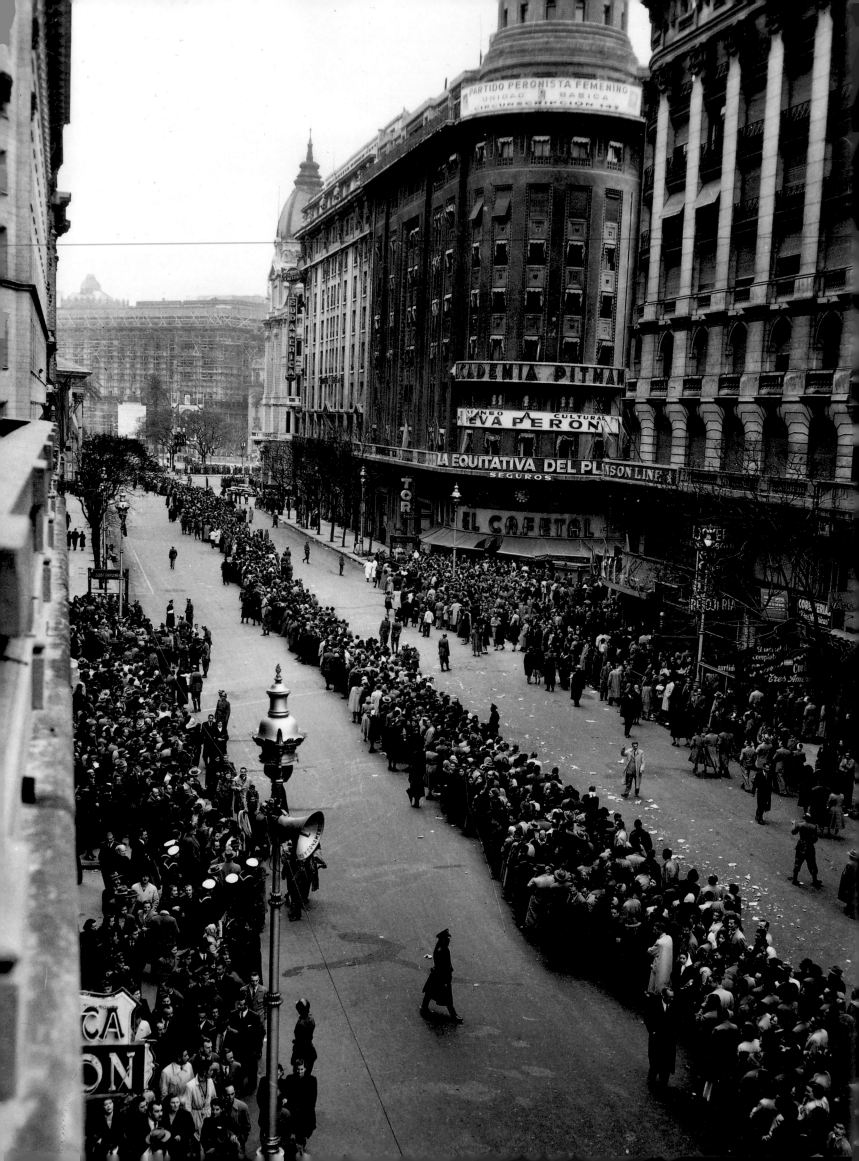

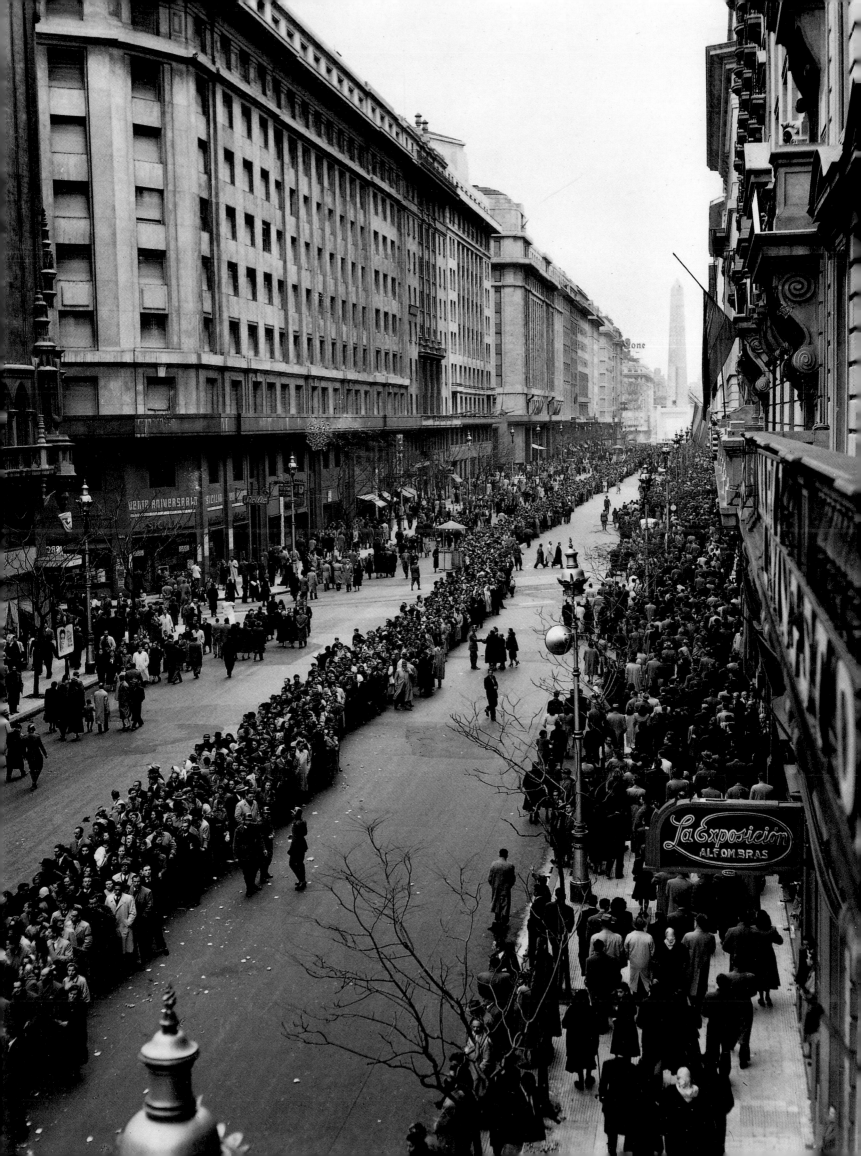

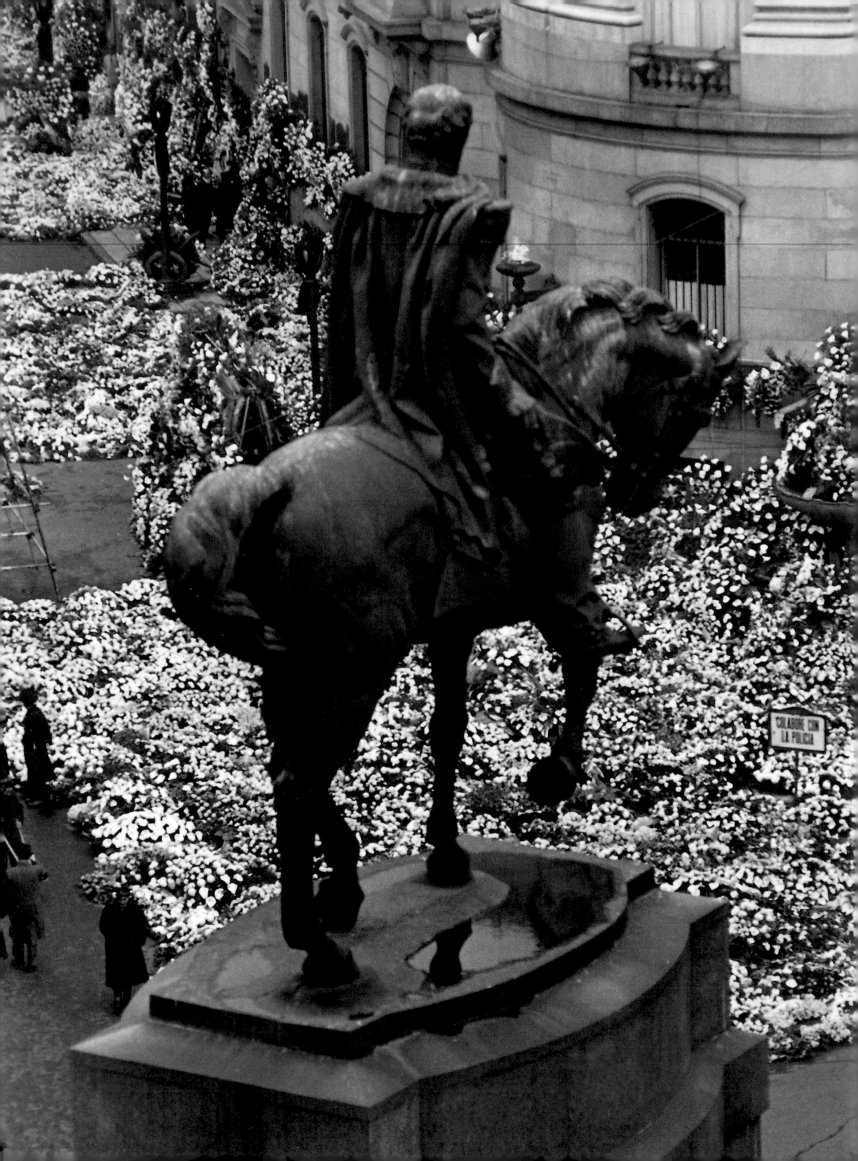

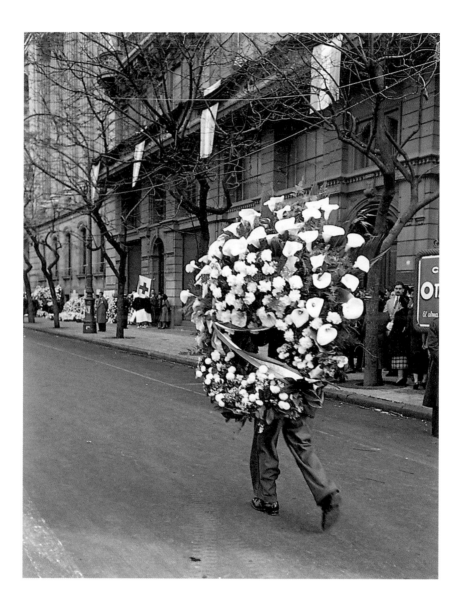

ABOVE

*A man races toward the Ministry of Labor to lay a memorial wreath on the
sidewalk, a scene repeated continuously in the days after the First Lady's death.
Planes filled with flowers and wreaths for Evita landed in Buenos Aires
from all parts of the world.*

FACING PAGE

*Funeral wreaths blanket the sidewalk and walls of the Ministry of Labor, where
Evita's body was displayed in a coffin draped with the Argentine flag.
The equestrian statue is a monument to Julio Argentino Roca,
a nineteenth-century Argentine president.*

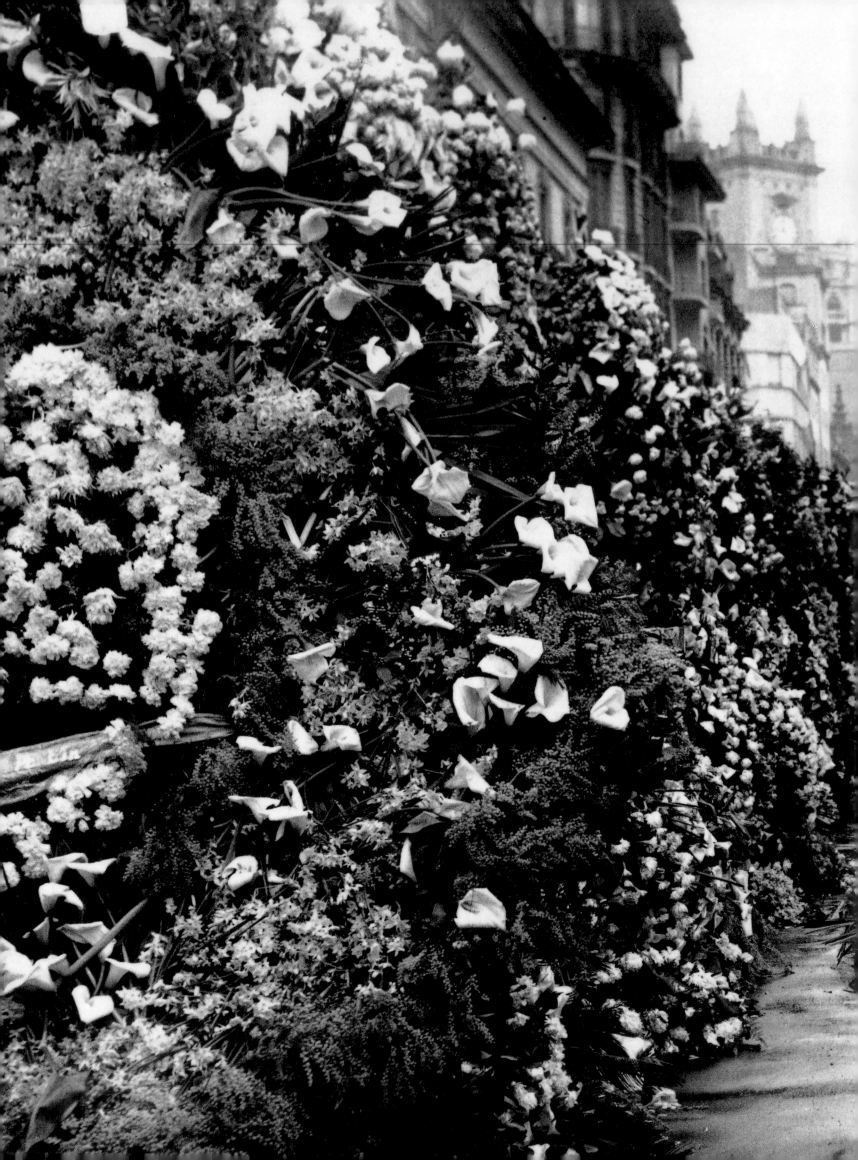

TRABAJADORES DEL
ARSENAL NAVAL Bs. AIRES

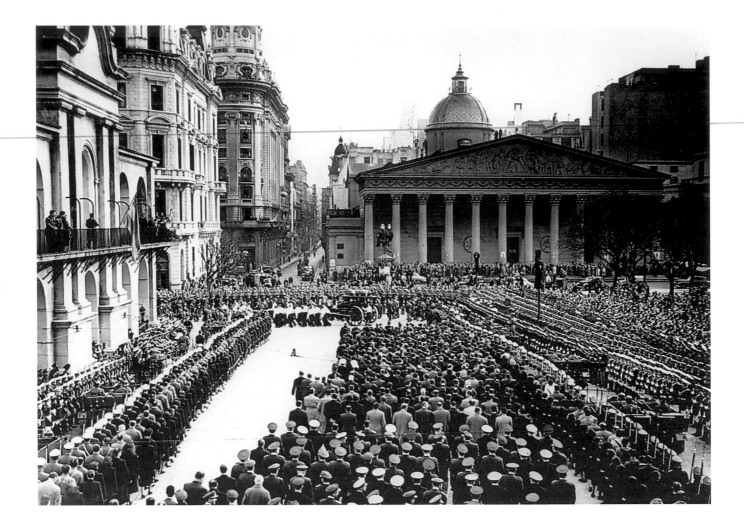

The streets of Buenos Aires overflowed with flowers and memorials in the two weeks after Evita's death on July 26, 1952. In rural villages and on ranches in outlying provinces, small altars glowed with candles surrounding flower-framed portraits of Evita.

Thirty-five members of the CGT labor federation and the Peronist Women's Party, dressed in white shirts and black pants, pull Evita's coffin on its carriage past the Cathedral of Buenos Aires on August 9, 1952.

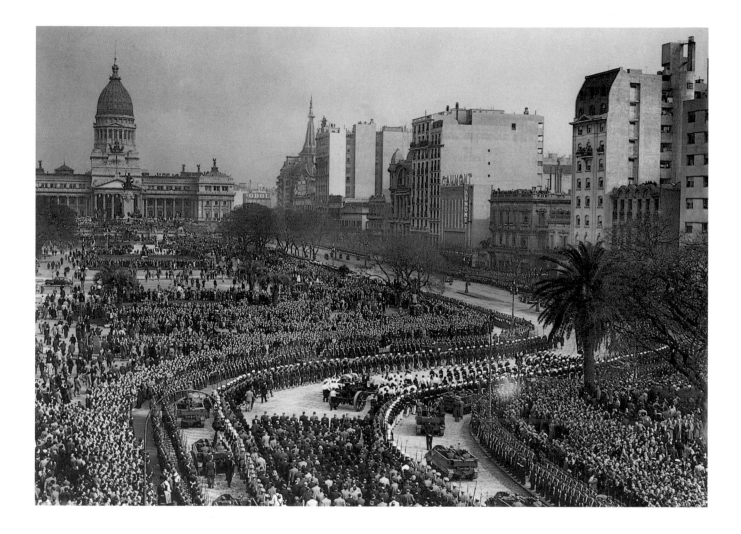

*Evita's funeral cortege winds along the Avenida de Mayo toward the National Congress
on August 9. The entire route became a stage for a dramatic outpouring of sorrow: mourners
fainted, cried uncontrollably, fell to their knees in prayer, and showered
the coffin with flowers.*

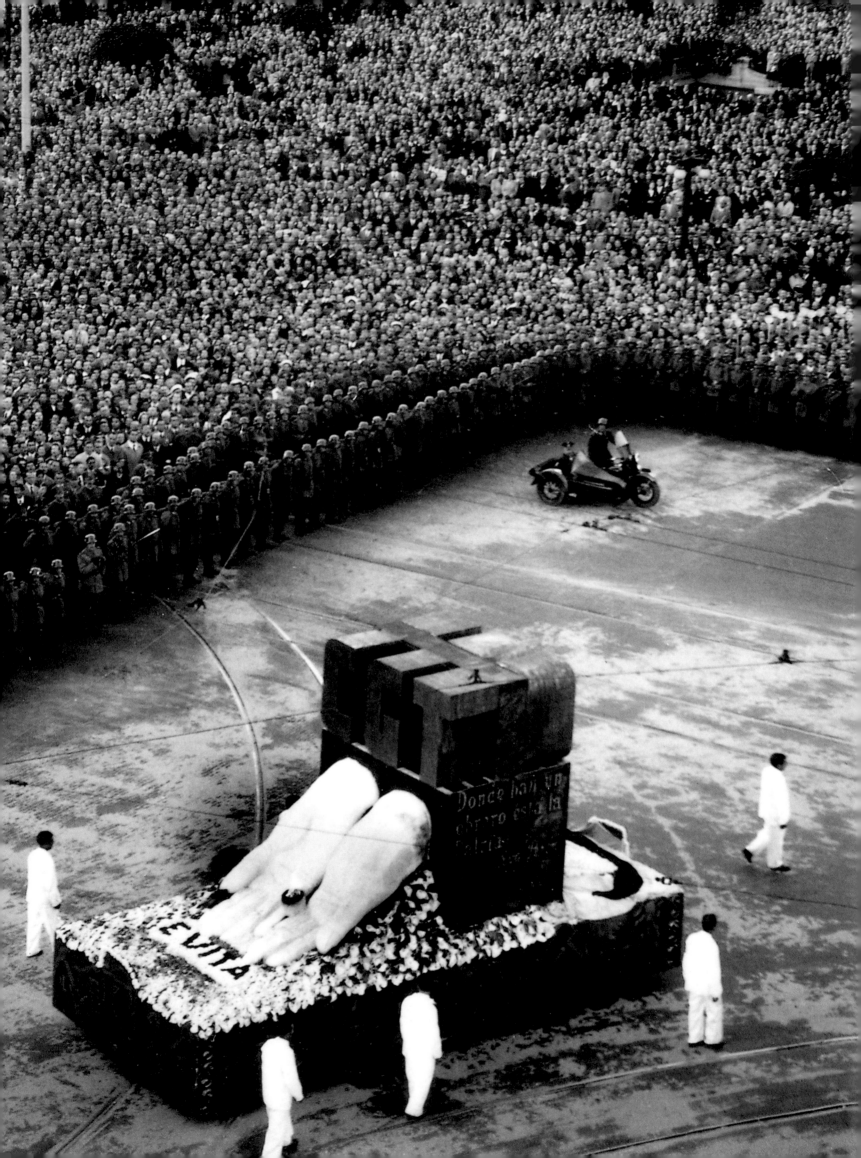

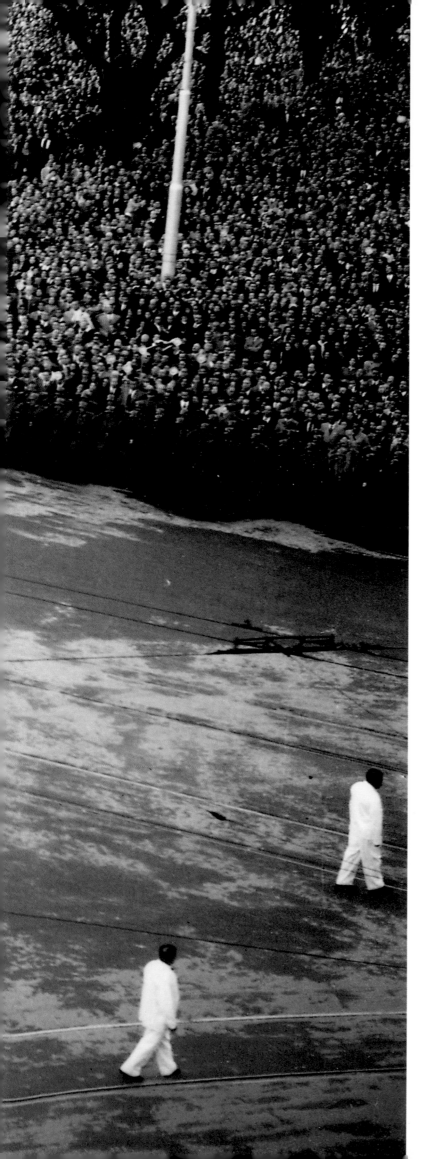

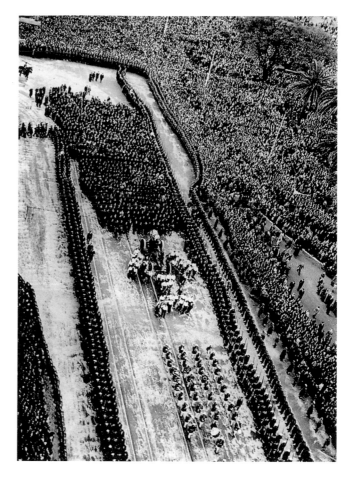

ABOVE *Evita's body was again transported through the streets of the capital on August 10, 1952, the day after the state memorial ceremony at the National Congress. The coffin was carried to the headquarters of the* CGT *labor federation before a crowd estimated at two million. More than a dozen mourners died as waves of people pushed to get a closer view of the funeral carriage, and four thousand were hospitalized.*

LEFT *A* CGT *float heads the funeral procession on August 10, attended by members of the federation dressed in labor uniforms. The open hands, highly symbolic in Argentina, evoke Evita's expressive hands and her generosity to workers, as well as Catholic ideals of sanctity and benevolence. The side of the float bears Evita's words "Where there is a worker, there lies the nation."*

181

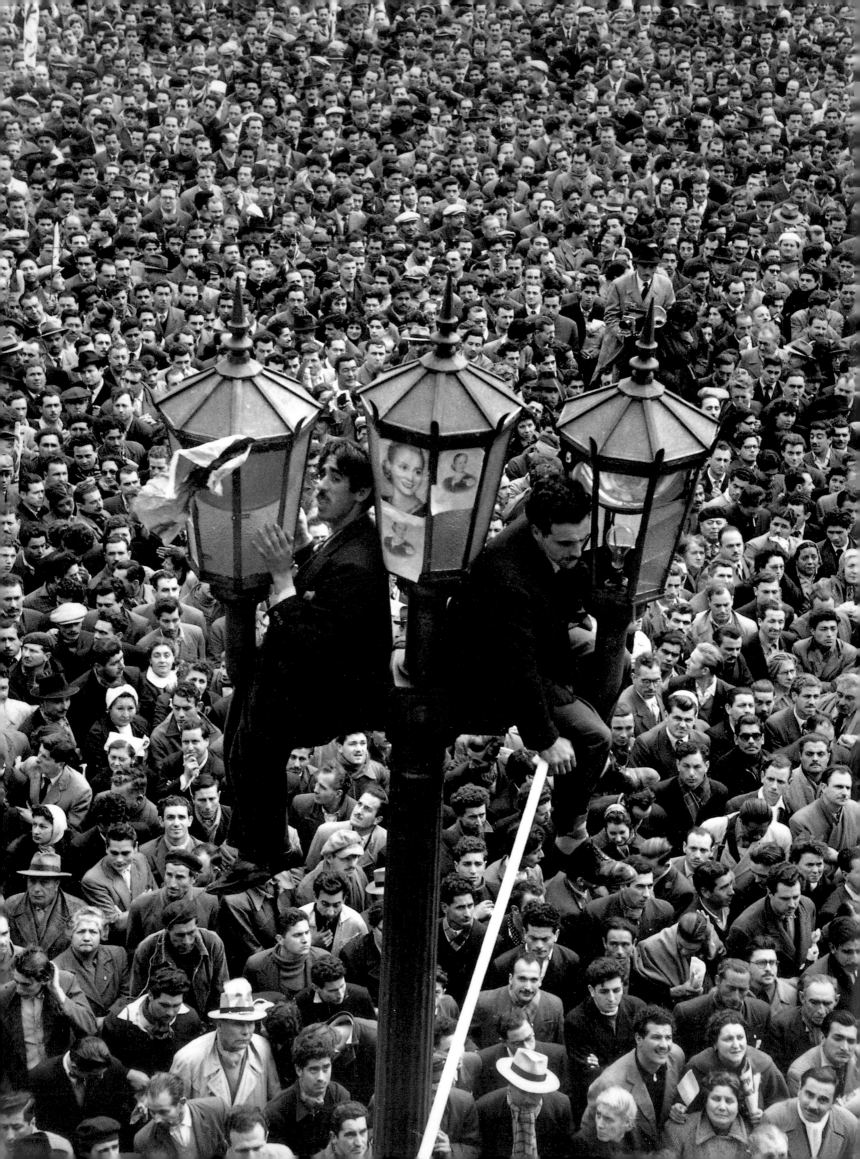

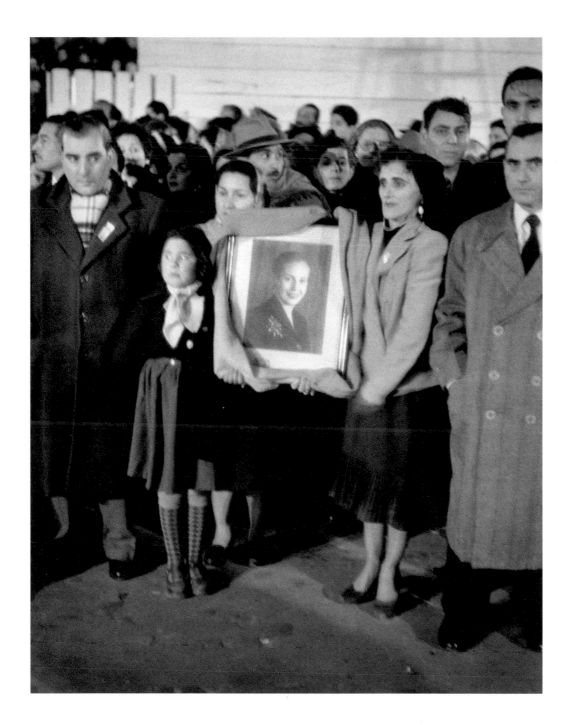

These images from a memorial ceremony in Buenos Aires held three years after Evita's death reveal the public's unremitting dedication to the late First Lady. The homage took place only a few months before Perón was deposed in the Liberating Revolution of 1955. Under the new government, possessing a picture of Evita—even inside one's own home—was a crime punishable by years of imprisonment.

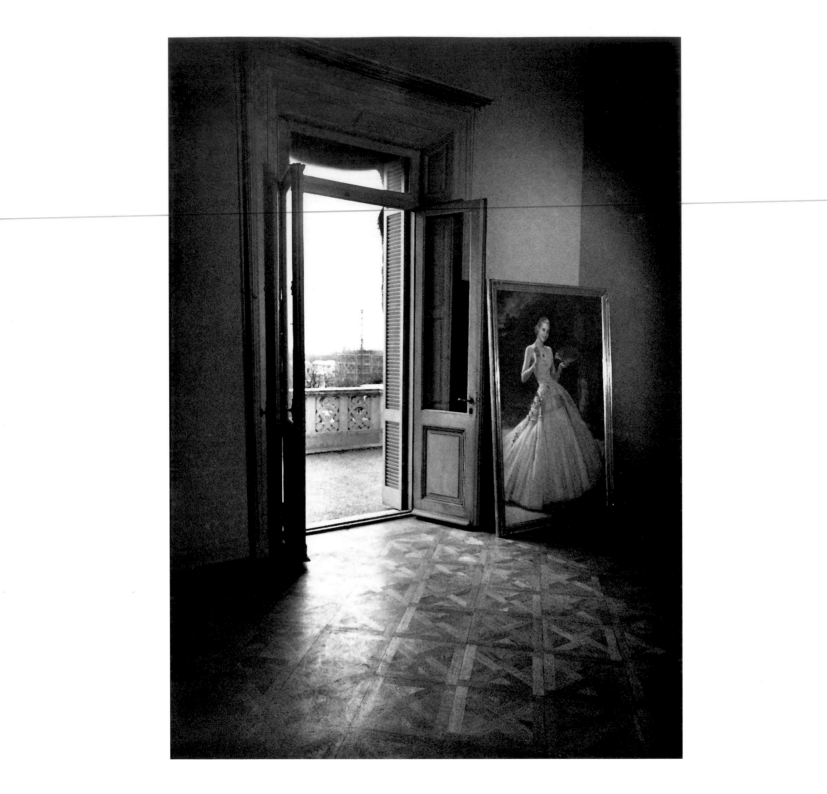

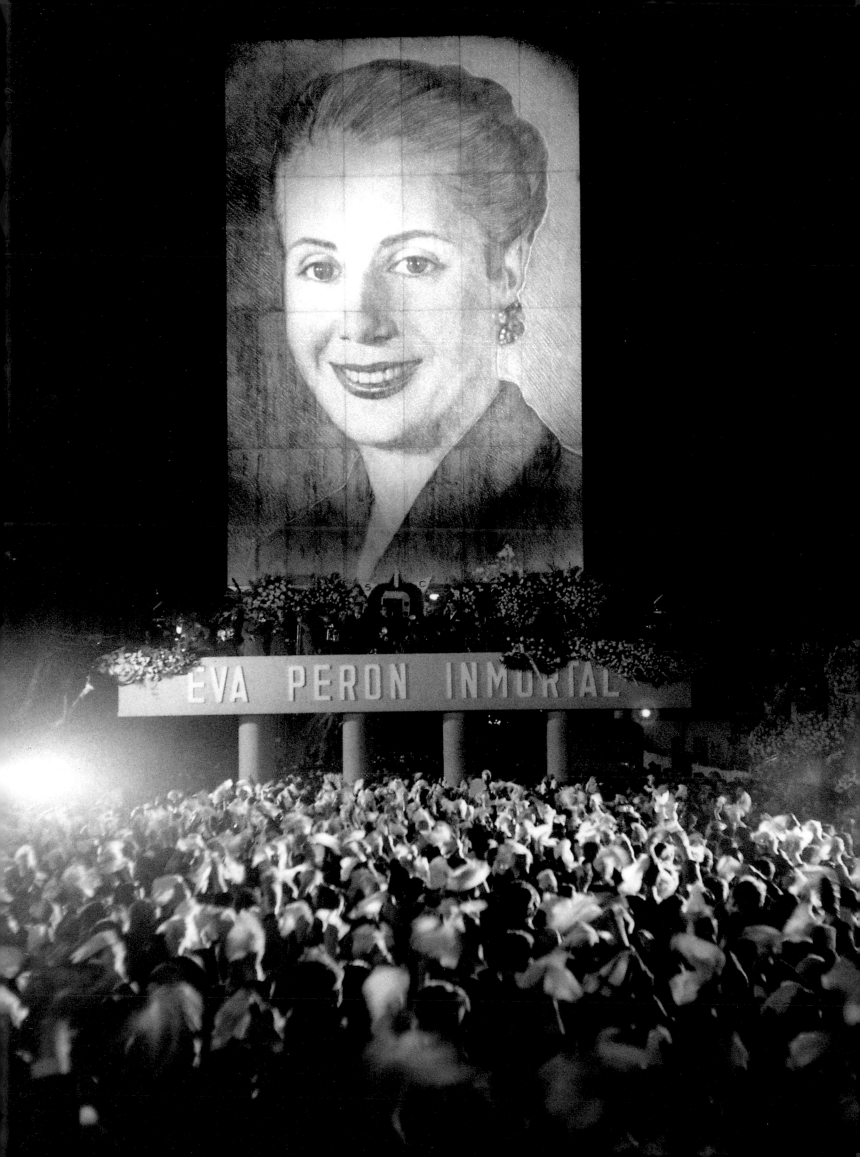

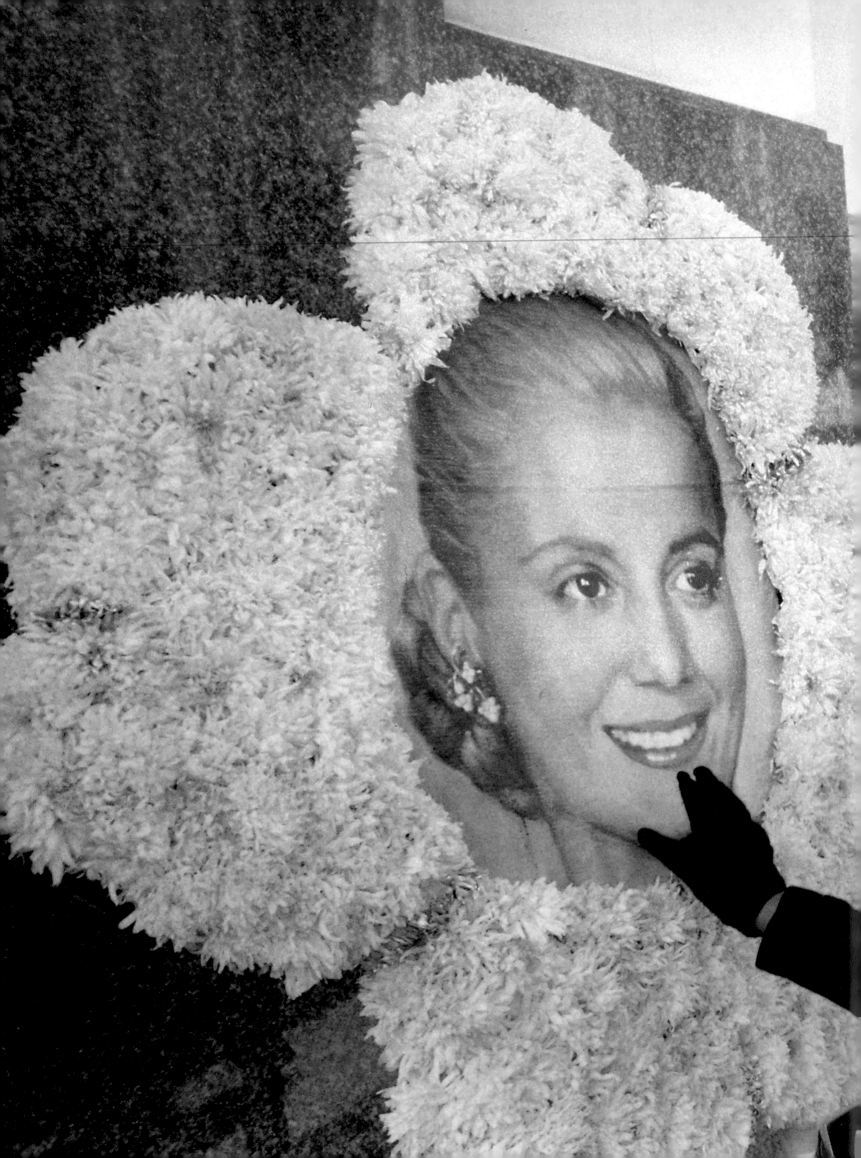

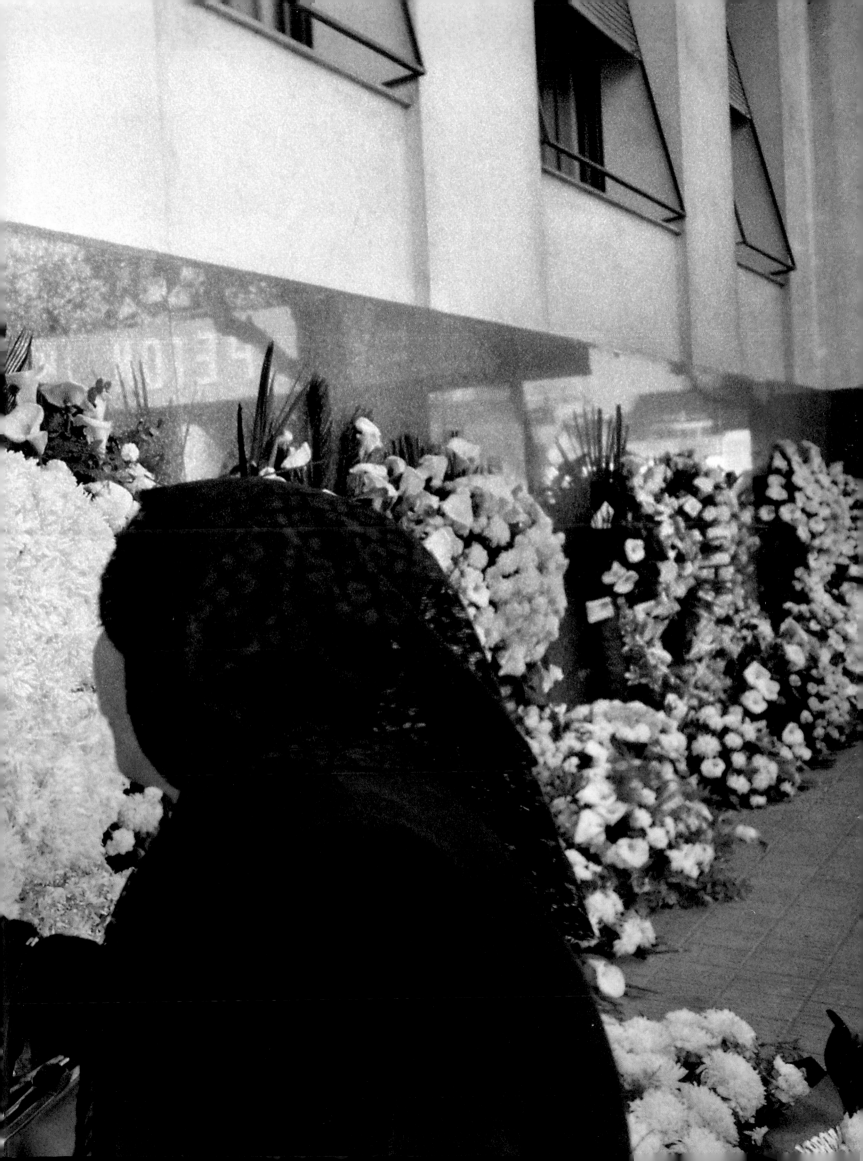

Acknowledgments

WE WOULD LIKE FIRST TO ACKNOWLEDGE Nicolás García Uriburu for encouraging us to undertake this project and for his unconditional assistance throughout its progress. Thanks to Alberto Dodero, who also collaborated with us from the beginning and opened his valuable family archive to us.

Through the generous support of Eva Perón's sisters, Blanca Duarte de Álvarez Rodríguez and Erminda Duarte de Bertolini, we were able to publish, for the first time, photographs of Evita's childhood—a period of her life that has been subject to conjecture and that these images may help to clarify. We extend our gratitude to Cristina Álvarez Rodríguez, president of the Evita Perón Foundation for Historical Research, to whom we are indebted for her time and dedication over the course of this project.

At Rizzoli International Publications in New York, our sincerest thanks to Solveig Williams, who supported this book from the moment she saw the first photographs and closely followed its progress until the final details took shape; and to David Morton, Elizabeth White, Megan McFarland, and Harris Sibunruang, with whom it was a pleasure to collaborate.

Thanks to Charles Churchward, who lent his expert eye to the final selection of photographs and contributed excellent ideas; and to our friend César Aira, who gave us sensible suggestions and generous assistance at difficult moments.

We are especially grateful to Mónica Douek for her excellent photographic research in Paris, and to Massoumeh Farman-Farmaian, who worked efficiently with us in New York.

The following individuals assisted us in various ways as we worked to produce this book: Sarah Jane Freymann, Javier Arroyuelo, Ambassador Benito Llambí, Jorge Antonio, Carmen de Iriondo, Felicitas Luna, Paulette Villanueva, Francis Echauri, Graciela García Romero, Alicia Sanguinetti, Eduardo Ayerza, Jr., Matilde Gyselynck, Diana Castelar, María Cristina Monterubbianesi, Fabio Grementieri, Emilio Lamarca, Eduardo García Belsunce, Noemí Castiñeiras, Elsa Palilla, Angel Farías, Roberto Müller, Ana Silvia Herrera, Nina Beskow, and Kevin Hanek. Thanks to all of you.

We also extend our appreciation to Marie Beauchard and Claude Lenoir, of Van Cleef & Arpels, Paris; and to Muffie Potter, Peter S. Kairis, and Lisa Cochin of Van Cleef & Arpels, New York.

At the National Archives in Buenos Aires, we thank Miriam Casals, head of the Department of Photographic Documents; Verónica Neme, Gabriela Álvarez Casals, María Evangelina Pravato, Marcelo Quilez, and Pablo Tripicchio. At the Cinema Museum, thanks to María Carmen Vieites and Andrés Insaurralde; at the archive of the newspaper *Clarín*, we thank Miguel Angel Cuarterolo. We would like to acknowledge the excellent photographic reproductions by César Caldarella, Juan Carlos Banchero, and Federico Zampaglione.

Finally, we are especially grateful for the contributions of Inocencio Caruso and Alfredo Mazzorotolo, who gave us access to their unpublished photographs of Evita.

— TOMÁS DE ELIA AND JUAN PABLO QUEIROZ

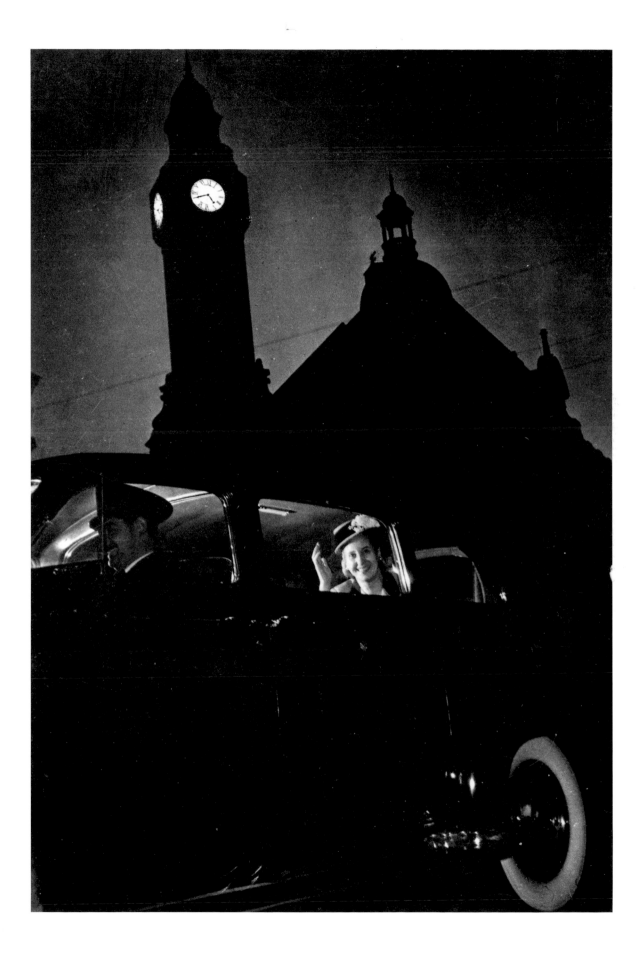

References

Borroni, Otelo, and Roberto Vacca. *La Vida de Eva Perón*. Vol. 1: *Testimonios para su historia* (Buenos Aires: Editorial Galerna, 1970).

Castiñeiras, Noemí. *Ser Evita* (Buenos Aires, 1996, unpublished).

Chávez, Fermín. *Eva Perón en la historia* (Buenos Aires: Editorial Oriente, 1986).

Duarte, Erminda. *Mi hermana Evita* (Buenos Aires: Ediciones Centro de Estudios Eva Perón, 1972).

Fraser, Nicholas, and Marysa Navarro. *Eva Perón* (New York: W. W. Norton & Co., 1980).

Guardo, Lillian Lagomarsino de. *Y ahora…hablo yo* (Buenos Aires: Editorial Sudamericana, 1996).

Navarro, Marysa. *Evita* (Buenos Aires: Editorial Planeta, 1994).

Page, Joseph A. *Perón: A Biography* (New York: Random House, 1983).

Perón, Eva. *La razón de mi vida* (Buenos Aires: Ediciones Peuser, 1951).

Tettamanti, Rodolfo. *Eva Perón* (Buenos Aires: Centro Editor de América Latina, 1971).

Sebreli, Juan José. *Eva Perón: ¿aventurera o militante?* (Buenos Aires, Editorial Siglo xx, 1966).

Photography Credits

Numbers below indicate page numbers.

Agence France Presse: 68, 178, 181 (right).

Agencia EFE, Madrid: 74 (top and bottom), 77.

Antena. Courtesy Hemeroteca de la Biblioteca Nacional, Buenos Aires: 44 (far right, second from bottom; bottom center).

AP / Wide World Photos: 78–79, 90, 103 (right).

Archive Photos: 138, 140 (left).

Archive Photos France / Archive Photos: 154, 160.

Archivo *Clarín*: 172, 173, 179.

Archivo General de la Nación, Buenos Aires: 24 (bottom), 34, 35, 64, 65 (bottom), 107, 114 (left), 118, 119 (bottom), 132, 135, 136–137, 143, 144, 145, 147 (top and bottom), 148, 149, 152, 153, 155, 157 (right), 162, 189.

Balzami. Courtesy the Dodero family archive: 98–99.

Cornell Capa / Magnum Photos, Inc.: 11, 167, 182, 183, 184, 185, 186–187.

Francisco and Inocencio Caruso: 94, 102, 108, 115, 116–117, 121, 171, 176–177, 180.

Cine Argentino. Courtesy Museo del Cine Pablo Ducrós Hicken, Buenos Aires: 41 (bottom).

Horacio Coppola: 38–39.

Corbis–Bettmann: 47, 69, 75.

Foto Crescente, Rome: 80.

Alfred Eisenstaedt / LIFE Magazine © TIME Inc.: 170, 174, 175.

Evita International Foundation, Miami: 13.

Hilario Angel Farías: 134.

Gisèle Freund / Agence Nina Beskow: 2, 5, 124, 125, 126, 128, 129, 130, 131.

Fundación de Investigaciones Históricas Evita Perón, Buenos Aires: 21, 22, 23, 24 (top), 25, 26, 27, 28, 29, 30–31, 60.

Courtesy Fundación de Investigaciones Históricas Evita Perón, Buenos Aires: 45, 158–159.

Nicolás García Uriburu: 192.

Manuel Gómez: 122–123, 133, 166.

Guión (Photo: Annemarie Heinrich). Courtesy Graciela García Romero: 41 (top).

Marie Hansen / LIFE Magazine © TIME Inc.: 106, 109, 110–111.

Annemarie Heinrich: 6, 36–37, 40, 42, 43.

Enrique Herrera. Courtesy Ana Silvia Herrera: 165.

The Hulton Getty Picture Collection Limited: 44 (far right, second from top), 112, 113.

Inter Prensa / Black Star: 70–71.

Tony Linck / LIFE Magazine © TIME Inc.: 84, 85, 86, 87.

Jean Manzon / © TIME Inc.: 92, 93.

Alfredo A. Mazzorotolo: 66–67, 97, 100, 101, 104–105, 150–151, 161.

Thomas McAvoy / LIFE Magazine © TIME Inc.: 48, 49, 50, 51, 52, 53, 54, 55, 56, 57, 58–59, 61, 65 (top).

Meldolesi / Black Star: 81.

Courtesy Museo del Cine Pablo Ducrós Hicken, Buenos Aires: 44 (bottom left corner; top right corner).

Reprinted from *Eva Perón*. Subsecretaría de Informaciones de la Presidencia de la Nación (Buenos Aires, 1952): 9, 82, 120 (left).

John Phillips / LIFE Magazine © TIME Inc.: 73.

Fernando Prado. Courtesy the Dodero family archive: 63.

Roger Viollet: 83, 88, 89.

Michael Rougier / LIFE Magazine © TIME Inc.: 95 (right).

Sintonía. Courtesy Museo del Cine Pablo Ducrós Hicken, Buenos Aires: 44 (top left corner; bottom right corner; far left center; center).

Photo Sommer, Samaden. Courtesy Ambassador Benito Llambí: 91.

SYGMA / Keystone: 76 (left), 139.

Courtesy *Todo es Historia* magazine, Buenos Aires: 163.

UPI / Corbis–Bettmann: 141, 146, 156, 164.

Foto Valenti: 33.

Van Cleef & Arpels, New York: 127 (top left and right; bottom).

Van Cleef & Arpels, Paris: 127 (center left and right).

Photographic reproductions:

Caldarella & Banchero: 6, 9, 21–31, 33, 43, 45, 60, 63, 64, 65 (bottom), 80, 82, 98–99, 107, 114, 118, 120, 132, 135, 136–137, 143, 144, 147, 148, 149, 152, 153, 155, 157, 158–159, 162, 163, 189, 192.

Guido D. Chouela: 41 (bottom), 44 (top right corner; bottom left corner), 133, 166.

Federico Zampaglione: 24 (bottom), 34, 35, 44 (top left corner; far left center; center; far right, second from bottom; bottom center; bottom right corner), 91, 145.

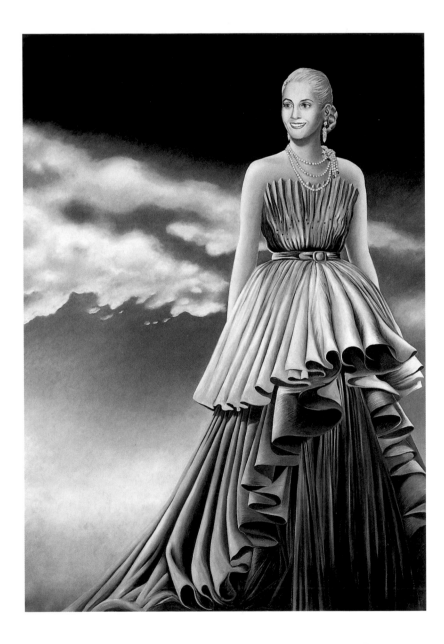